HERTFORDSHIRE

THROUGH TIME

Stephen Jeffery-Poulter

BRADWELL
BOOKS

Acknowledgements

The author would like to thank Luke Clark, Collections Officer at Watford Museum, for his help with confirming the location of one of the shots; Shirley Everall, Reader Development Officer for Libraries, Culture and Learning at Herts County Council; and Phil Oldridge, Information Services Librarian, East Libraries, Culture & Learning, also at Herts County Council. He is also very grateful to Alan for putting up with his sudden and repeated absences on those rare sunny Sundays, and for the Books@Hoddesdon staff for covering him dashing off at short notice to take selected shots when glorious sunshine broke through the clouds at the right time of day. Examples of many of Tom Cottrell's wonderful period cartoons can be found at the National Cartoon Archive (www.cartoons.ac.uk). The author has, where appropriate, made every effort to trace copyright holders of the images in this book, and apologises to anybody who has been missed.

First published in 2013 by
Amberley Publishing for Bradwell Books

Amberley Publishing
The Hill, Stroud, Gloucestershire, GL5 4EP
www.amberley-books.com

Copyright © Stephen Jeffery-Poulter, 2013

The right of Stephen Jeffery-Poulter to be identified as the Author of this work has been asserted in accordance with the Copyrights, Designs and Patents Act 1988.

ISBN 978 1 4456 1617 9 (print)
ISBN 978 1 4456 1632 2 (ebook)

British Library Cataloguing in Publication Data.
A catalogue record for this book is available from the British Library.

Typesetting by Amberley Publishing.
Printed in Great Britain.

Introduction

Having lived over half my life in my home county of Hertfordshire and travelled around it pretty extensively for over thirty years, I had the impression I had visited most of the places in what is, after all, not a particularly large geographical area. However, it was only when undertaking this book that I discovered, to my surprise and delight, the many charming towns, villages and hamlets that I had either passed by, or simply never had occasion to take a detour to reach down narrow side roads and winding country lanes.

My aim in this book has been to try to cover as many locations as possible in the pages available, and the selection of period photographs I had available to choose from. I also felt it appropriate to give more space to the larger towns or more historically important places, in order to give enough interesting information within the limitations of space.

The three previous *Through Time* titles for which I have provided the contemporary photographs over the last three years have covered the individual towns of Hoddesdon, Hertford and Ware. With a whole book devoted to a single place, the local historians who wrote the text for those were able to provide a great deal of factual and historical information. One of the challenges I faced when compiling a single volume to cover a whole county was how to provide the most interesting facts about a single neighbourhood in a maximum of 120 words.

Rather than simply report my own historical research and personal observations, I thought it would be more interesting to look at the guide books and historical publications that appeared in the first fifty years of the last century, when the period photographs featured in this book were actually taken. The five main works I quote from are:

Tomkins, Herbert W., *Hertfordshire* (Methuen & Co, 1903) [referred to as 'Tomkins' in the text]

Lydekker, R., *Hertfordshire* (Cambridge County Geographies, 1909) [shortened to 'Lydekker' in captions]

Page, William (ed.), *The Victoria History of the Counties of England* (Victoria County History, 1902) [an epic and encyclopedic series, the three volumes on Hertfordshire appearing in 1902, shortly after the monarch to whom they were dedicated had died – referred to as 'the *Victoria*' in the text]

Mee, Arthur, *Hertfordshire: London's Country Neighbour* (1939) [part of his ambitious King's England series – just 'Mee' in the text]

Pevsner, Nikolaus, *The Buildings of Britain* (1953) ['Pevsner' for convenience]

It seemed to make sense to present the places in the book in straightforward alphabetical order, mainly because this is the format used by all the period guides from which I have quoted. The one exception is the *Victoria*, which not only splits the shire up into its ancient parishes, but does not include an index, making it a very difficult series of volumes to navigate. That was until I

discovered that all the volumes of the *Victoria* were accessible and searchable at British History Online, one of the most invaluable research websites for historians (www.british-history.ac.uk).

Taking the contemporary photographs was, as usual, a fascinating experience. Where the historic scenes were virtually unchanged the exercise was pretty straightforward, although many required me to stand in the middle of main roads, dodging speeding traffic. For Victorian and Edwardian photographers, the worst risk they faced in the middle of the public highway was a jogging horse and cart or the odd bicycle. Many of their pictures also feature children carefully posed for the camera, who were bribed with a penny each for their cooperation. A modern photographer offering such enticements today would probably be rather less well received.

In some instances, it was quite a challenge to spot clues as to the one or two buildings that had survived (chimneys are often the best evidence), and then line up the shot to copy the original period photograph. Not that I've been slavish about making exact matches, as the main change over a century has been with the growth of trees and shrubs, which means if I had taken certain shots from exactly the same spot then the buildings featured would have been totally obscured!

The several hundreds of miles I travelled in taking the photographs for this book over more than six months were a journey of discovery. I stumbled across many sleepy rural backwaters from Nobland Green, Cockernhoe and Trowley Bottom to Gubble, Mobb's Hole and Clapgate.

I hope readers will enjoy exploring the rich and fascinating heritage of our county as much as I have in compiling it, and use this book as an excuse to visit or revisit many of the historic places featured here. The trick is just to look up above the garish modern shop fascias, or to take a little extra time in your journey for a detour down that enticing country lane...

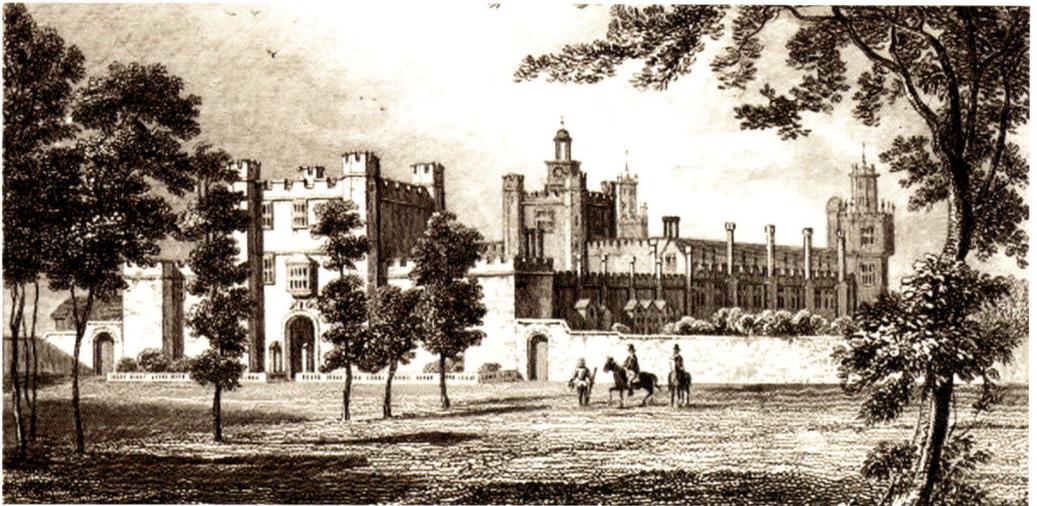

Theobolds Palace is one of the grandest lost royal palaces, originally built by William Cecil and then 'appropriated' by James I who gave Robert Cecil the old palace at Hatfield in return. Charles I was in residence there when he heard news of his father's death and his accession to the throne. Most of the site was demolished during the Commonwealth, and Old Palace House was built incorporating features from the previous building, only to be burned down in the 1960s. Cedar Park in Cheshunt today contains some impressive walls and remnants of carved stone.

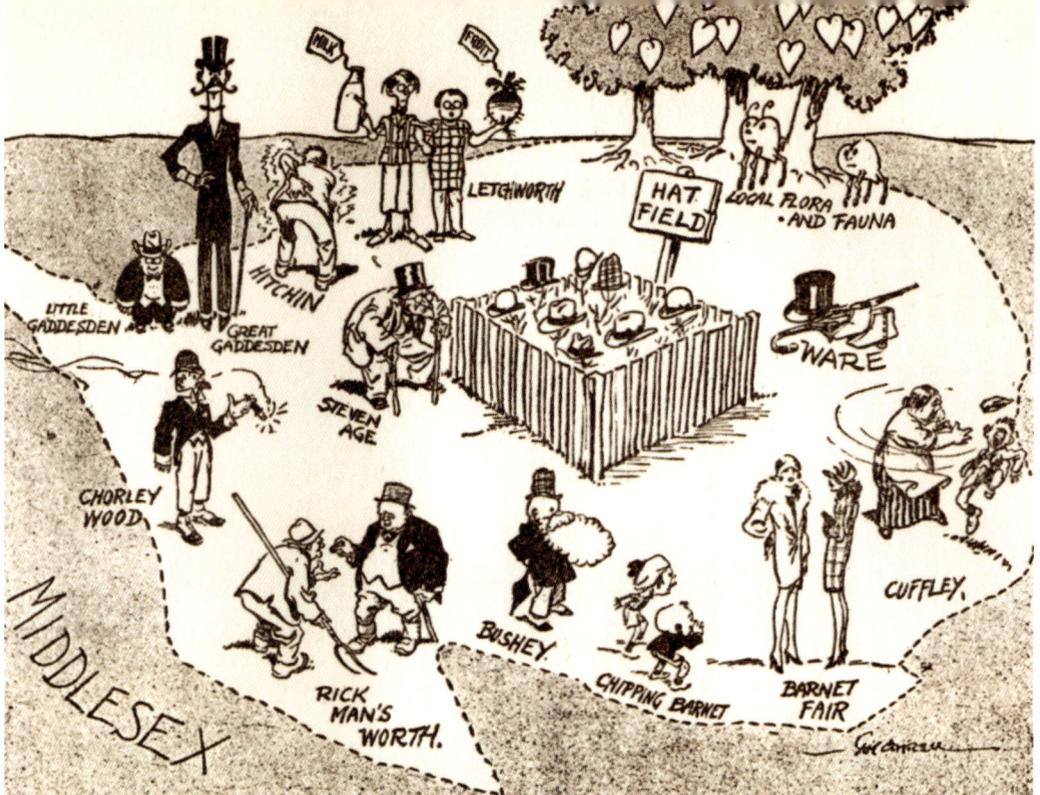

Hertfordshire – according to Tom Cottrell. (*Historic Hertfordshire* by W. Percival Westell, 1930)

I turn my back on thy detested walls, proud city
And I shall muse on thee, slow journeying on
To the green plains of pleasant Hertfordshire.

Charles Lamb

A county whose delicate structure particularly needs the attentive eye. Hertfordshire is England at its quietest, with little emphasis of river and hill; it is England meditative.

E. M. Forster

Originally Hertford was essentially an agricultural county, as it is to a great extent at the present day; its northern three-quarters being noted for its production of corn ... Nowadays, however, more especially on the great lines of railway, conditions have materially altered ... The old-fashioned timbered and tiled or thatched cottages formerly so characteristic of the county are rapidly vanishing and giving place to the modern abominations in brick and slate. Gone, too, is the old-fashioned and picturesque smock-frock of the labourer and the shepherd, which was still much in evidence some five and forty years ago, or even later; its disappearance being accompanied by the loss of many characteristic local words and phrases...

Hertfordshire by R. Lydekker (1909)

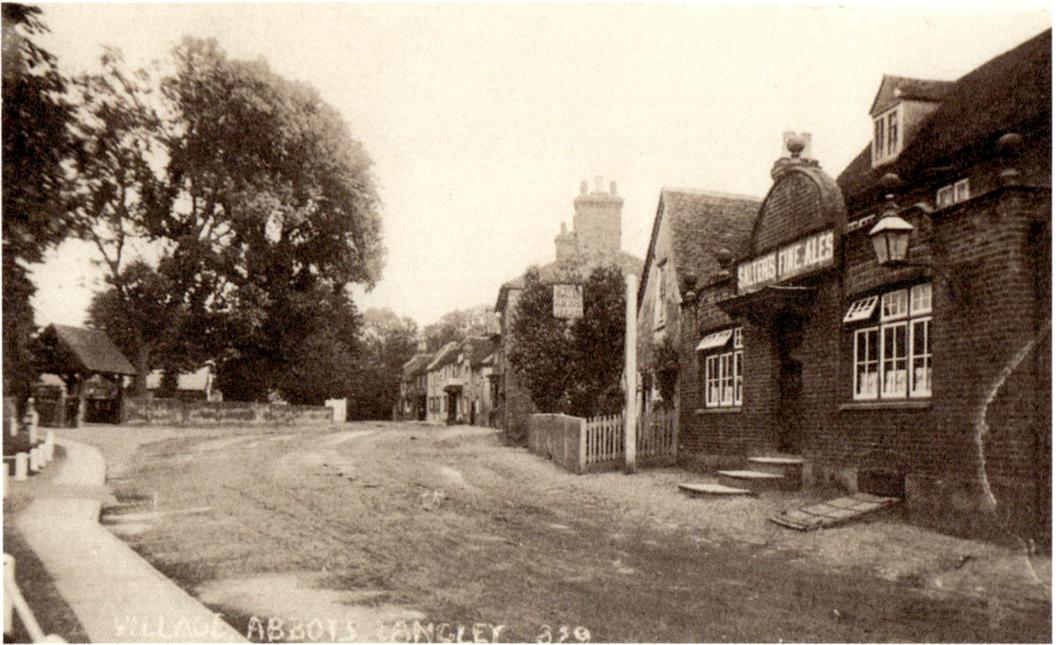

VILLAGE ABBOTS LANGLEY 359

Abbots Langley

According to Tomkins, 'The village probably owes its name, first, to its length, 'Langley' signifying a long land; second, to the fact that in the days of Edward the Confessor it was given to the Abbots of St Albans.' Now a straggling suburb of Watford, this was the birthplace of Nicholas Breakspeare who, having unsuccessfully applied to be a monk in the great monastery at St Albans, went off to Paris and eventually became the one and only English Pope, Adrian IV. In 1909, the paper mills on the canal were considered the most important manufacturing industry in the county.

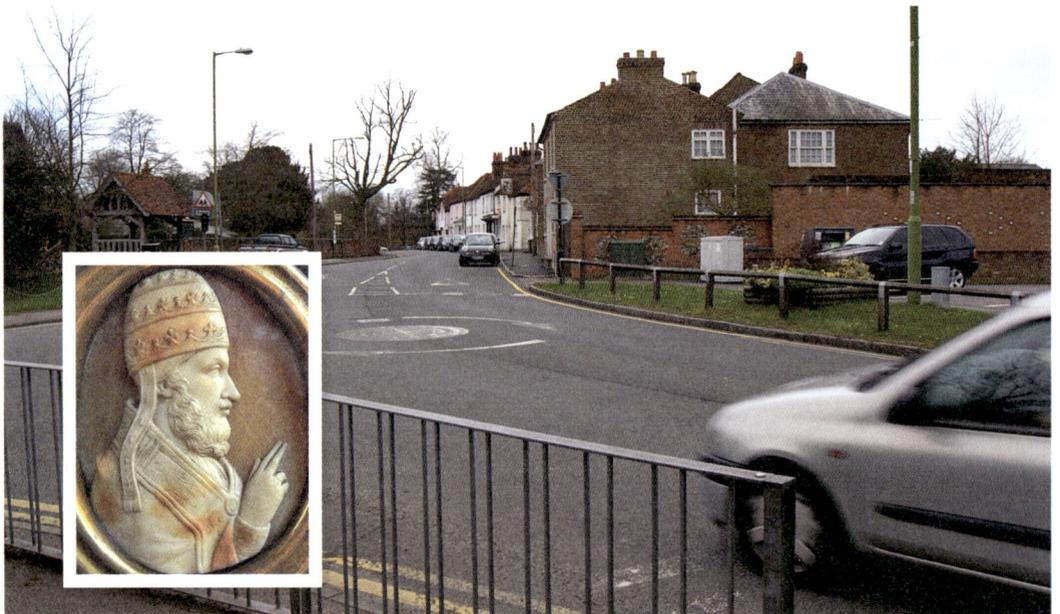

Albury

Little has changed here since Tomkins wrote, 'The village is usually a quiet spot, with little business, but it is pleasantly situated; the proximity of the river and some scattered cottages and farms enhance its attractiveness.' However, according to the *Victoria*, 'In the middle of the last century the village was in a deplorable state. There was no resident clergyman and the curate who rode over to take the service was accustomed, if he found only a few people assembled, to bribe them to go away.' The original thatched and boarded eighteenth-century Catherine Wheel Inn burned down on the night of 29 October 2004 in a suspected arson attack. Five years later, this smart gastropub opened in its place.

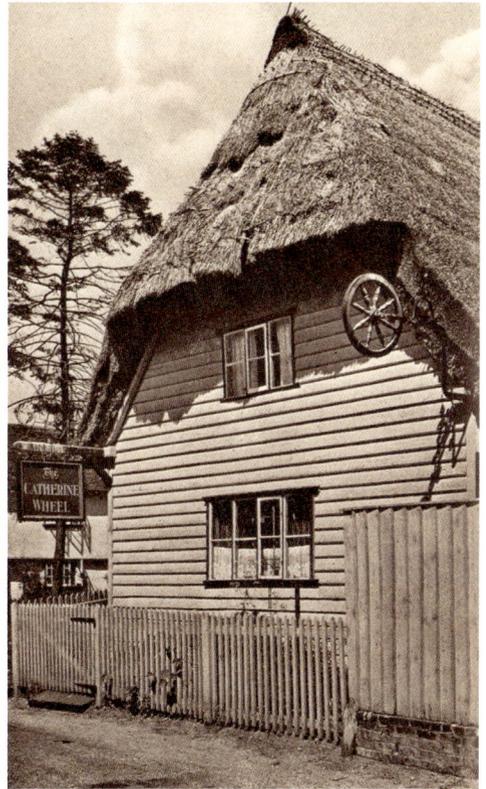

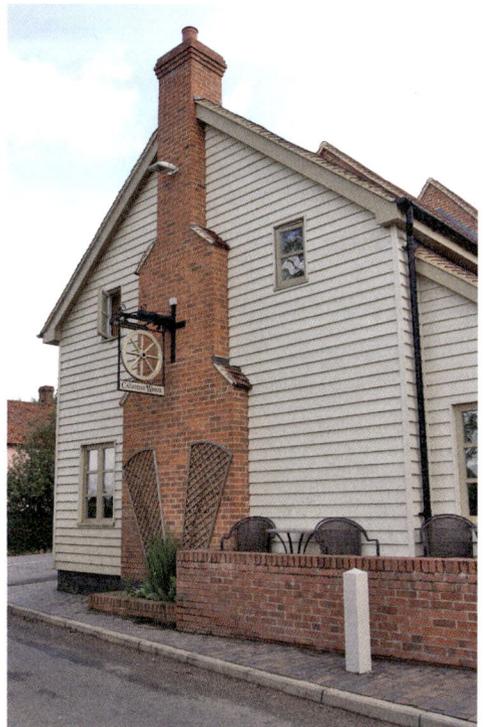

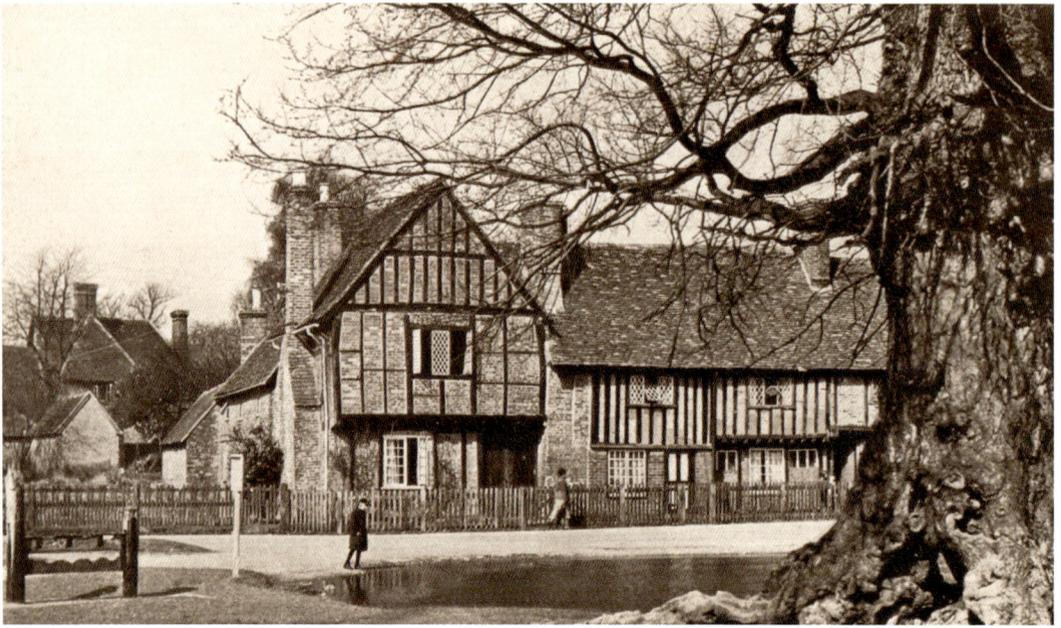

Aldbury

Tomkins tells us in 1903 that, 'As a village of the Old English type Aldbury has perhaps no equal in the county. In the centre is the green and pond, under the shadow of an enormous elm; close by stand the stocks and whipping-post, recently in excellent preservation.' Over a century later the scene is virtually unchanged, with the seventeenth-century timbered manor house beautifully maintained. However, the great elm in the photograph, which consisted of five trees intertwined, was blown down in 1939. Not surprisingly, the village still attracts hordes of walkers, cyclists and tourists. To the east is the 100-foot-tall monument to the 3rd Duke of Bridgewater, known as 'the father of inland navigation'.

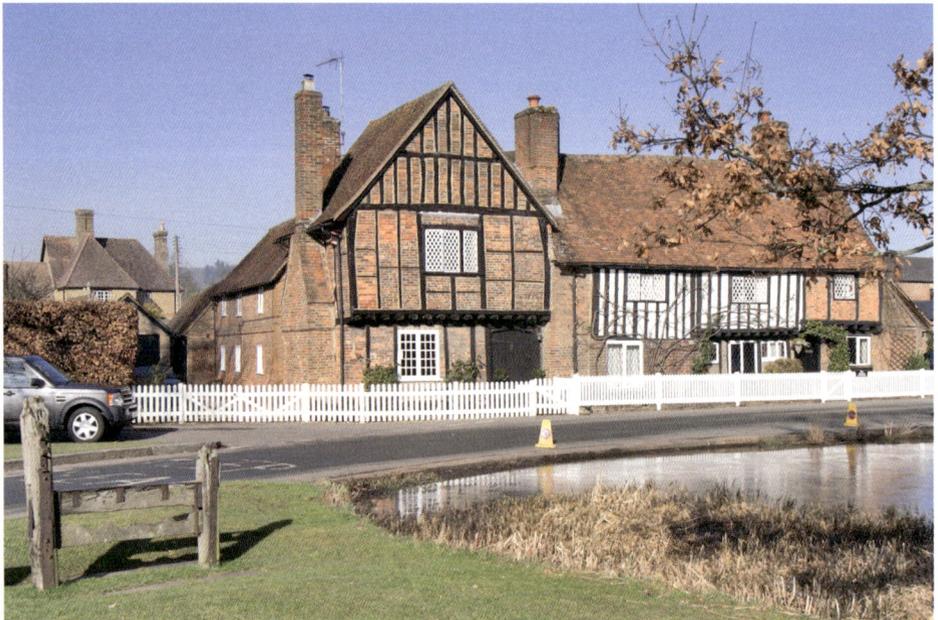

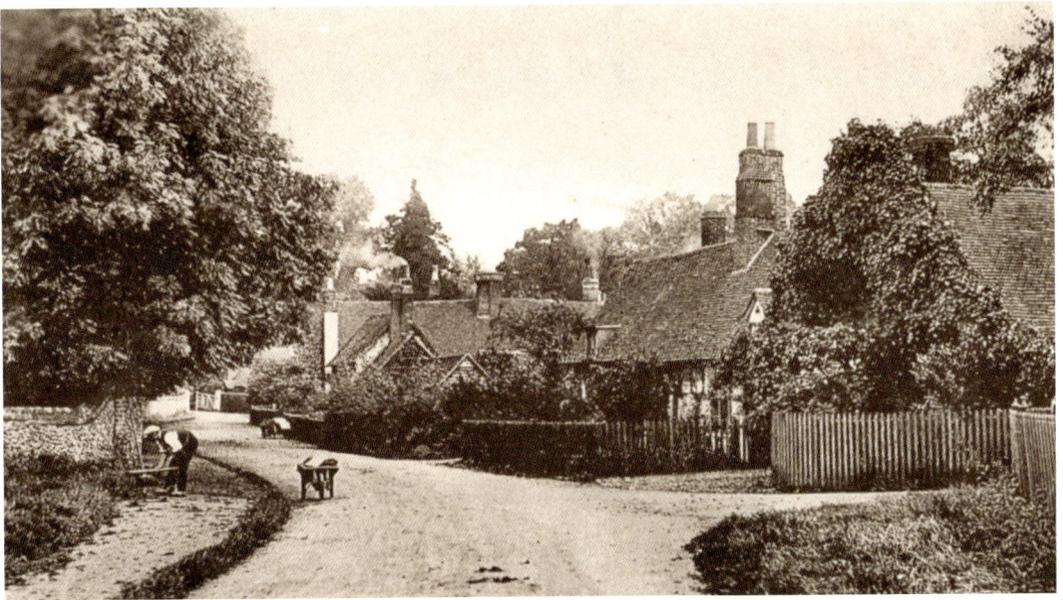

Ayot St Lawrence

'The village has at different times been styled Eye, Aiot, Great Aiot, and Ayot St Lawrence, and was a parcel of the property of Harold Godwin,' Tomkins' 1903 guide informs us. More poetically, Mee writes in 1939, 'The ancient and the beautiful, the quaint and the curious. All come near each other in this quiet place.' The former residence of playwright George Bernard Shaw, now a National Trust property, a few hundred yards south of this spot ensures the village is filled with tourists and, inevitably, their cars. Fifty yards up on the right-hand side in a fourteenth-century building, formerly used as monastic quarters, is the Brocket Arms pub, which offers dining and accommodation as it has for centuries.

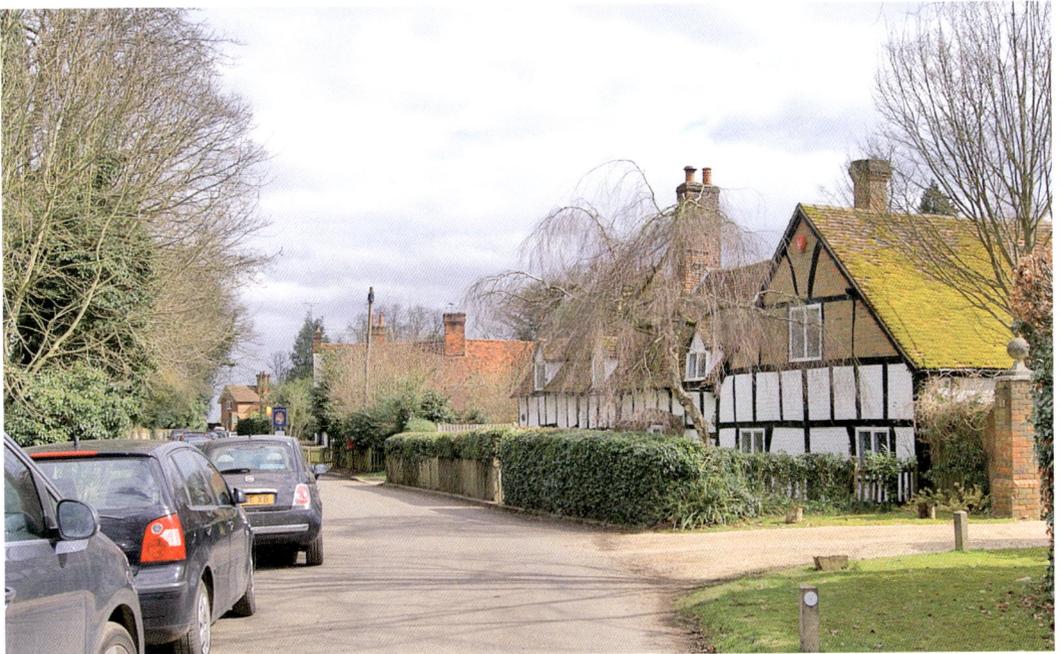

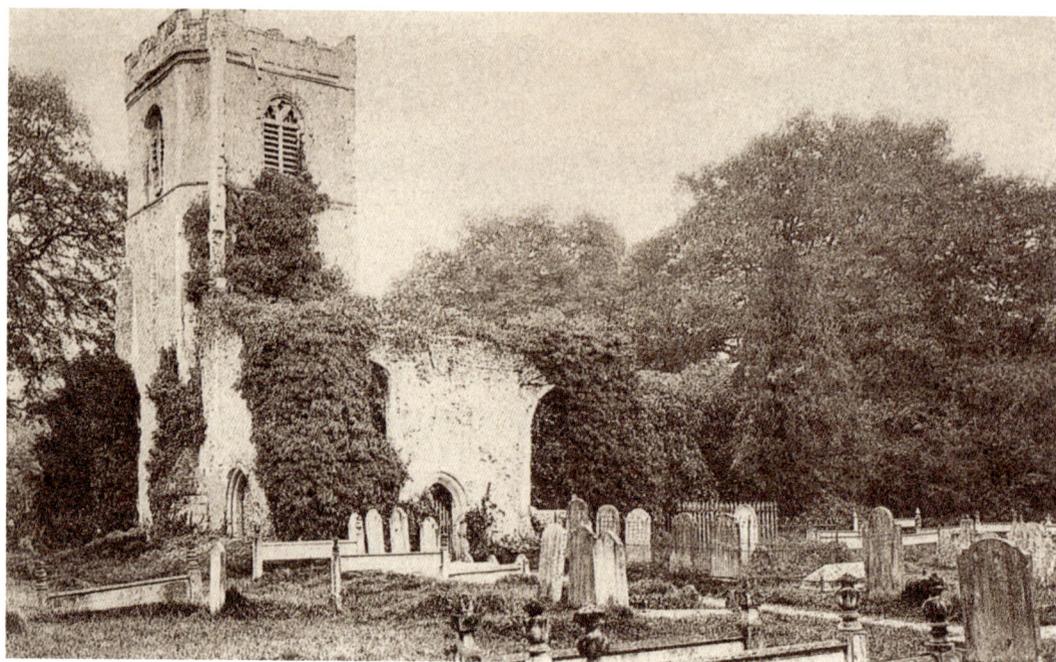

Ayot St Lawrence: St Lawrence Church

On the opposite side of the same road are the remains of the old church of St Lawrence. Pevsner recounts the tale in 1953: 'Tradition has it that Sir Lyonel Lyte began to pull it down when he decided to build – as one would then have called it if today's jargon had already existed – an ultra-modern church in the grounds of his house. The Bishop heard of this when the demolition was gone some way, and prevented further destruction.' The new Palladian church, designed by Nicholas Revett in 1778/79, was built half a mile away, but the picturesque ruins were never restored.

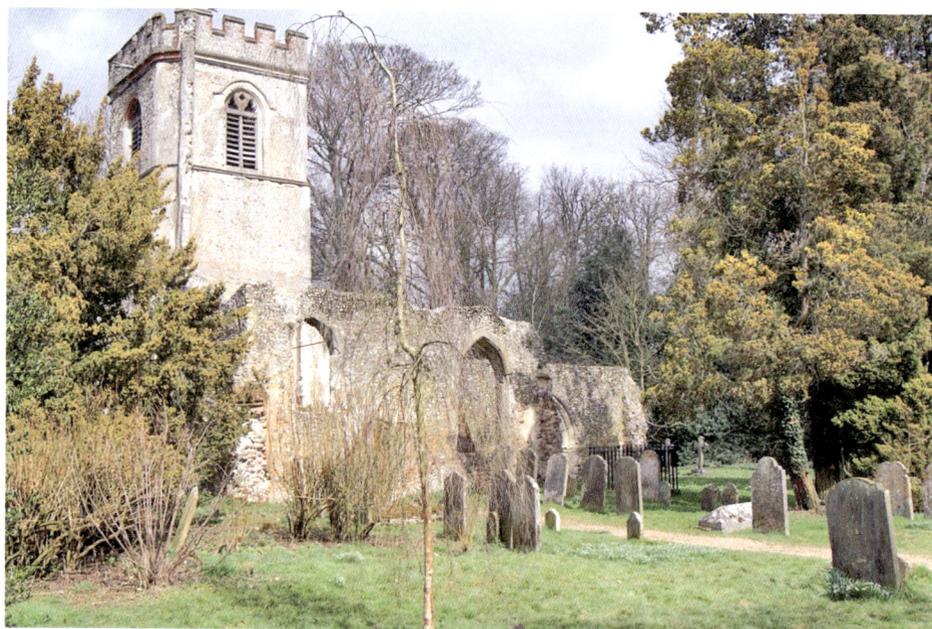

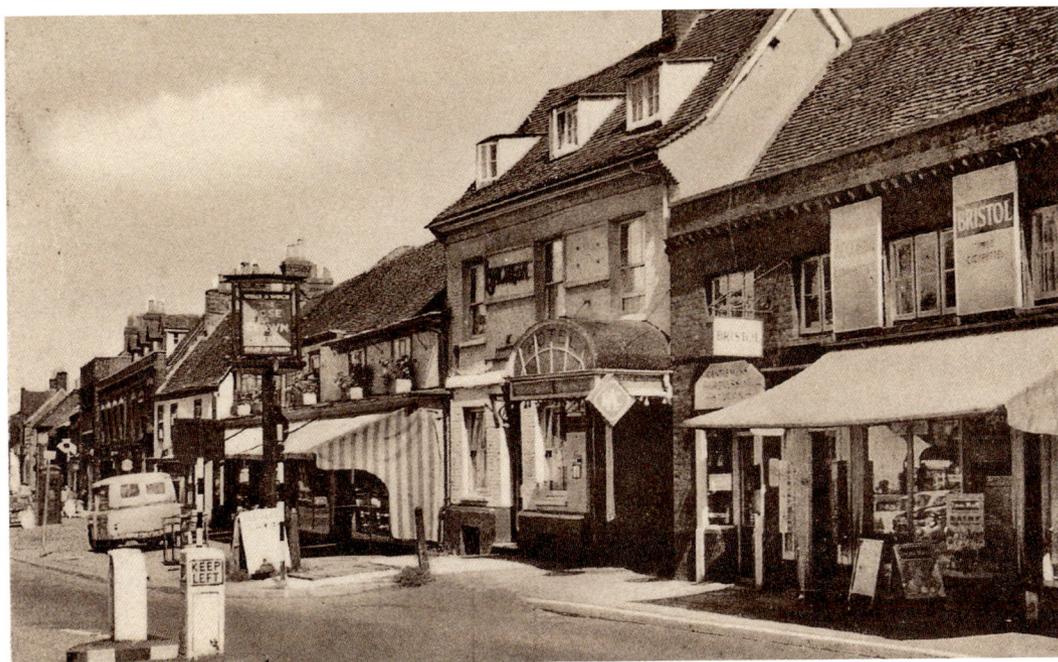

Baldock: White Horse Street

'It dates from Norman times, when it was known as Baudok. During the Crusades, Baldock ... had a lazar-house for lepers, who were at that time numerous all over England,' according to Lydekker's *County Geography* in 1909. 'The horse fairs, of which there are several annually, are well attended,' Tomkins adds. 'Two houses on the south side of White Horse Street, formerly occupied by the postmaster, are ancient. That on the west has a modern front of brick, but the back is a red-brick building of two stories with an attic probably of the middle of the 16th century,' the *Victoria* informs us.

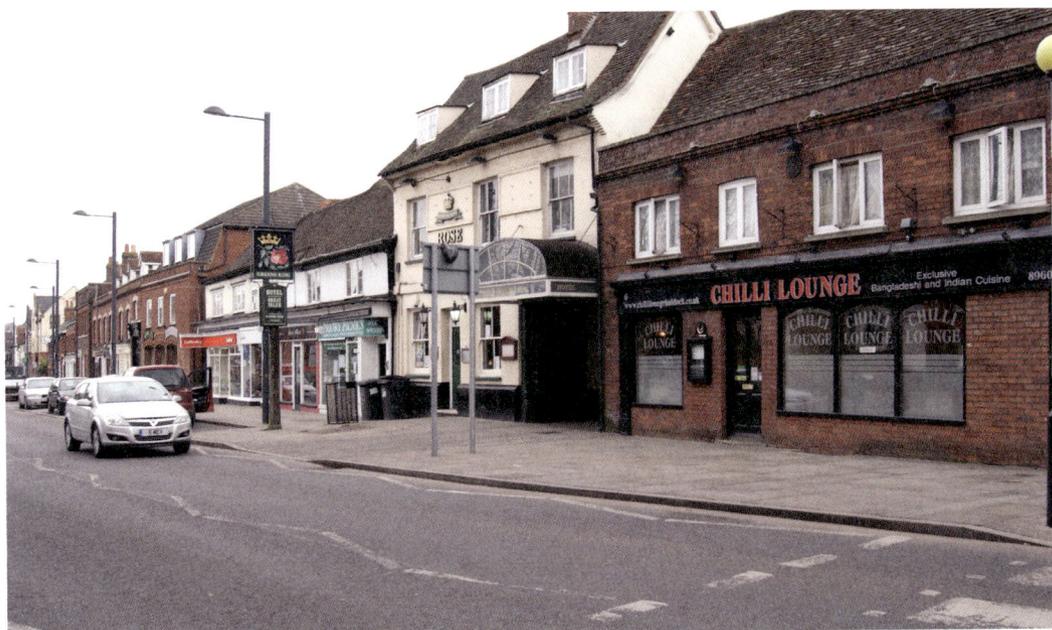

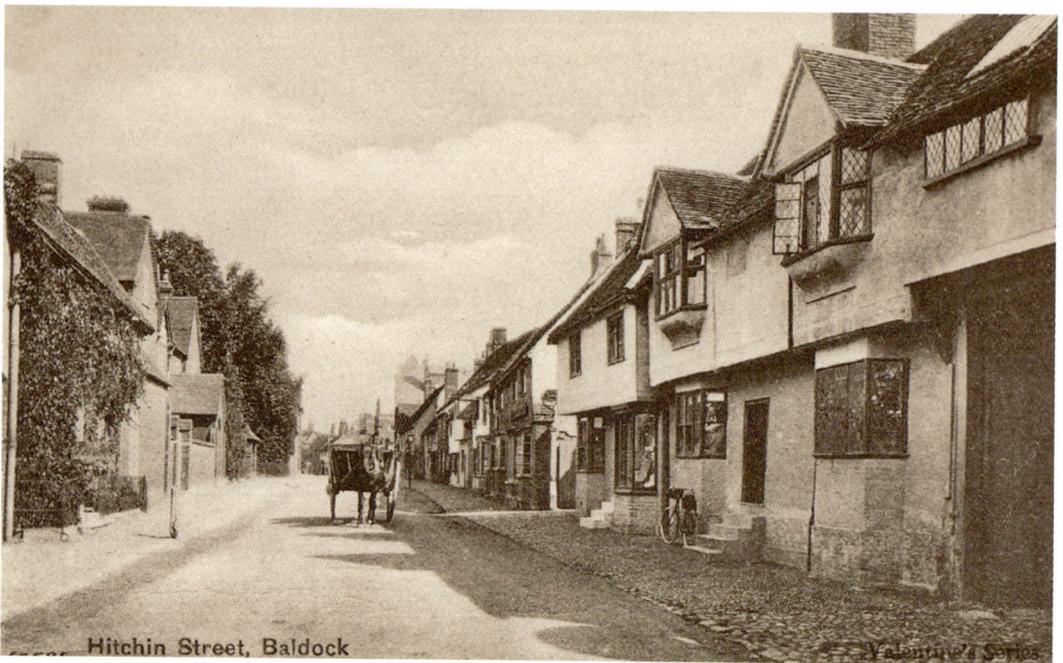

Hitchin Street, Baldock

Baldock: Hitchin Street

The town was founded by the Knights Templar, and by the Elizabethan period was well known for its fine barley, which led to malting and brewing becoming the main industries. Pevsner points out: 'To judge from the houses of Baldock its wealth was of the 18th century rather than the 16th to 17th centuries. One remembers Georgian but no Tudor or Jacobean houses, red brick but no half-timber.' However, in Hitchin Street there are a wealth of beautifully-preserved, plastered cottages from the seventeenth century, many with overhanging gables, which include several of the town's ancient inns still doing business.

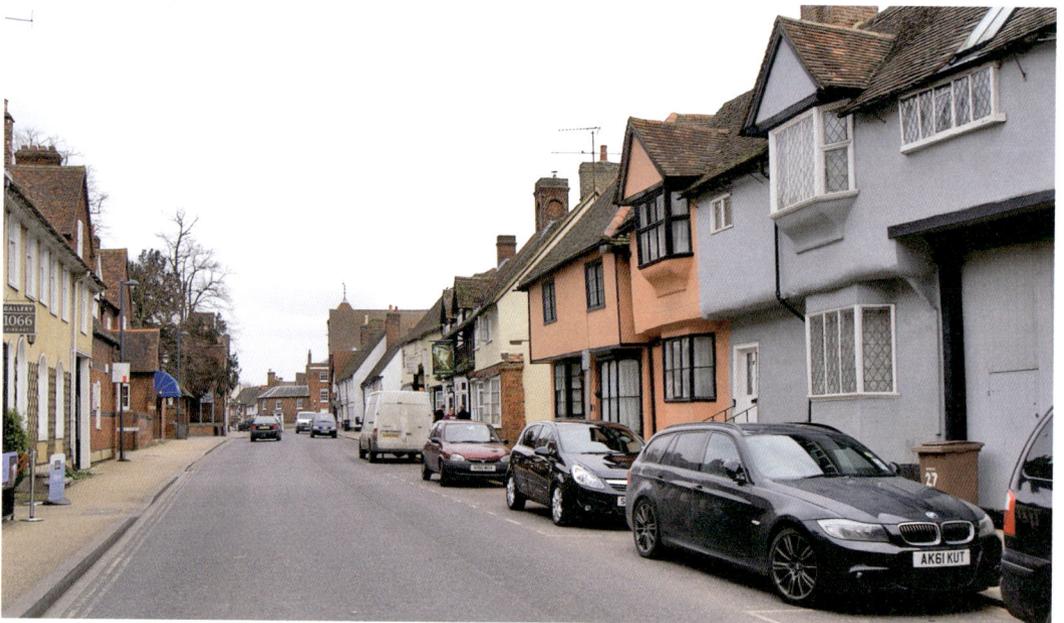

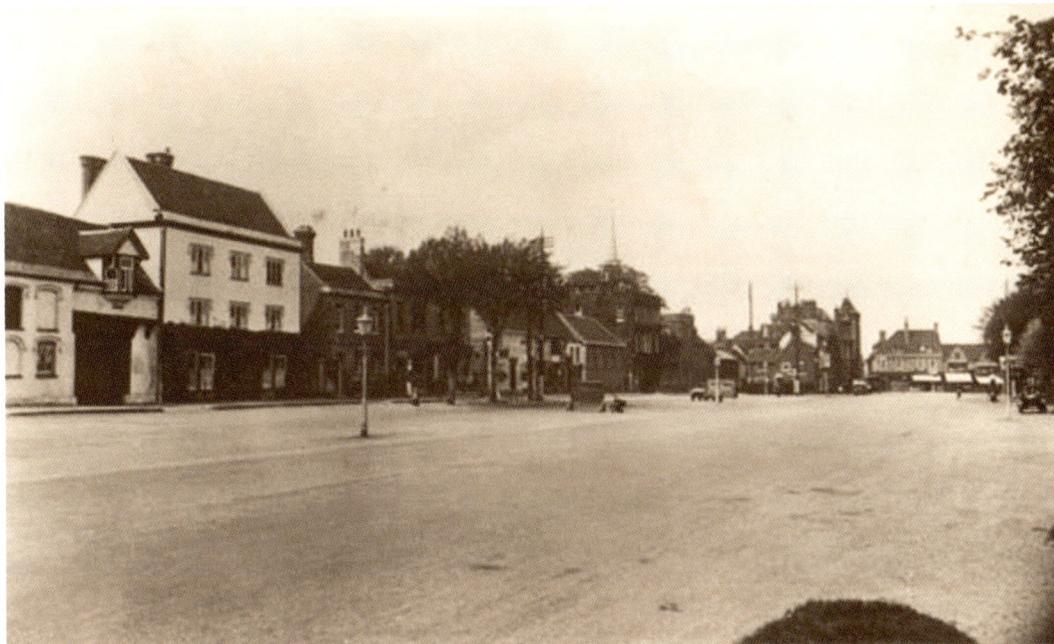

Baldock: High Street

The town's wide main street, with its acres of green sward lined with many fine Georgian properties, has changed very little since this photograph was taken 100 years ago. However, the businesses that use the variety of buildings along the way are very different. At the west end, the former Art Deco factory of Kayser Bondor is now a listed building occupied by a Tesco supermarket. If this modern photograph had been taken only five years ago, the road would have been choked with vehicles, as the town was a notorious bottleneck for traffic in the latter half of the last century. A recently-completed bypass has finally rid the town of that congestion.

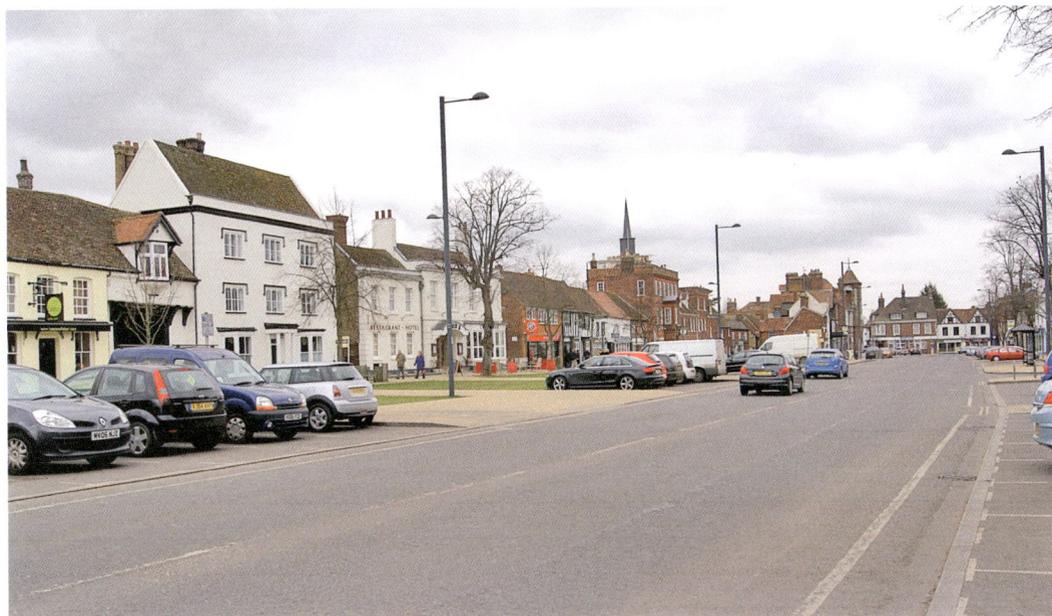

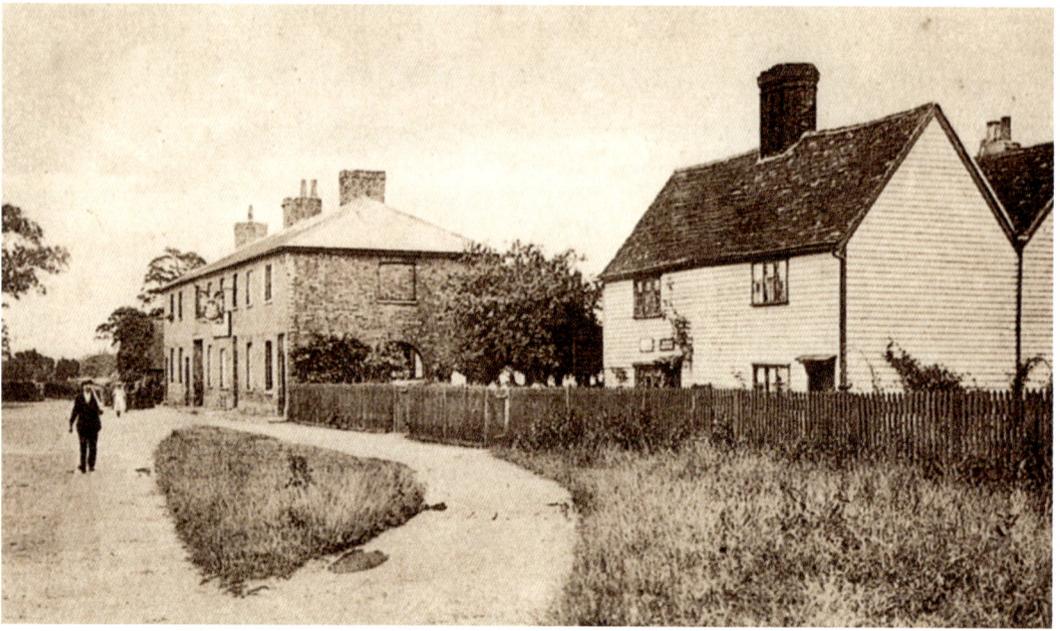

Bayford

Virtually nothing has changed since the *Victoria* reported, 'The cottage now used as the post-office [on the right] appears to date from the first half of the 17th century ... Most of the cottages here are of brick and date from the 18th and early 19th centuries.' The Bakers Arms pub on the left consists of three such dwellings. Apparently, in 1366 the parishioners appealed for right of burial in their own local chapel, rather than three miles away in Essendon church. To get there, funeral processions had to squeeze past a water-mill where 'the carts going with bodies are often brought to grief in the river, and the people attending annoyed with attachments in passing through Berkhampstead.'

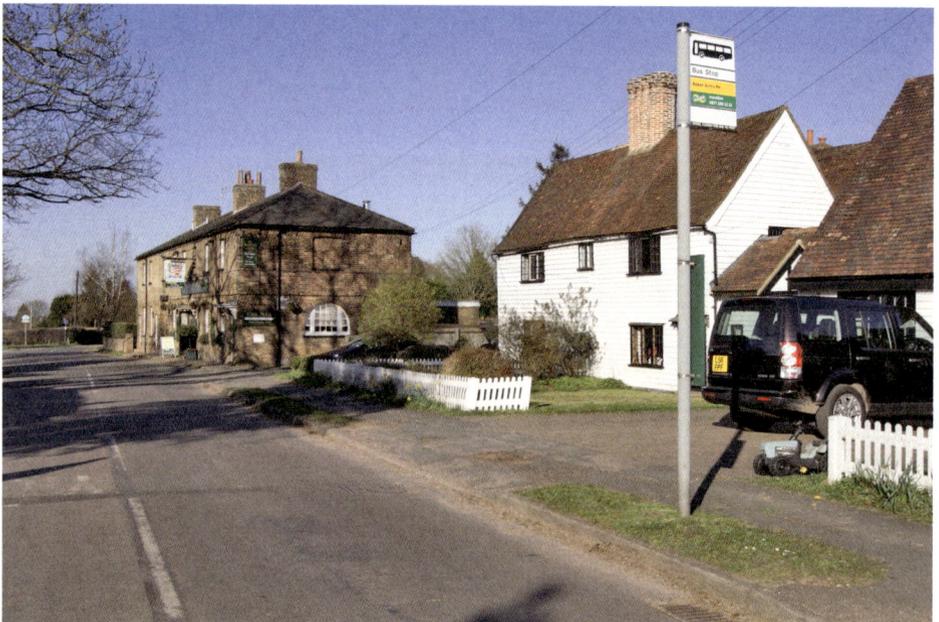

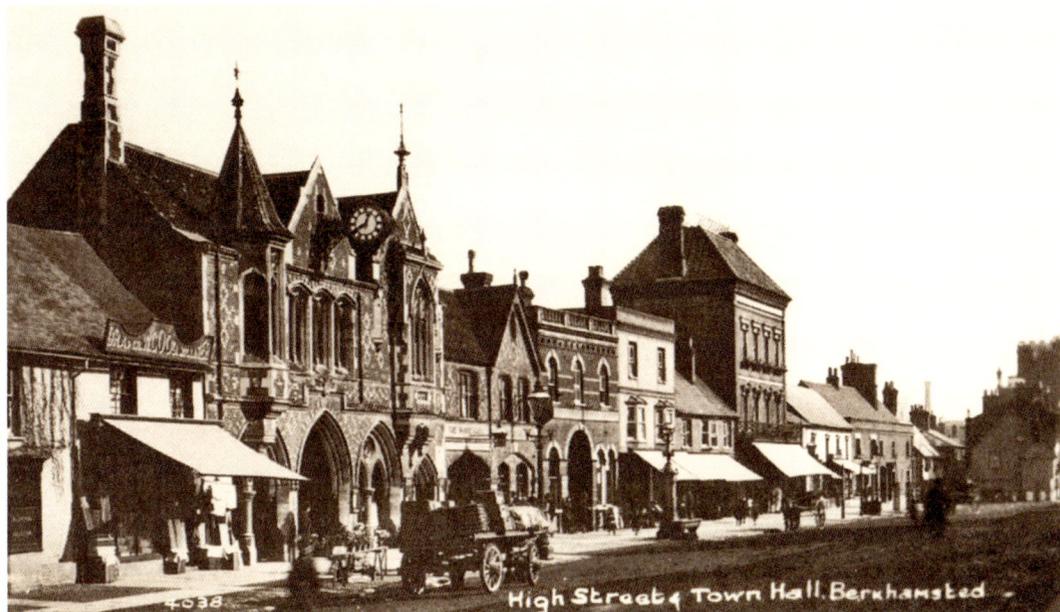

High Street & Town Hall. Berkhamsted

Berkhamsted

The ancient market town of 'Beorchehamstede', which grew up on the old Roman Akeman Street, still has the remains of a royal castle where the crown of England was offered to William the Conqueror after he had won the Battle of Hastings. The *Victoria* entry says, 'The High Street consists for the most part of two-storied houses or shops of brick and plaster, slated or tiled, the very varied styles of architecture of which are a pleasant and characteristic feature. Around the market place are the principal inns, all 18th century houses...' Despite the inevitable modern infill, the same is largely still true today of the mile-long High Street.

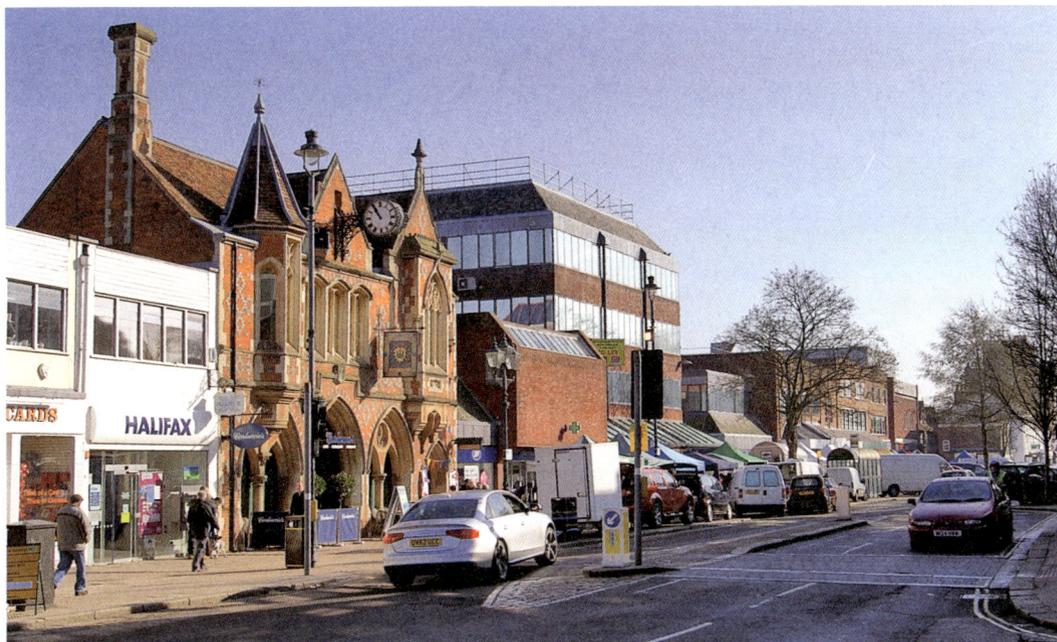

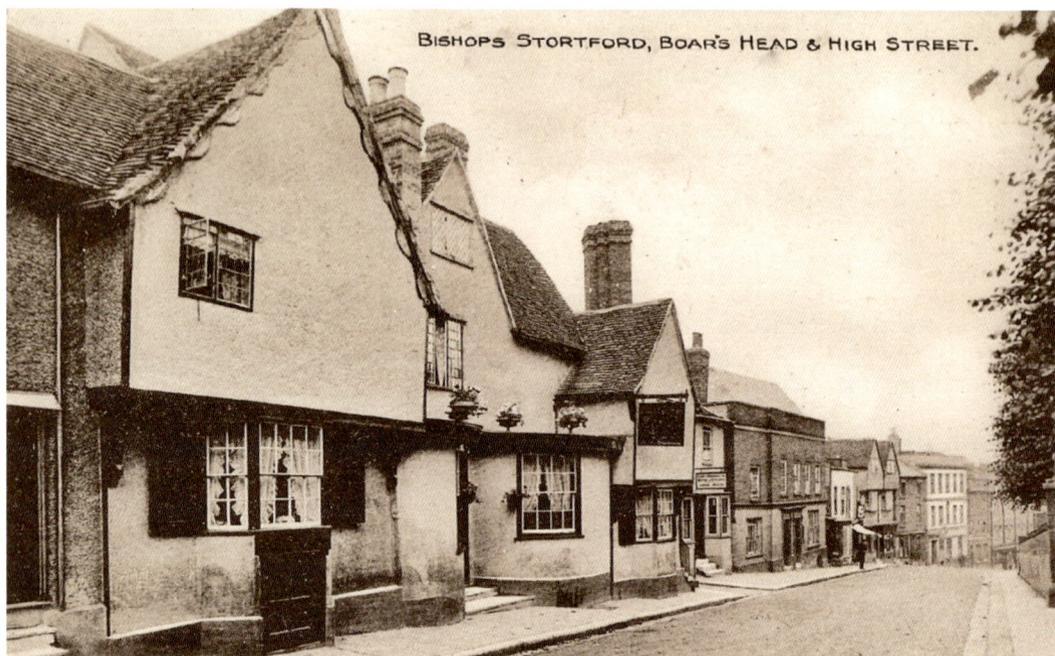

Bishop's Stortford: High Street

Tomkins writes, 'It is an ancient town, deriving its name from the ford over the river Stort, and from the fact that William I gave the town to Maurice, Bishop of London. It is famous for its Grammar School, at which the late Cecil Rhodes, a native of the town, was educated.' The *Victoria* describes the Boar's Head Inn in the High Street as 'built about 1600 of timber and plaster, but so much altered that the original plan is obscured. The projecting wings as well as the main building are gabled. In a few of the windows are still the old metal casements; the quartercircle bay windows in the re-entering angles are an 18th century addition.'

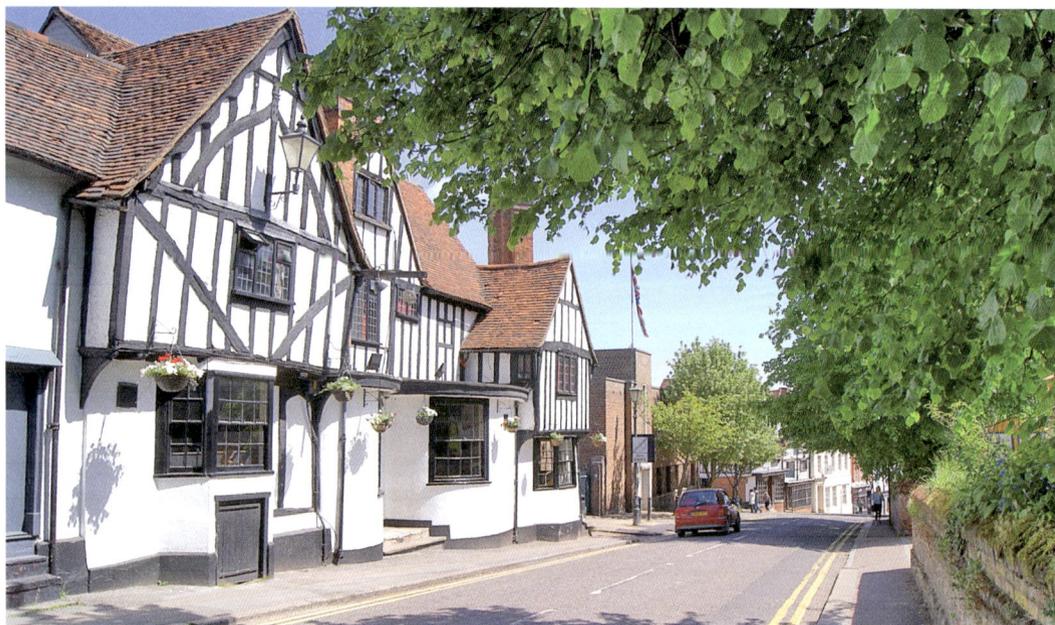

16

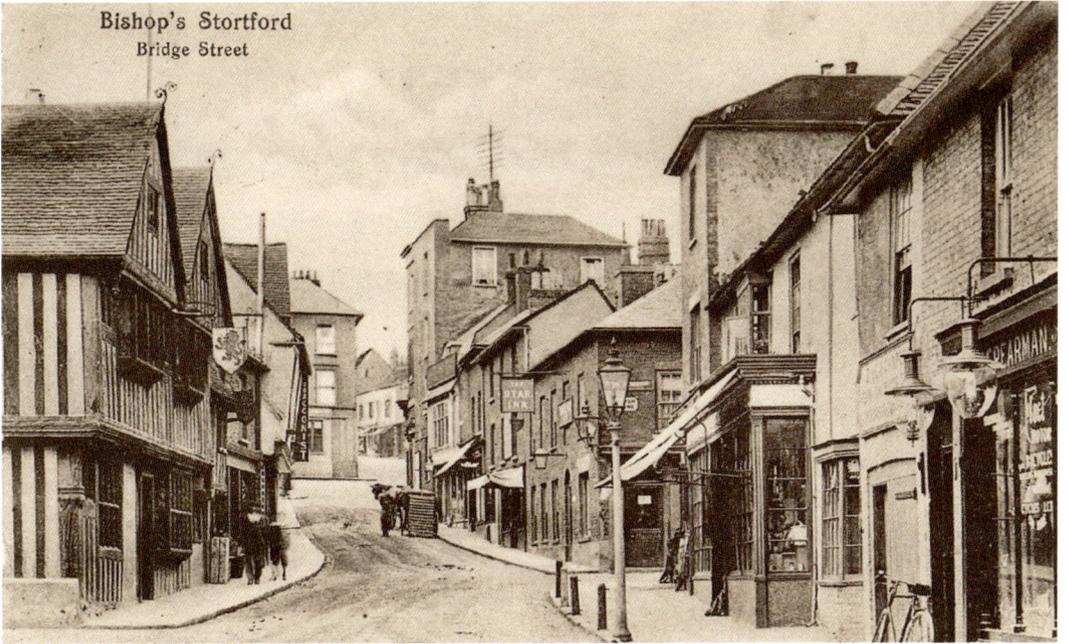

Bishop's Stortford
Bridge Street

Bishop's Stortford: Bridge Street

According to the *Victoria*, The Star Inn (on right of photograph) 'is a 17th-century house of timber and plaster, much restored. There is a carved bracket under the eaves ... The Black Lion Inn is a 16th-century timber and plaster rectangular house of two stories and an attic. The upper story overhangs on the north and east, and the attic again projects; on the north the upper story has a moulded sill with a twisted ornament and is carried on carved brackets.' Pevsner, however, finds the building 'very picturesque, although rather over-restored'. Before the First World War, other industries in the town included brickfields, limekilns, coach and sacking works, a hatters' furrier manufactory, and a foundry.

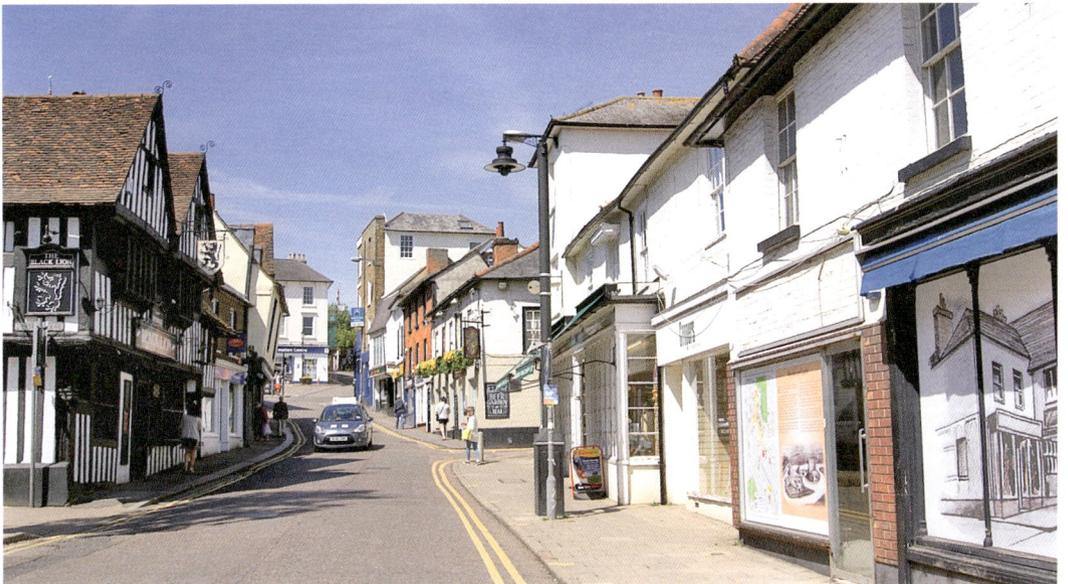

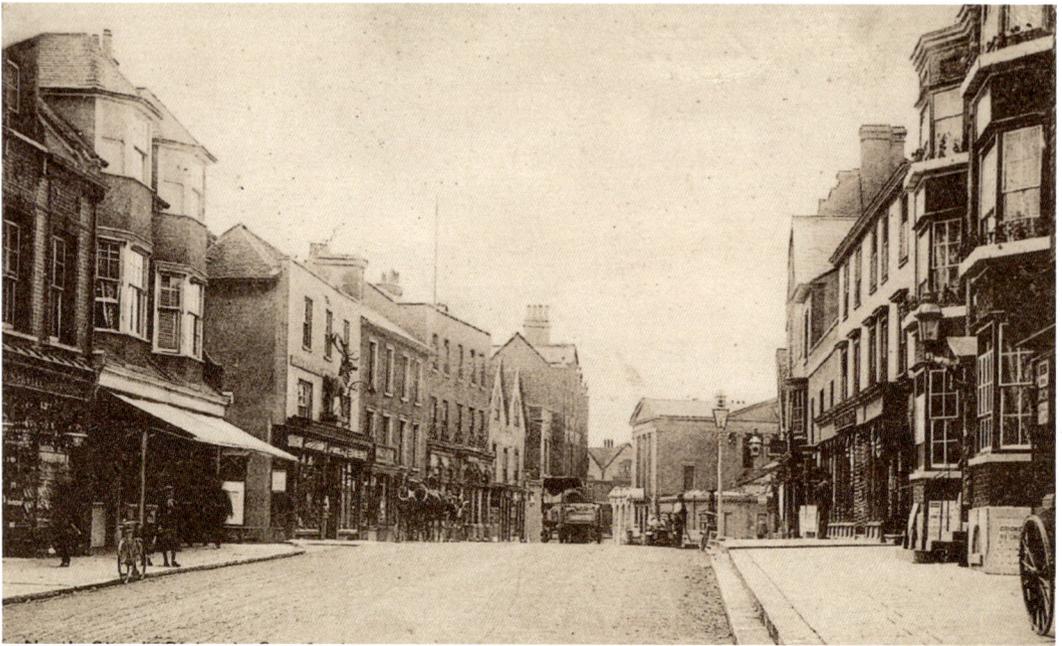

Bishop's Stortford: North Street

'We read that in old times a cross was erected on each of the four roads leading from the town. The main thoroughfares are still in the form of a cross,' Tomkins tells us. 'A cattle sale is held every Thursday, which is market-day. The trade in malt is still very large.' Hence the need for the grand Corn Exchange at the top of North Street, which Pevsner christens, 'The secular centre of the town, built 1828 in a self-confident neo-Greek style.' The rest of the street he describes as 'Victorian Business Gothic of stock brick and stone and red brick trim. Northern and Tuscan in design.'

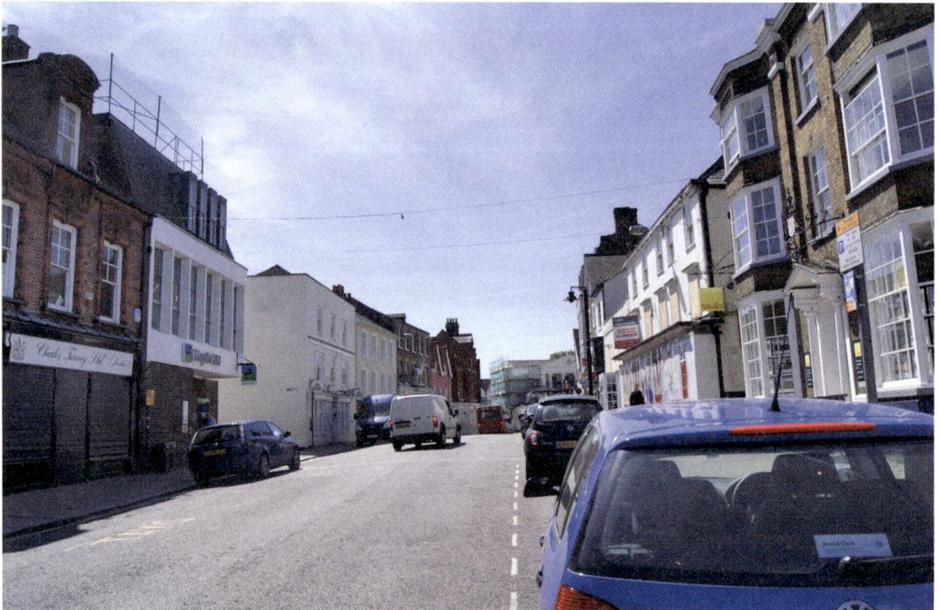

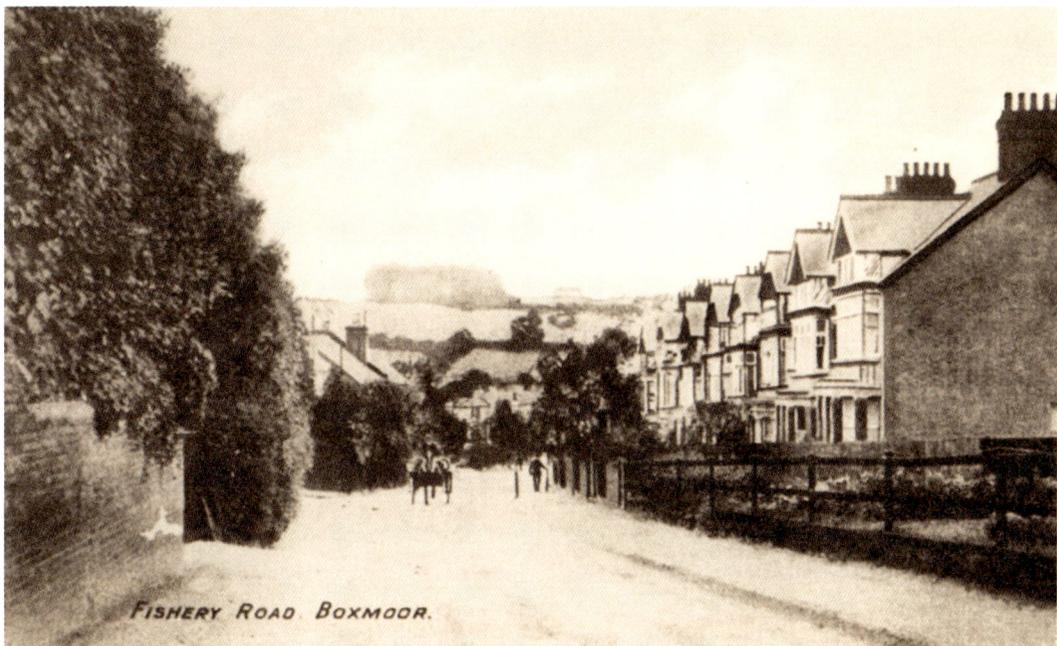

FISHERY ROAD BOXMOOR.

Boxmoor

'Its chief street runs along the edge of a long open common, through which the river Bulbourne takes its course ... there are fisheries on the Bulbourne and large watercress beds,' reports the *Victoria*. Tomkins observed in 1903 that, 'Private residences are increasing so rapidly that the place is now almost a suburb of Hemel Hempstead.' Today that trend is even more apparent. However, Mee's pre-war description still applies: 'There is charm in its stretches of green, its long lines of chestnut trees, and the occasional glimpses through the willows of gaily-painted barges gliding along the Grand Union Canal.'

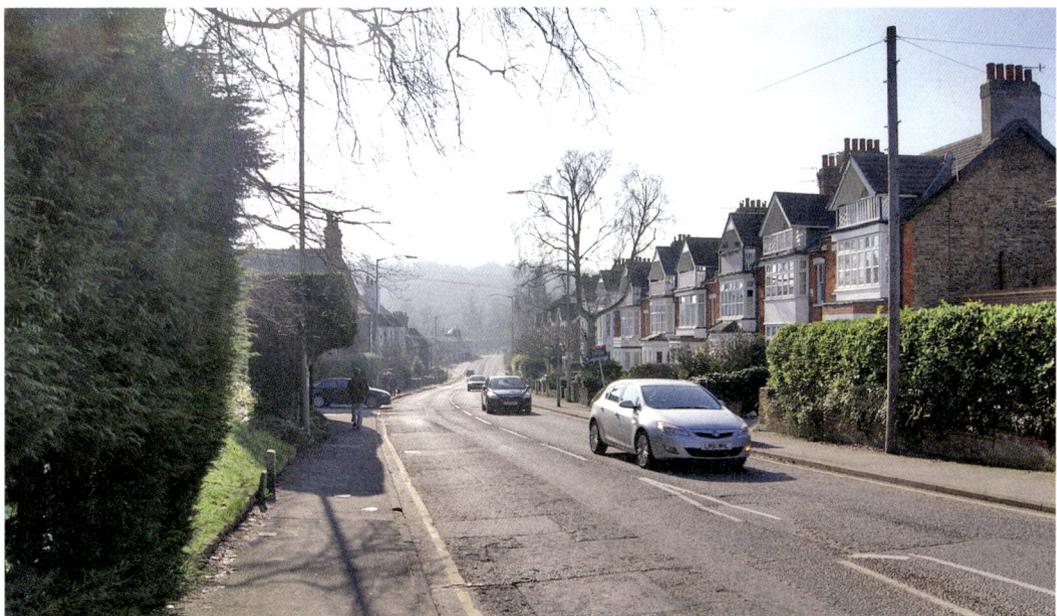

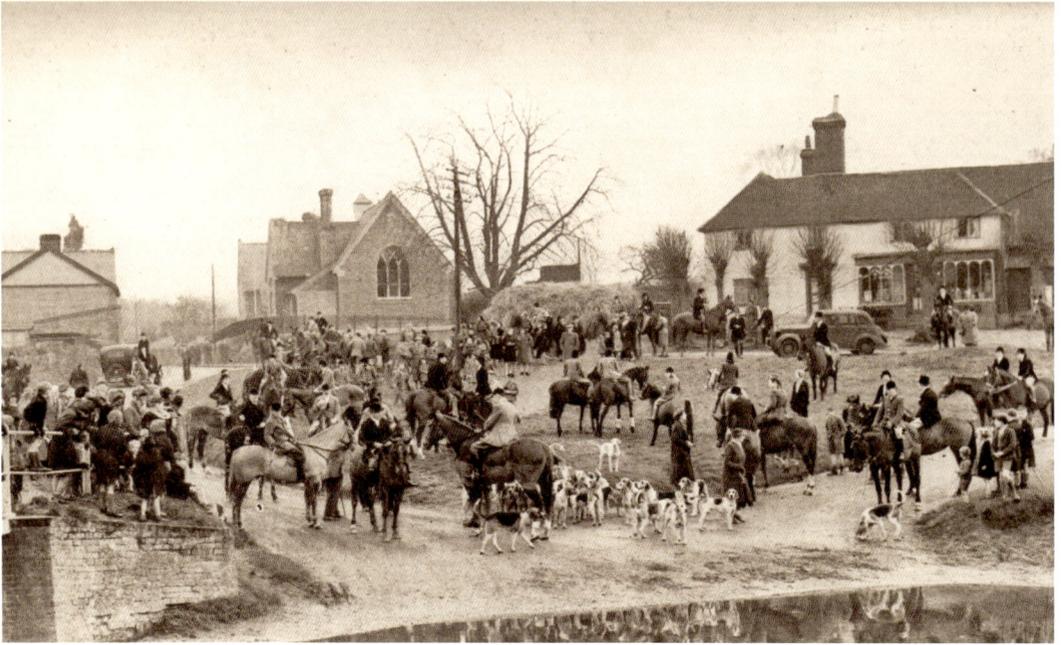

Braughing

The scene here of the Boxing Day Hunt in 1950 takes place in what Tomkins depicts as 'an ancient parish, the "Brachinges" of Domesday Book, and was a Roman station. The church and few streets of which the village consists are very picturesquely scattered on the S.W. slope of a hill overlooking the river Quin.' Today, the river can still only be crossed by car in the village centre at this ford. There was a market each week, dating from the reign of Stephen, and an annual fair, both abolished in the nineteenth century, according to Tomkins. Braughing's tasty sausages are very popular locally.

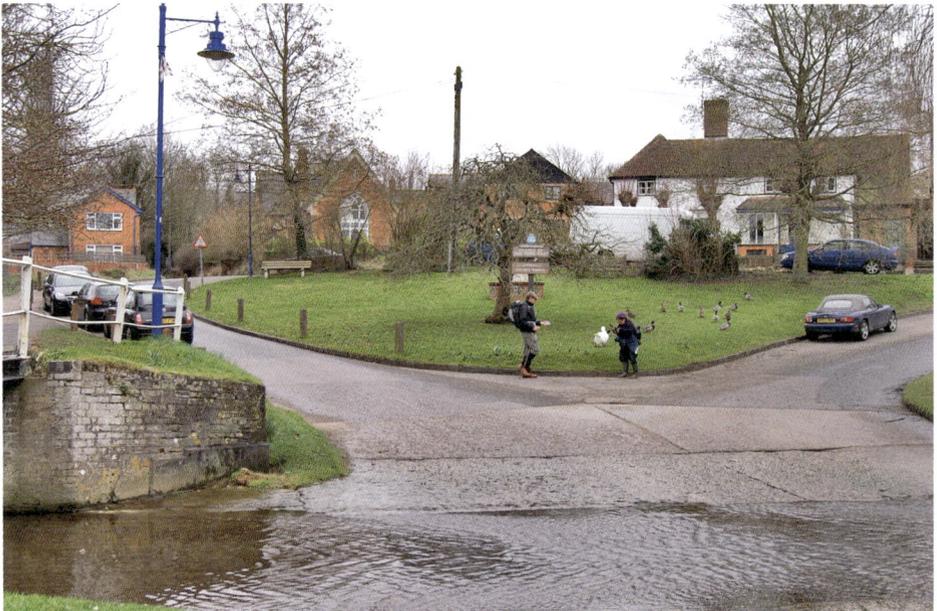

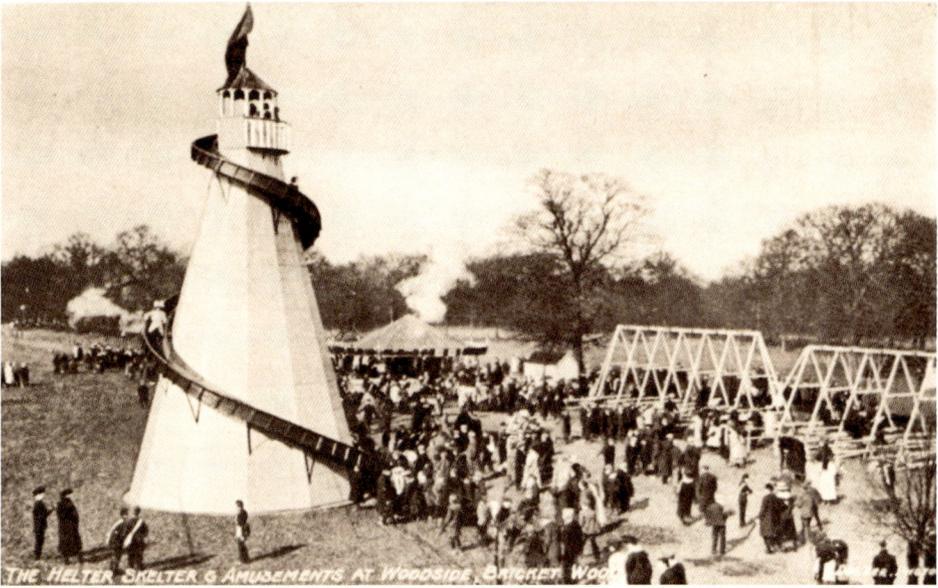

THE HELTER SKELTER & AMUSEMENTS AT WOODSIDE, BRICKET WOOD

Bricket Wood

Tomkins' entry says that the village, which is today hemmed in by the M1 and M25, 'consists of some cottages scattered around an extensive wood and common ... which is much frequented by picnic parties, school treats, etc.' This refers to the Woodside Retreat Fairground, pictured here, set up by the Gray brothers in 1889, which became so popular that the nearby station had to be extended to accommodate the hordes of visitors. In 1923, the aptly named Mr Christmas set up Joyland in competition on Smug Oak Green featured in the contemporary photograph. The hugely wealthy Lady Yule, who lived at nearby Hanstead House, purchased both sites in 1929 and promptly closed them.

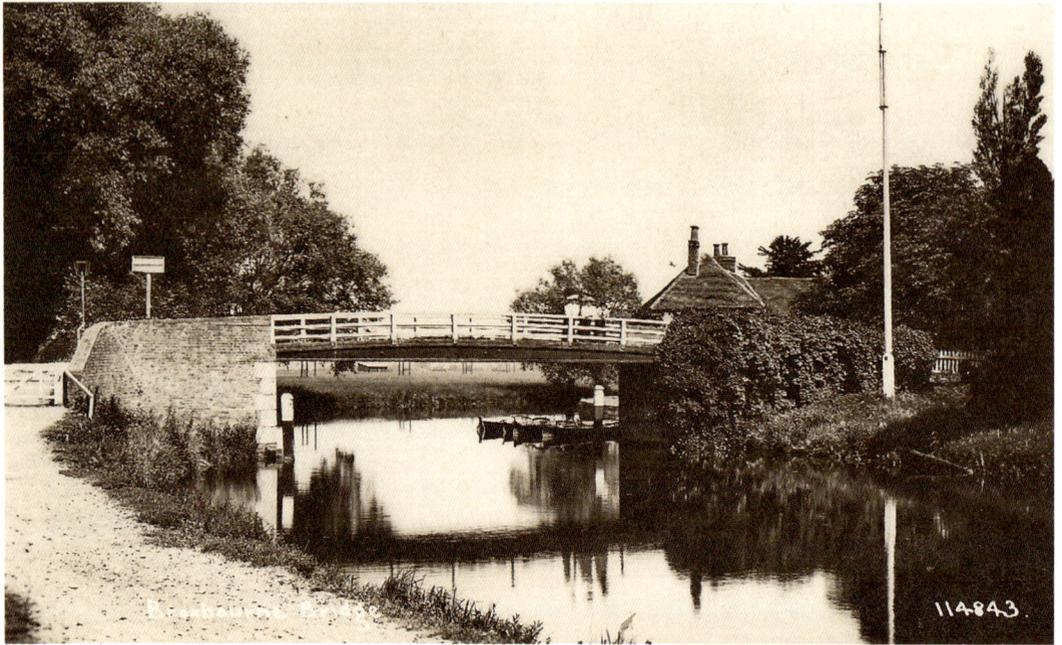

Broxbourne: Riverside

According to Tomkins, 'Broxbourne, a large village near the river Lea and New River, is a favourite fishing resort.' Fifty years later, Pevsner was pretty dismissive: 'The High Street is part of that long ribbon of houses 17th – 20th century, timber-framed and plastered or of Georgian brick outer-suburban London types which stretch north all the way from the Middlesex border to Hoddesdon.' As an architectural historian, he wasn't interested in the miles of charming riverside just five minutes' walk away, which are still being run today by the Lea Valley Park for the enjoyment of locals and visitors for walking, boating, fishing and other recreational pursuits.

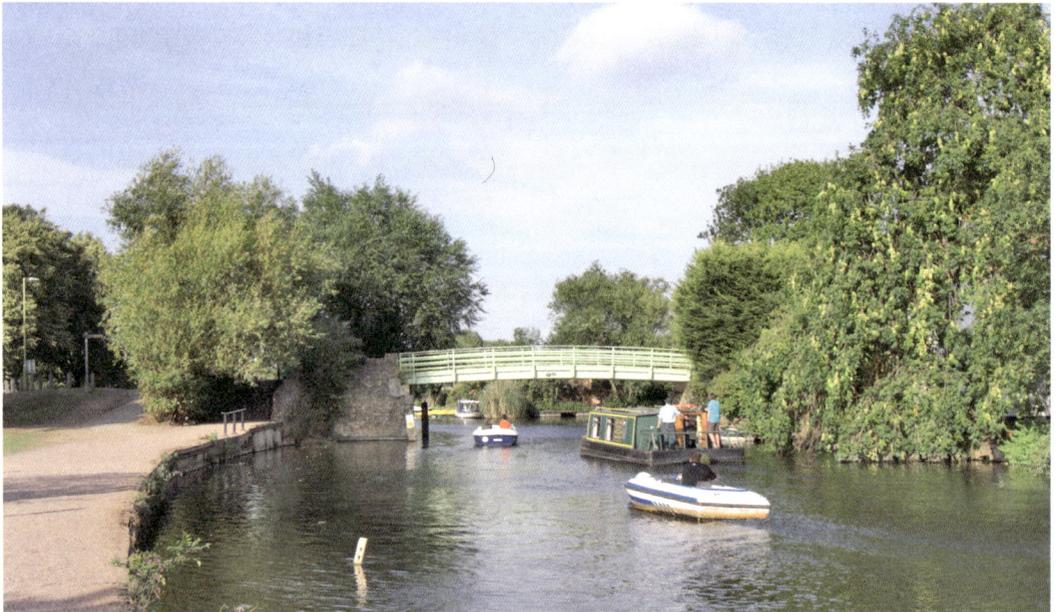

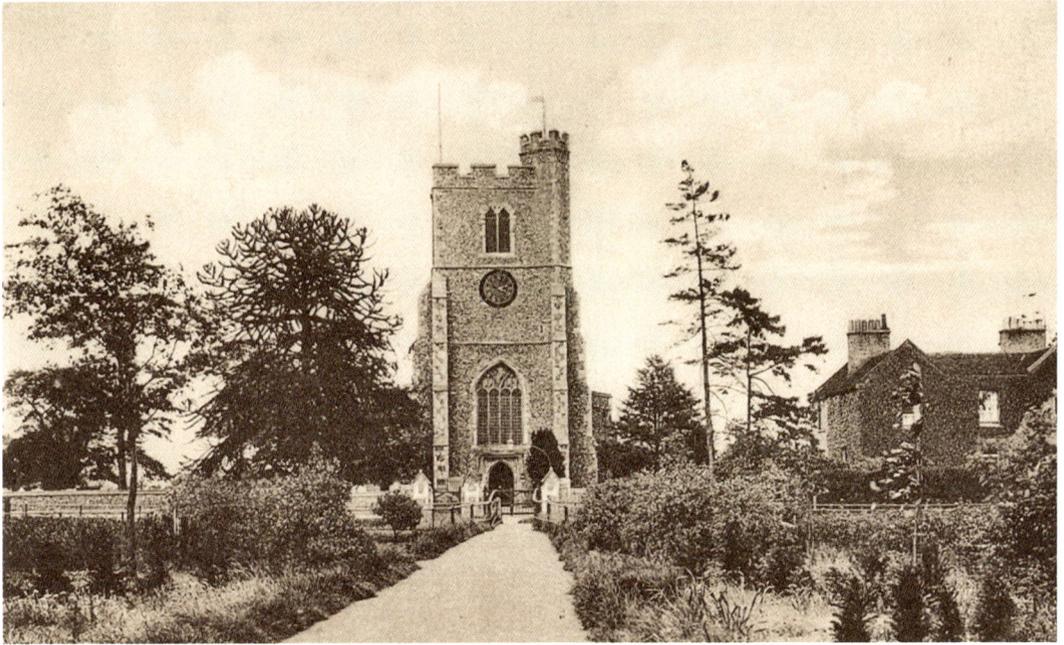

Broxbourne: St Augustine's Church

Mill Lane runs eastward from the village, 'passing the church of St Augustine and the vicarage, and leading to the Broxbourne mill, which is picturesquely situated on the old stream of the River Lea,' the *Victoria* tells us. Inside the predominantly sixteenth-century church, for Mee it is the local people 'in brass and stone who interest us most. Two priests who must have lived in the old gabled house when it was new have their portraits in brass ... Exquisitely sculptured in his Elizabethan armour lies Sir Henry Cock, resting his bearded head on his hand ... A tablet recalls a famous figure of 100 years ago, John Macadam, the Scottish engineer who taught us how to make good roads.'

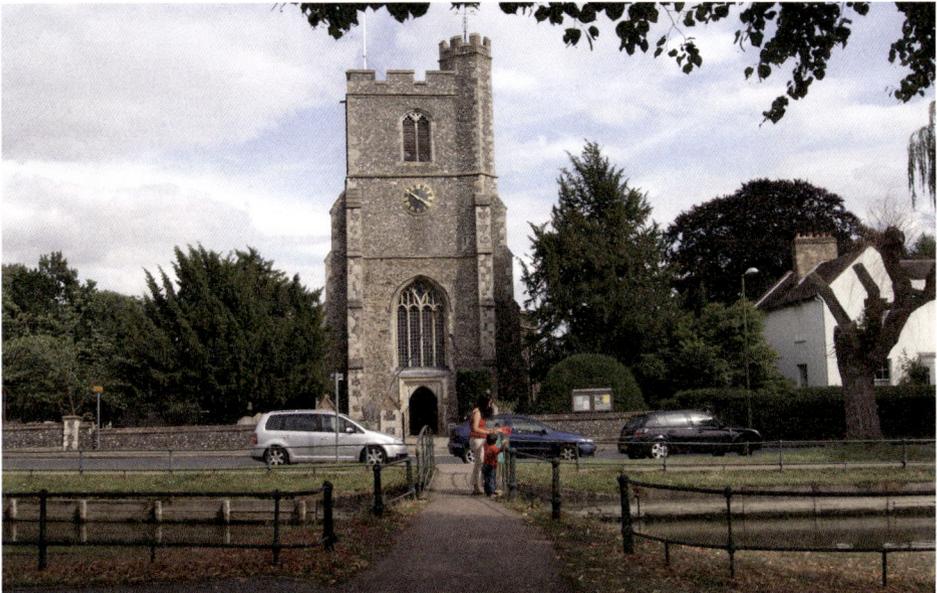

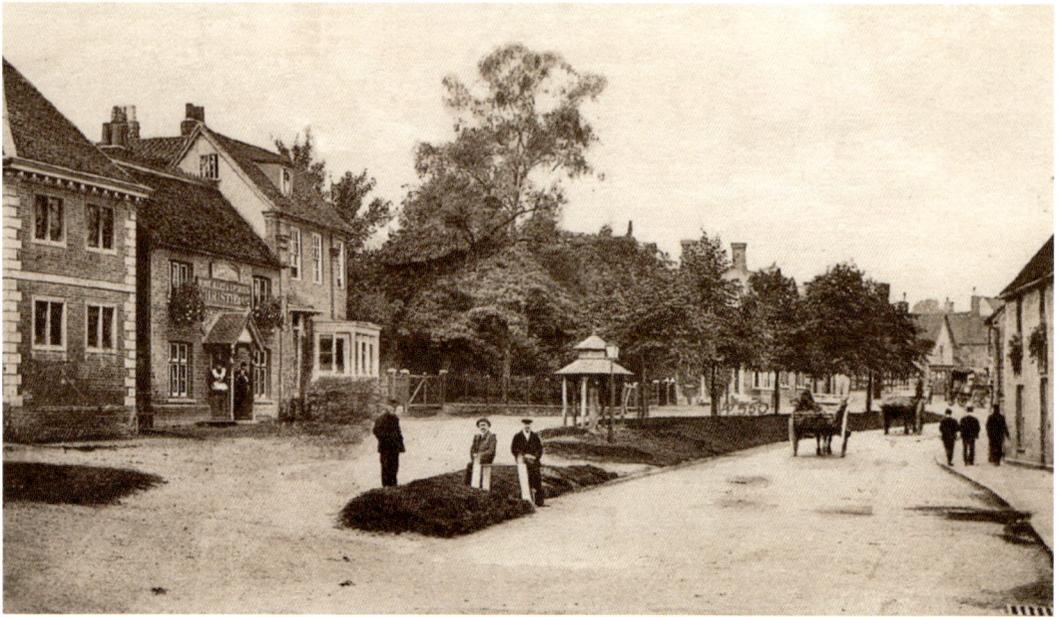

Buntingford

'It has a wide stretch of Roman road for its High Street, full of quaint houses with gables, overhanging storeys, deep archways, and red roofs turned yellow here and there with creeping stone-crop,' so Lydekker tells us in 1909. The place is still as charming today, with its water pump preserved (behind the bus stop) and the town centre relieved of the curse of twenty-first-century traffic by a ring road. The Crown is still going strong, although Christie's Brewery closed in 1929; the Almshouses (the north wing of which appears on the far left of the picture) are beautifully maintained, having been described by Pevsner as 'the stateliest Almshouses in the County'.

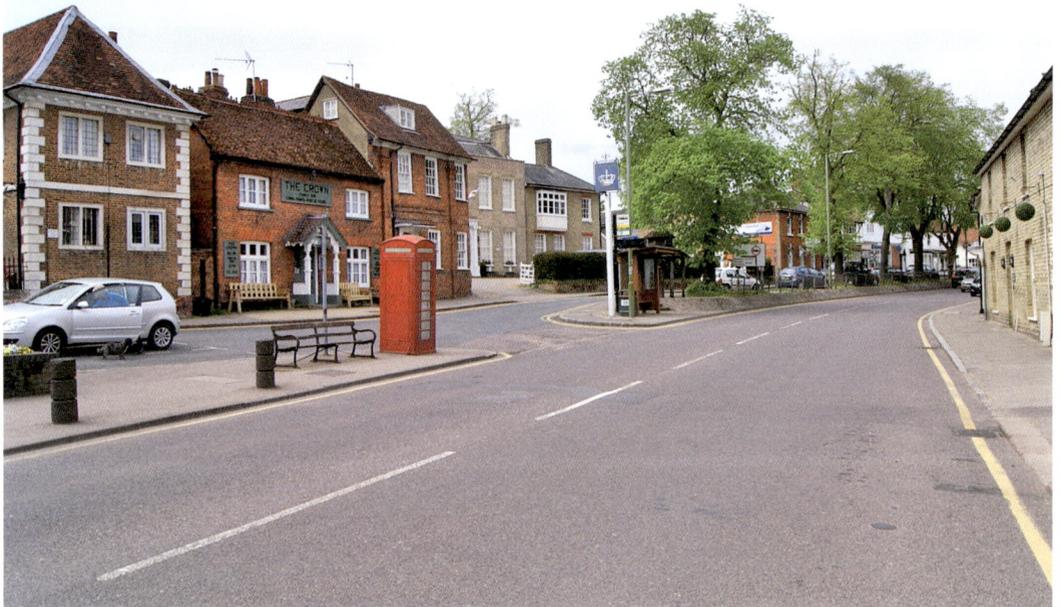

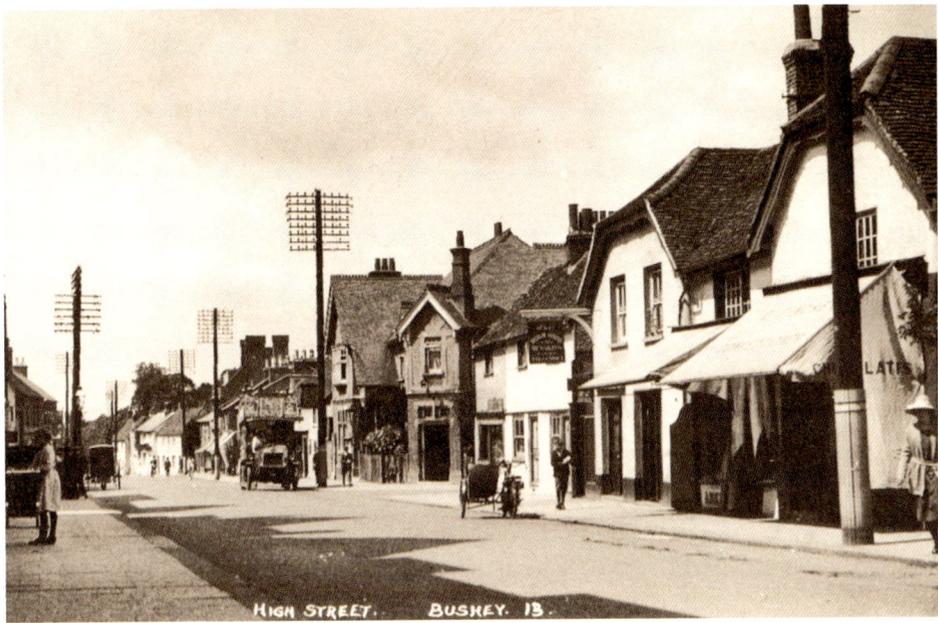

HIGH STREET. BUSHEY. 13.

Bushey

The *Victoria* noted that 'the influence of the Herkomer School (1883–1905) pervades the village, and is noticeable in the colony of artists, the numerous studios, and in the design of many of the houses.' But Pevsner obviously wasn't impressed half a century later by the latter, which he dubbed 'outer London suburban, Watford suburban...' Mee reckoned the view from the Heath in 1939 was worth the climb up the hill from Watford. While local hostelry The Robin Hood has disappeared, the more spacious Golden Lion now operates just a few doors down – and the road is an awful lot busier.

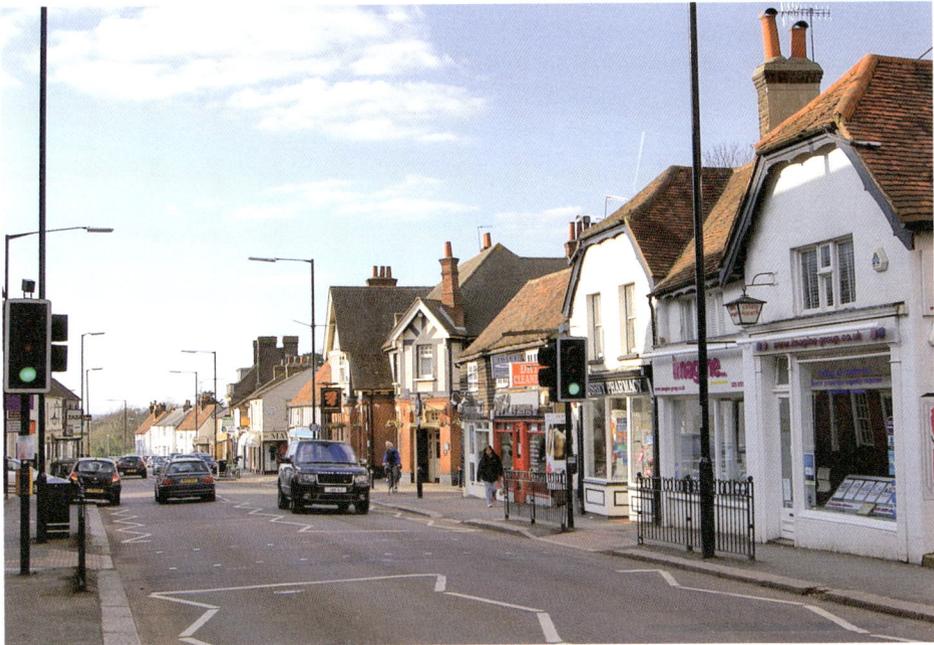

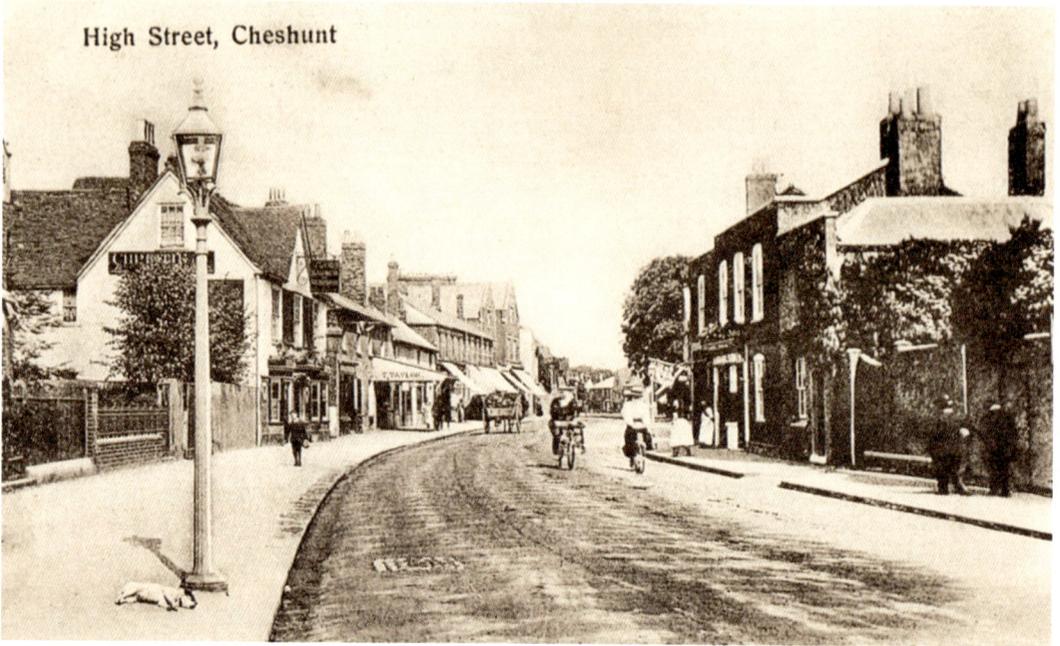

High Street, Cheshunt

Cheshunt

Tomkins tells us that the town can be traced back to the Romans and that 'Cheston, yet another old name of this spot, has been thought to be derived from the chestnut trees once plentiful in the neighbourhood, of which many of the houses were built.' Lydekker describes it as, 'A large market-town in the south eastern corner of the county ... It is celebrated for its nursery gardens, roses being especially cultivated. Within Cheshunt parish is situated Theobald's Park, at one time a royal residence.' Today, the prosperous nursery business has almost disappeared, and on the western side of the town, Bishops College, has the dubious honour of being incorporated into Broxbourne Council's HQ.

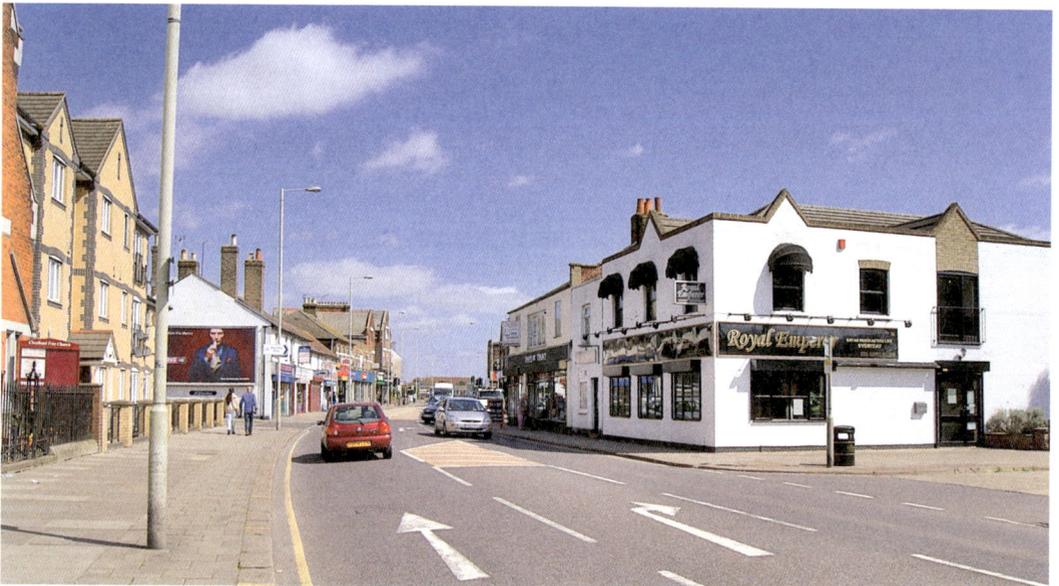

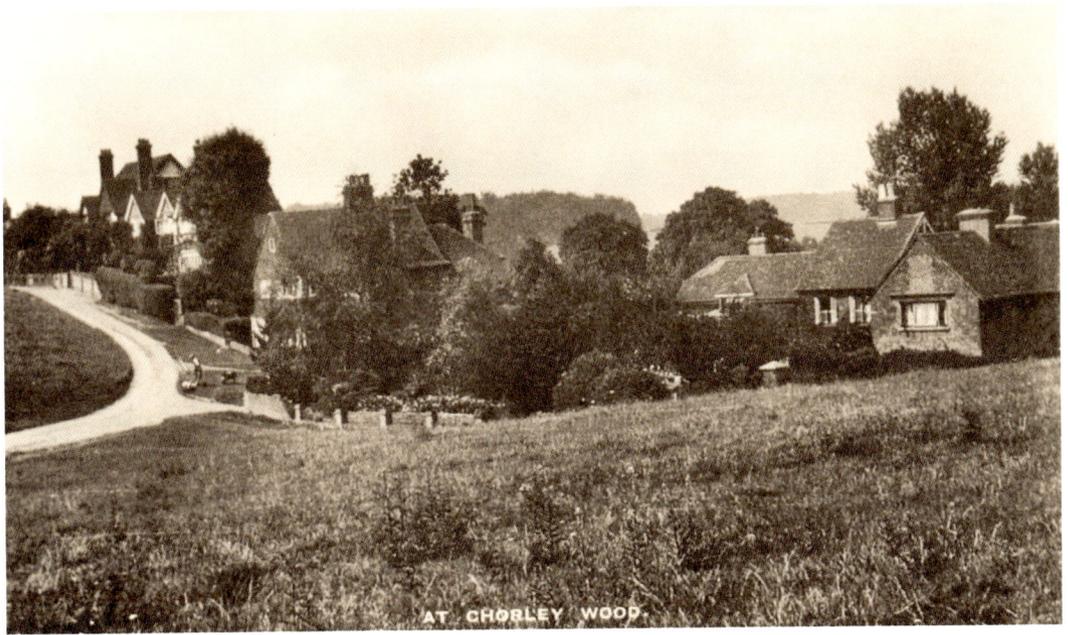
AT CHORLEY WOOD.

Chorley Wood

Mee enthuses, 'It is the nearest Hertfordshire village to the Chalfont country, whose loveliness it shares. Here is a beautiful and extensive gorse common, and there are wide views over the valley of the Chess.' However, according to *The Victoria History*, the area was not entirely a rural idyll in the past: 'Watercress beds abound on the banks of all three of the rivers, and the cultivation of this plant is an important industry of the townspeople. Straw plaiting was also largely carried on ... There were also silk and flock mills here.' William Penn, the Quaker who founded Pennsylvania, married here in 1672. Today the common remains virtually unchanged, and is very popular for leisure pursuits.

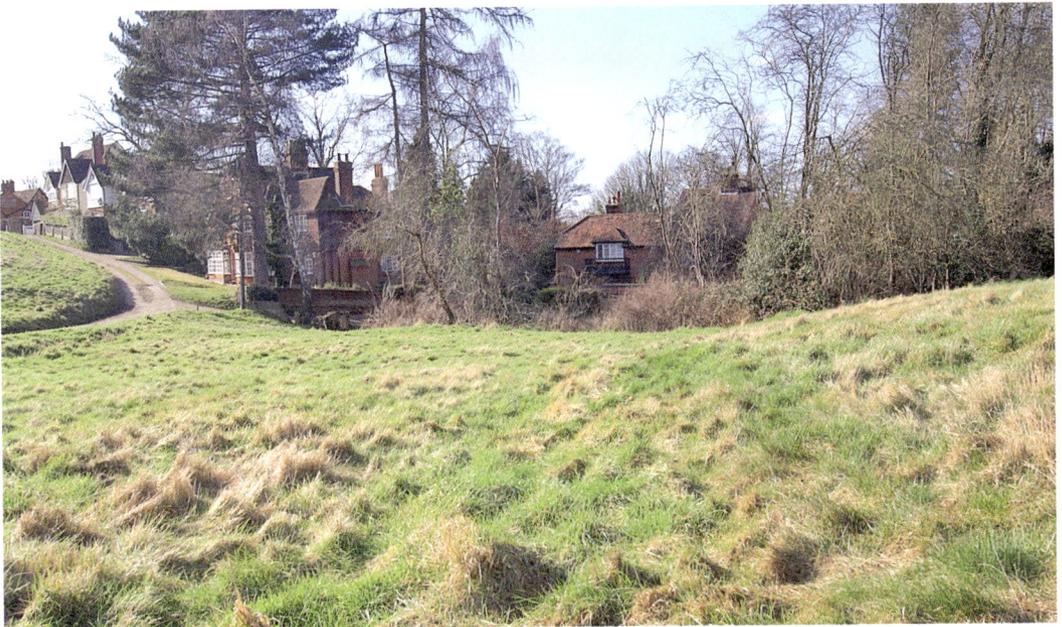

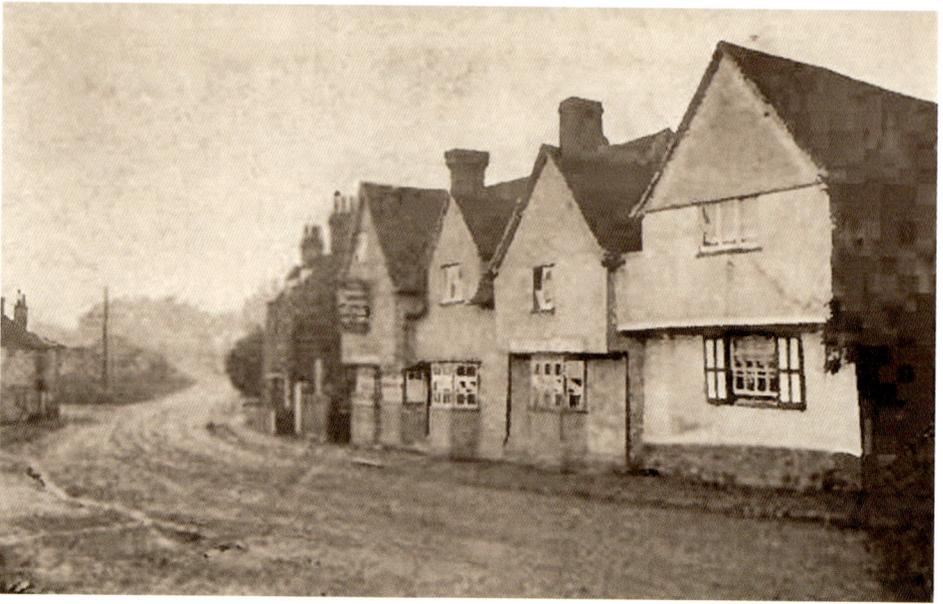

Codicote

'At the triangular village centre some pretty half-timbered (George & Dragon Inn) as well as chequerwork brick houses,' Pevsner reports. The ubiquitously English George & Dragon is currently reincarnated as a Chinese restaurant; otherwise, little has changed at the epicentre of this straggling settlement. Due to its location on the Great North Road, in the eighteenth century the village was frequented by a notorious gang of highwaymen called 'the Codicote cutthroats'. 'There was a maid, perhaps her name was Beck; She would not let him, so he broke her neck.' This local rhyme recalls the doings of the ghost of an evil farmer named Sissavenres.

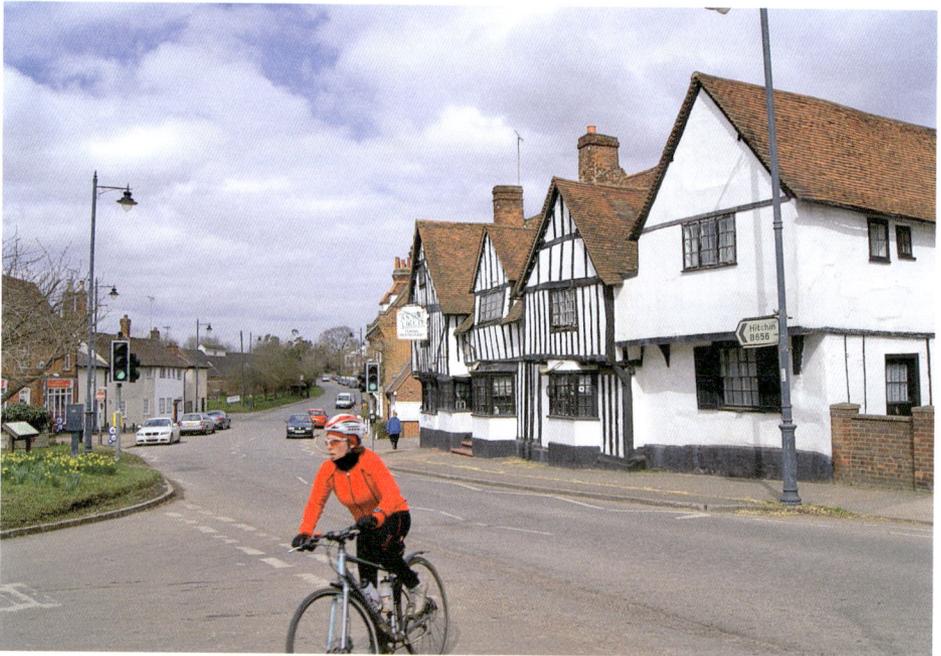

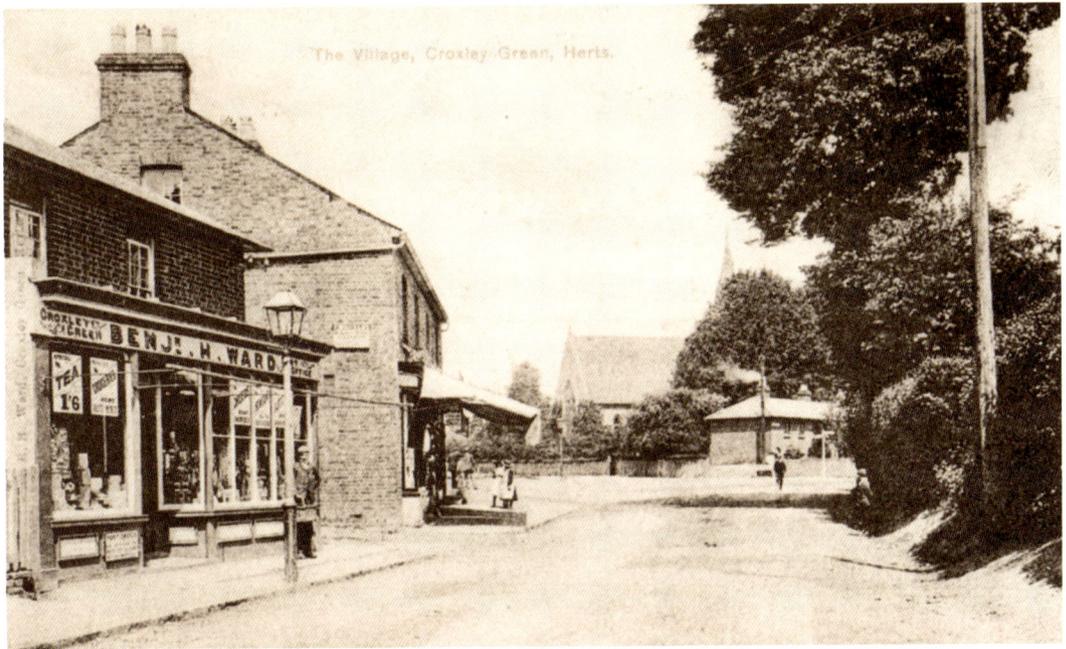
The Village, Croxley Green, Herts.

Croxley Green

The *Victoria* tells us that, at the top of a hill just outside Watford, 'a road branching from here north to Sarratt runs through Croxley Green, a long open piece of grass land edged with a few houses, and many cherry orchards.' Mr Ward, who ran the grocery store and post office on the left, also produced this early twentieth-century postcard. The row of Almshouses in front of All Saints church, known as 'Penny Row' because the rent was 1d per week, were demolished in 1932 and replaced by the current church hall. Costcutter continues to sell groceries today, but the junction is exceptionally busy due to the Rickmansworth School entrance located on the right.

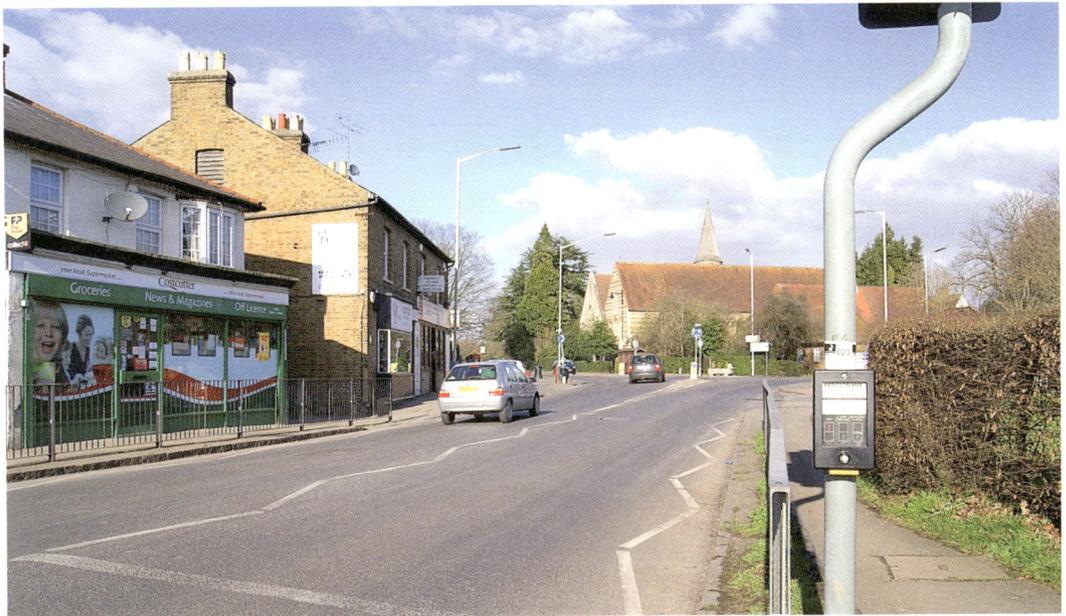

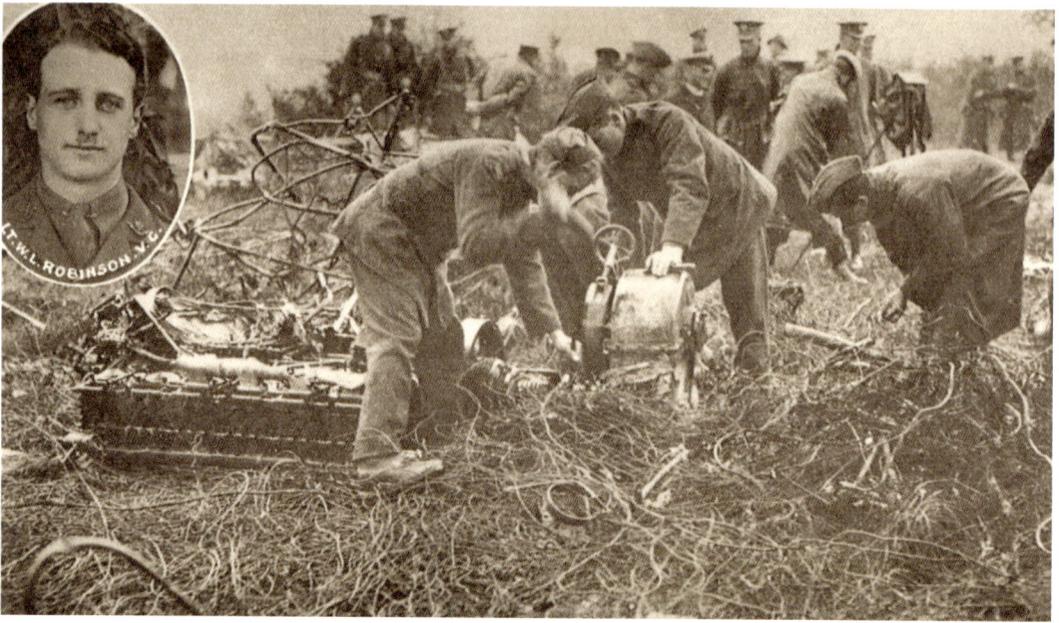

Cuffley

Just before the outbreak of the First World War, the *Victoria* describes this sleepy backwater as 'the hamlet of Cuffley, which consists of a few cottages, a room used as a school and church, and Wells Farm.' However, on the night of 3 September 1916, a German Zeppelin was shot down in flames behind the Plough pub. The small village was subsequently inundated by 60,000 sightseers, and police had to be called to keep control. Lt William Leefe Robinson, who bought the airship down with incendiary bullets, was later awarded the Victoria Cross. Today, the memorial to the crew still stands, having been restored in 1986.

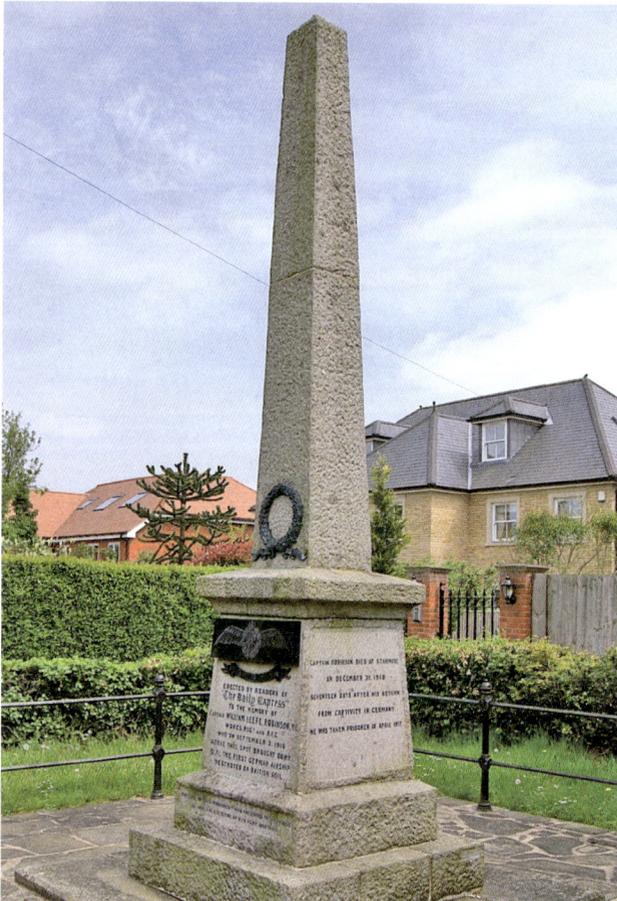

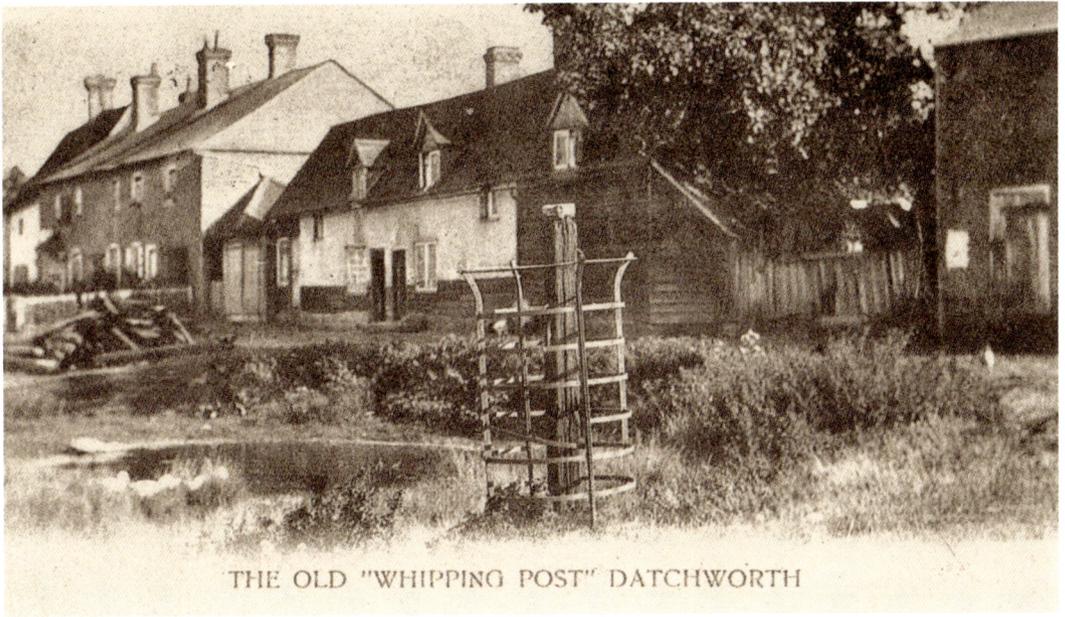

THE OLD "WHIPPING POST" DATCHWORTH

Datchworth Green

'The place is very ancient,' says Tomkins, 'we read that four hides of land at 'Decewyrth' were granted by an early Saxon king to the Monastery of St Peter at Westminster.' The scene described in the *Victoria* has hardly changed in the century since. 'On the north side of the green is a late 17th-century building of timber and plaster and brick with a tiled roof now divided into two cottages. The initials WD and date 1694 are placed in plaster over three gabled windows. Nearby on the green is the whipping-post, to which the handcuffs are still attached.' However, on closer examination, the post does appear to be several inches shorter.

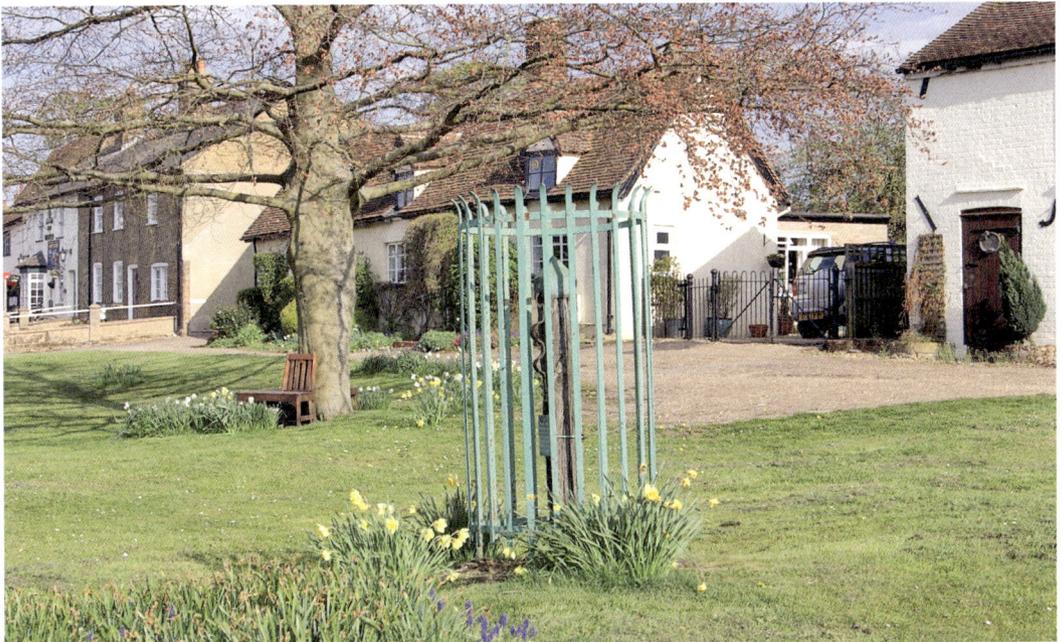

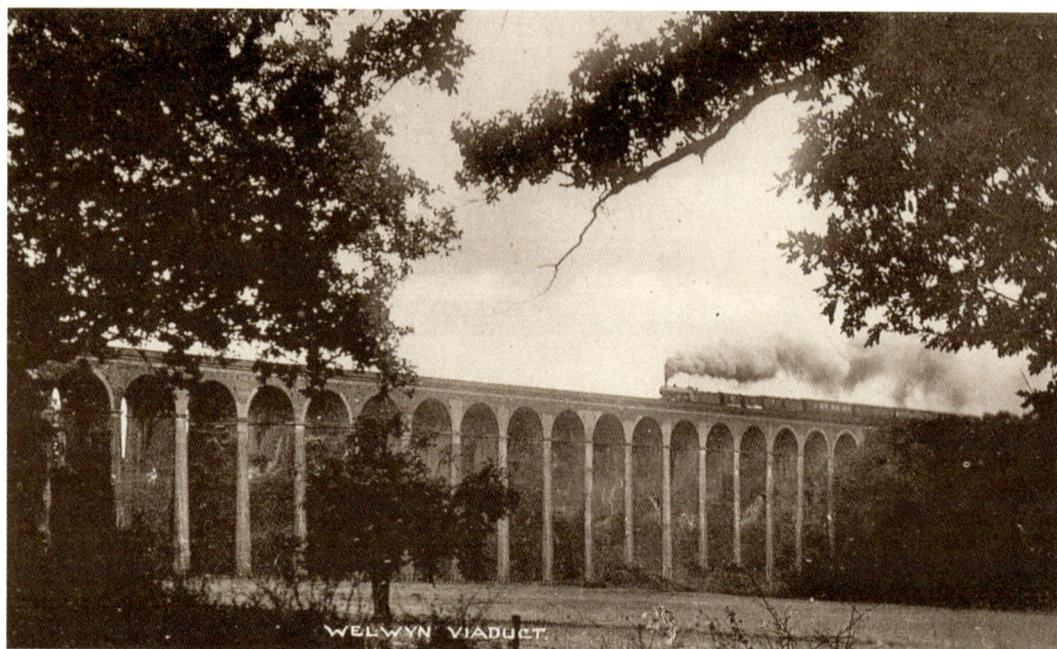

WELWYN VIADUCT.

Digswell Viaduct

Tomkins calls this remarkable feat of Victorian engineering 'the Great Northern viaduct of forty arches over the deeper portion of the Maran Valley.' Designed by Lewis Cubitt in the style of a Roman aqueduct 100 feet high and 1,560 feet long, it took 6,000 labourers, using five million locally-made bricks, two years to complete. Queen Victoria herself opened it in 1850, but was so frightened of its height that she refused to travel across it, and so the train carrying her had to stop and a horse-drawn carriage then drove Her Majesty the length of the bridge on the ground. Blondin practised here before his famous tightrope crossing of Niagara Falls in 1859.

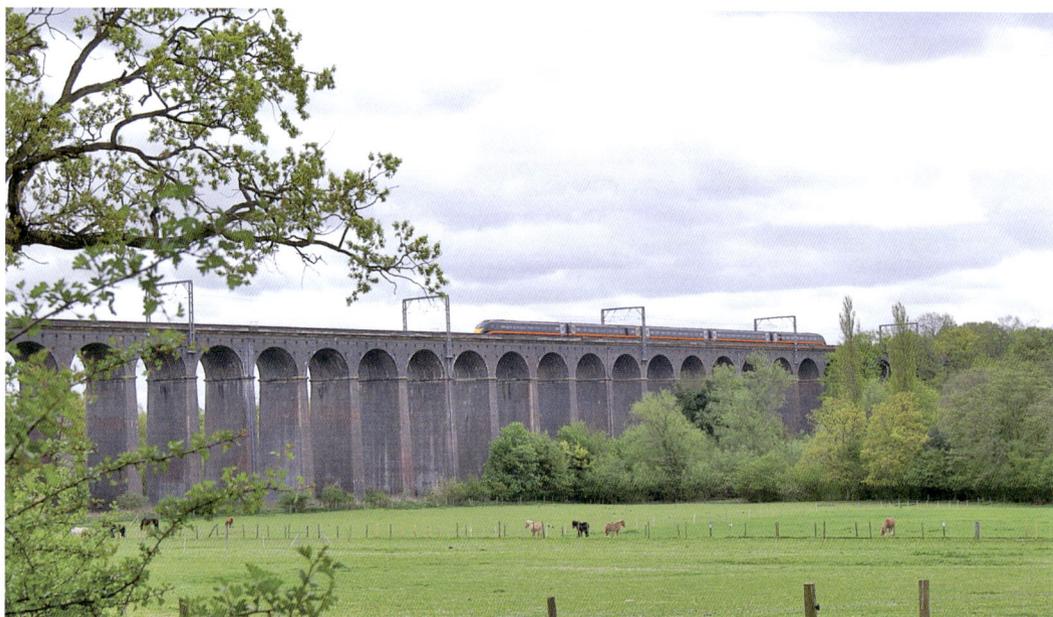

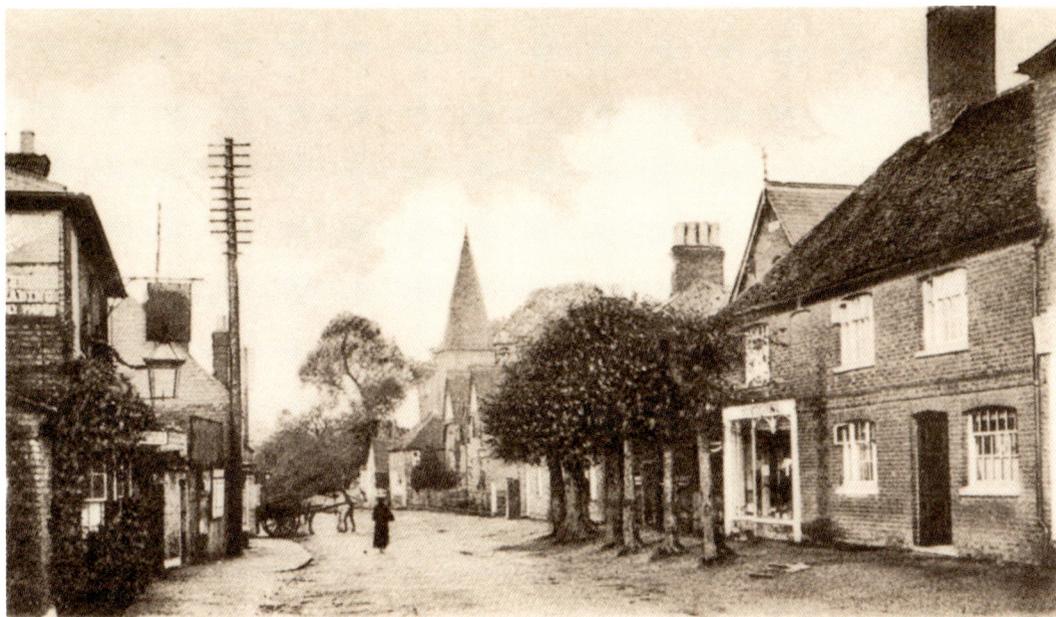

Elstree

In Tomkins' time, this place was 'a large village beautifully situated on the Middlesex border. There is excellent fishing to be had at Elstree Reservoir.' A decade later, silent film-makers arrived looking for good natural light. When Mee visited thirty years later, it had become 'the chief centre of British films ... When a big production is in hand, calling for crowds, these normally quiet roads are scenes of great excitement. The passer-by may be intrigued to see the funnels of an Atlantic liner appear over the roofs of houses here, or a medieval castle suddenly appearing on the skyline...' Now both film and TV studios thrive here, alongside the new and very popular Harry Potter movies attraction.

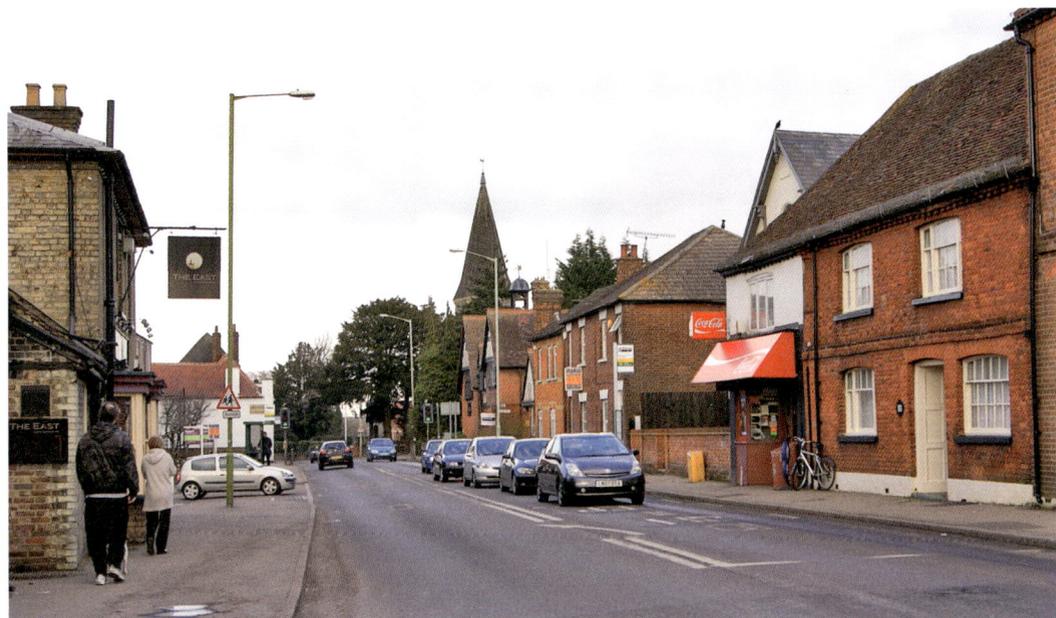

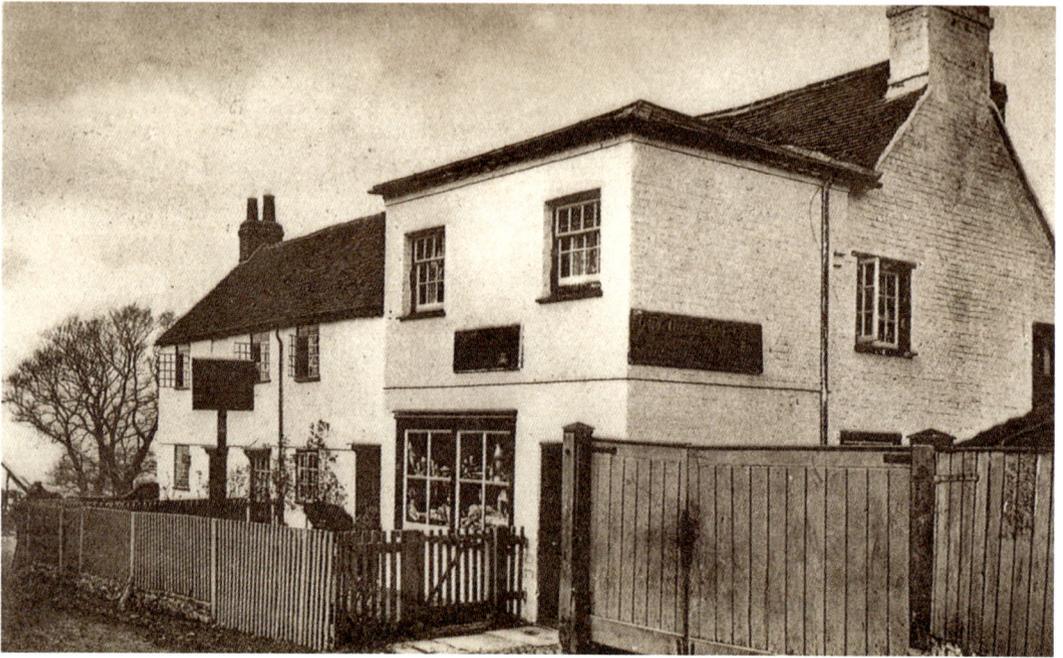

Essendon

'Down the valley by the River Lea is a mill still vigorous and strong after 300 years at work; it has the same mighty timbers.' Mee goes on to recount the dramatic event on the dark September night in 1916 when a German Zeppelin, 'one of the first criminals of the air, had emptied what was left of its load of bombs on this peaceful village, shattering cottages and wrecking the chancel of the church.' The airship was later shot down in Cuffley. The 1906 photograph shows the Cyclist's Rest, a temperance café, conveniently situated adjacent to the church, and run by Mr Oliver to tempt thirsty travellers away from the Salisbury Crest Inn nearby.

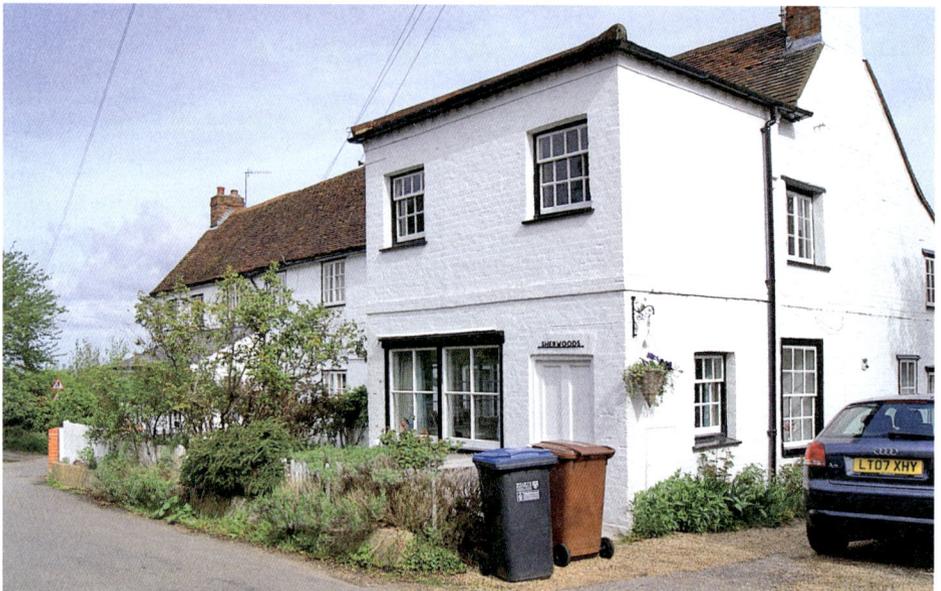

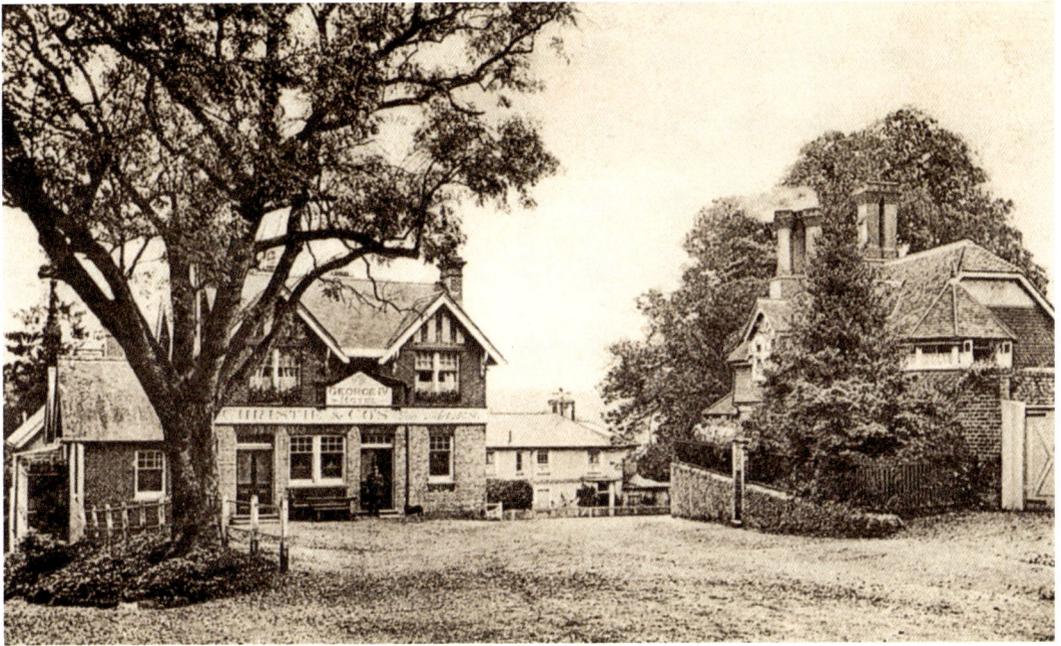

Great Amwell

The *Victoria* quotes lines written by the eighteenth-century Quaker poet John Scott, who lived in the village: 'Roofs of russet thatch, Rise mix'd with trees, above whose swelling tops, Ascends the tall church tow'r and loftier still, The hill's extended ridge.' Tomkins tells us it is 'Very prettily situated near the New River ... the village is frequently mentioned in the essays and letters of Charles Lamb. The church stands on a wooded slope; nearby are the village stocks.' That description remains exactly the same today, with the George IV Inn maintaining its name and usage, having been known as The Kings Arms and Quart Pot Alehouse before a makeover in 1890.

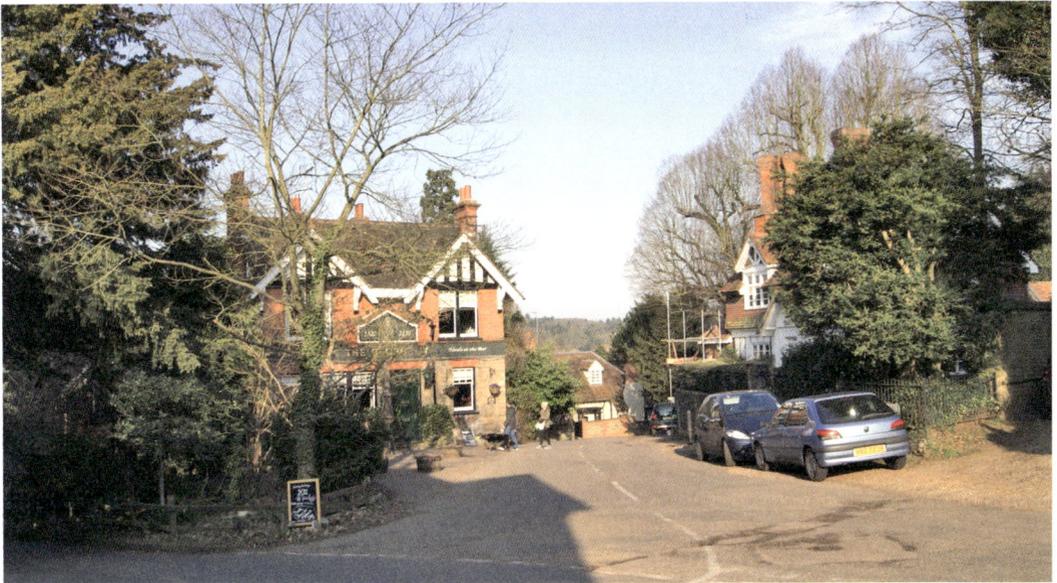

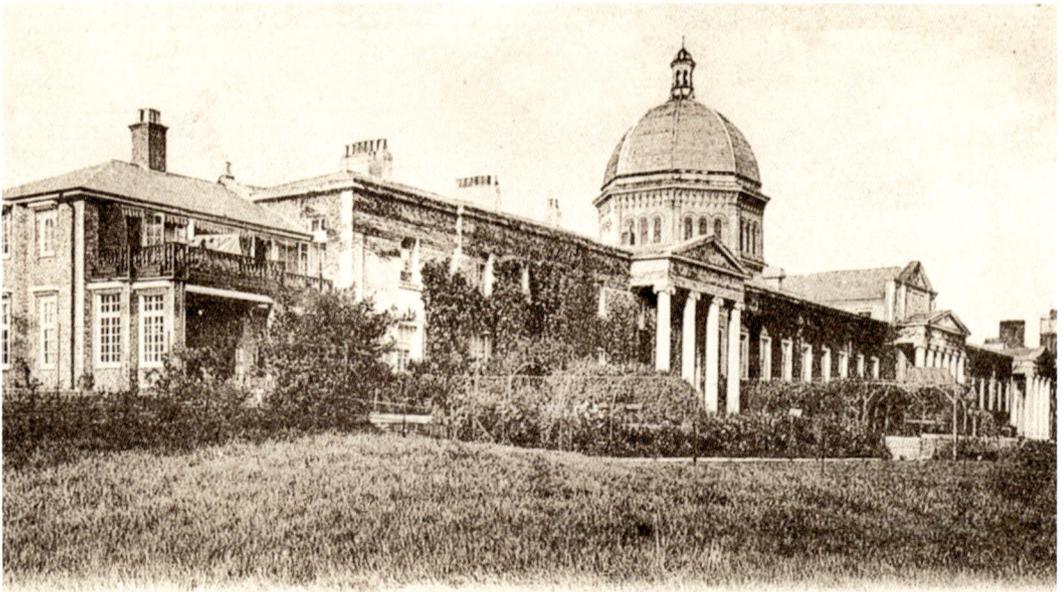

Haileybury College, Hertford E. Munnings, Hertford.

Haileybury

'The college was opened in 1809 for the training of civil servants of the East India Company.' The *Victoria* continues, 'in 1862 the college was converted into a public school. It is built in the classical style after the designs of Mr William Wilkins, architect of the National Gallery. The buildings ... surround a large quadrangle, having the chapel, library and head master's house on the south.' But for the perfectionist Pevsner, in the quad 'the individual parts appear somewhat scattered ... The new chapel, designed by Sir Arthur Blomfield, is a hefty building in a kind of Byzantine or some such 'Rundbogen' style.' The school still thrives in 2013, now accommodating 760 pupils.

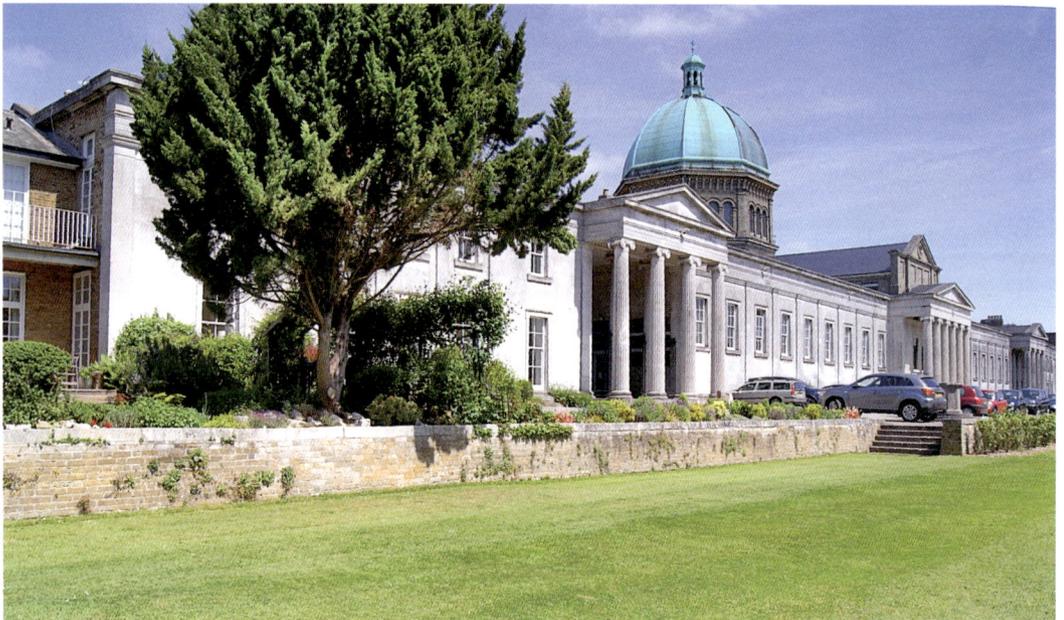

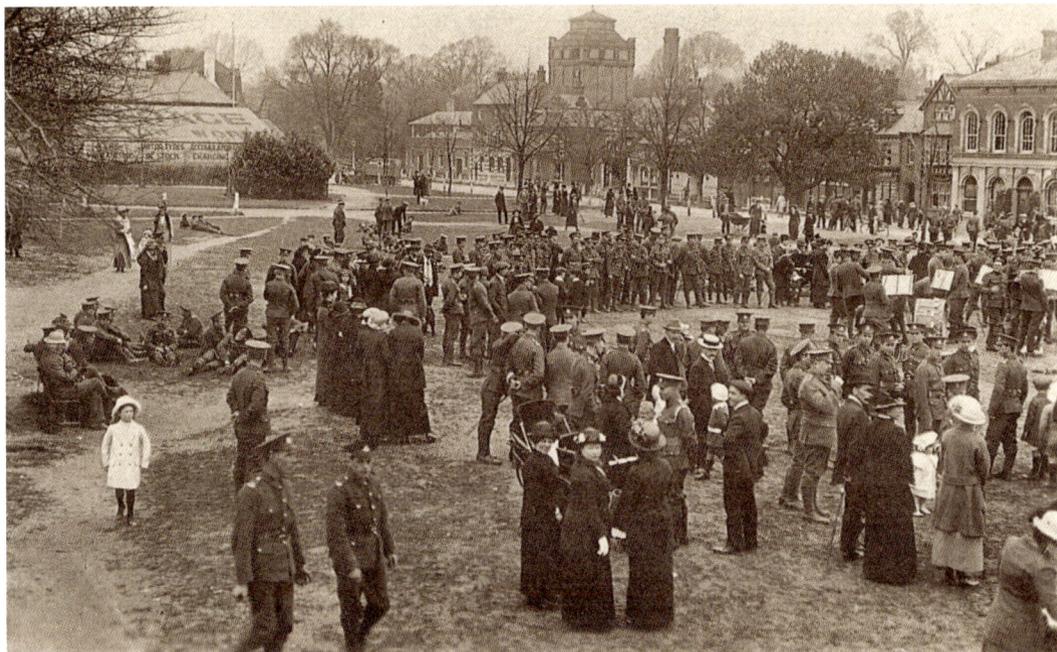

Harpenden: The Common

Mee's effusive entry in 1939 describes, 'The country town of great delight, unspoilt by the industrial age, with a touch of gold forever on its gorse-clad common, lovely walks through the woods and fields, and an air as sweet and pure as any corner of the British Isles. Its very name means valley of the nightingales, and it is worthy of it.' In this photograph, taken some time during the First World War, the Notts & Derbyshire Regiment are attending a Sunday service. In a sad irony, the town's war memorial would be erected nearby within a few short years. Fortunately, the extensive common still remains relatively unspoiled today.

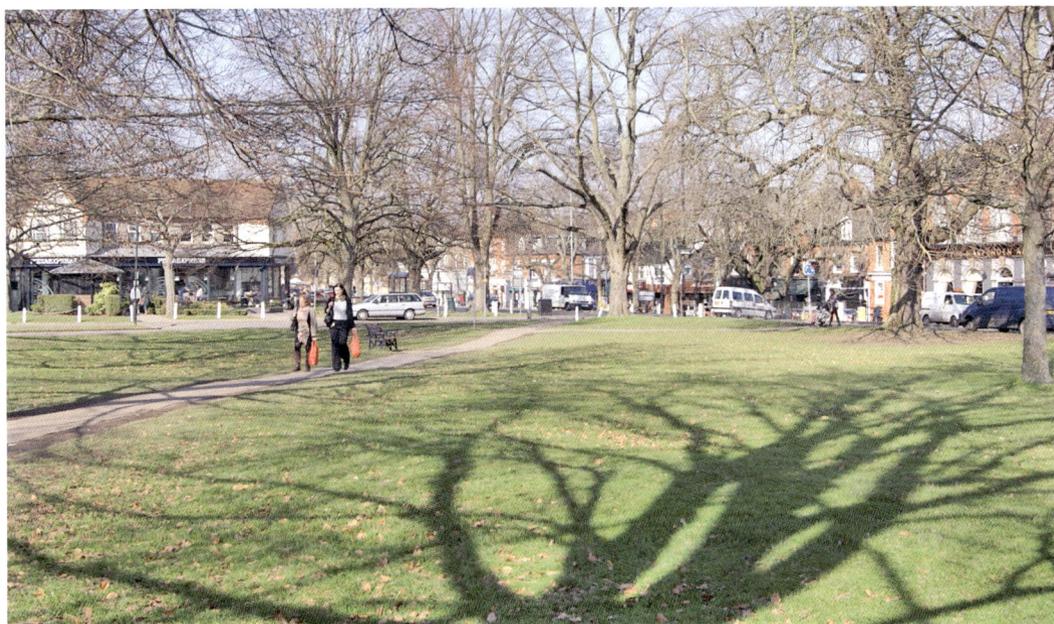

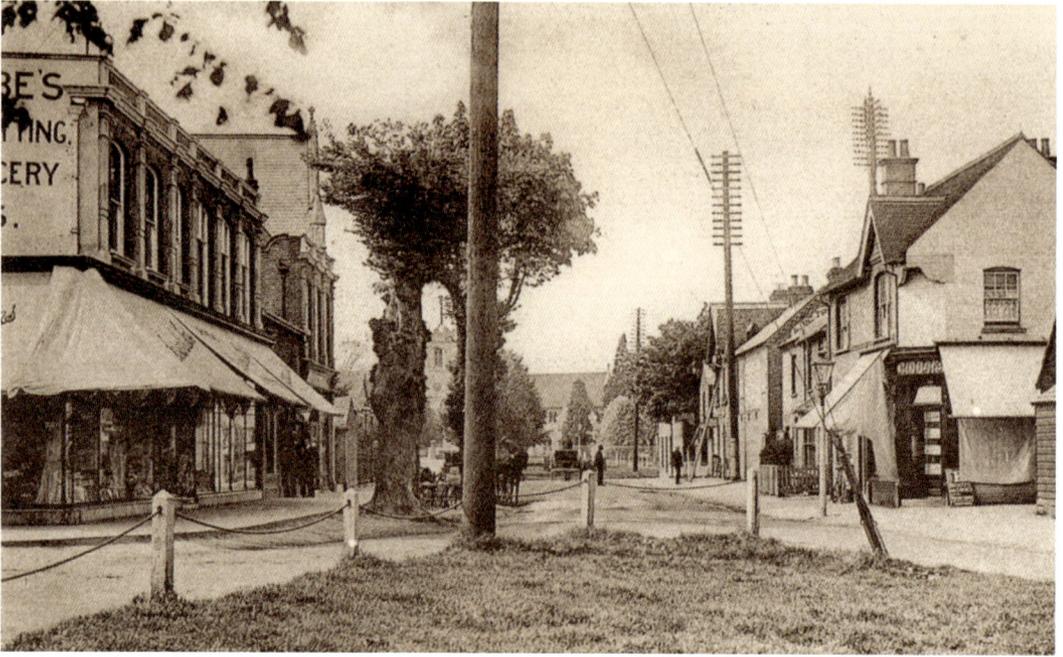

Harpenden: Leyton Road

Lydekker tells us, with a population of 4,725 in 1901, the village during the previous twenty years 'has nearly doubled in size, and is rapidly increasing.' This was primarily due to the Midland Railway station affording easy commuting into London. Anscombe's Drapers, Outfitters and Furniture Store here in Leyton Road was one of many local emporiums serving affluent suburban families. Waitrose now occupies the same site, alongside many upmarket independent retailers, ensuring the village remains a popular shopping destination. Mee points out that 'in the background stands the medieval tower of the church built with flint and plaster in 1470.'

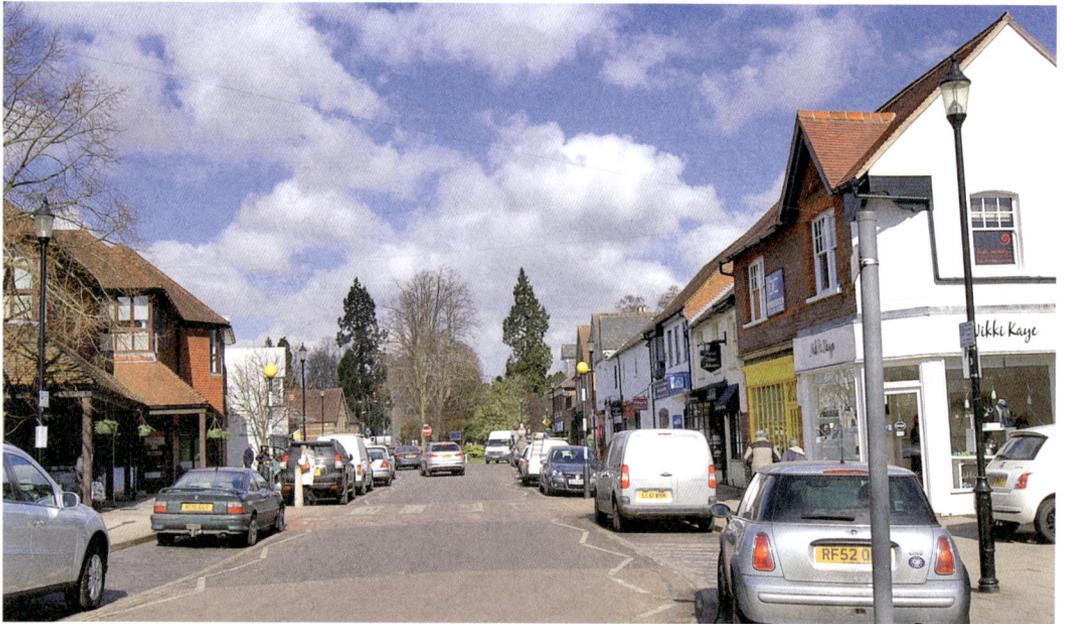

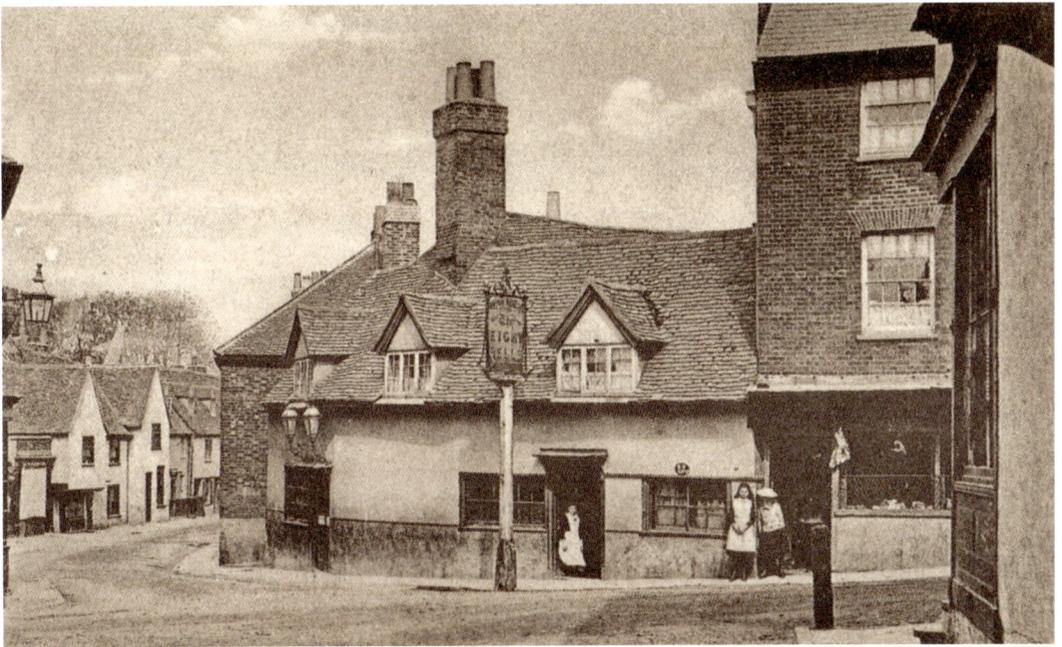

Hatfield: Eight Bells

According to Tomkins, 'The older parts of the town lie on the western slope of a hill close to the railway; at the top stand the church and portions of the old palace, beyond which, in the park, stands the fine mansion of the Cecils. The town is of great antiquity; the Saxon Kings ... called it Heathfield.' Charles Dickens was a visitor, and the seventeenth-century Eight Bells features in *Oliver Twist*. The *Victoria* notes that by 1913 the town had already expanded north from the station. Today, of course, the 'new town' dwarfs the original settlement with vast housing estates, the University of Hertfordshire campus, the Galleria shopping mall and a high-tech science park.

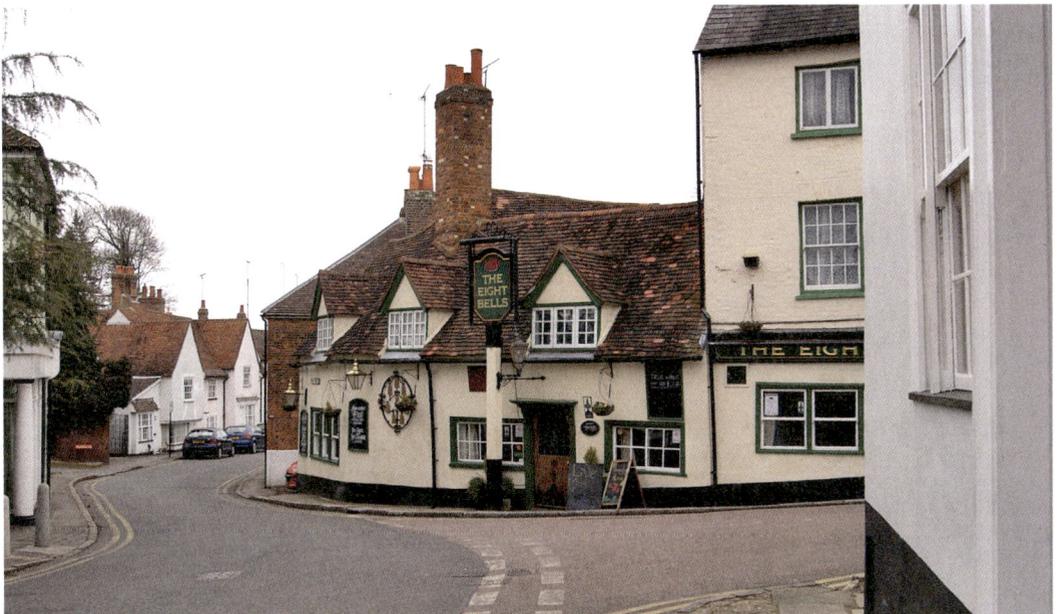

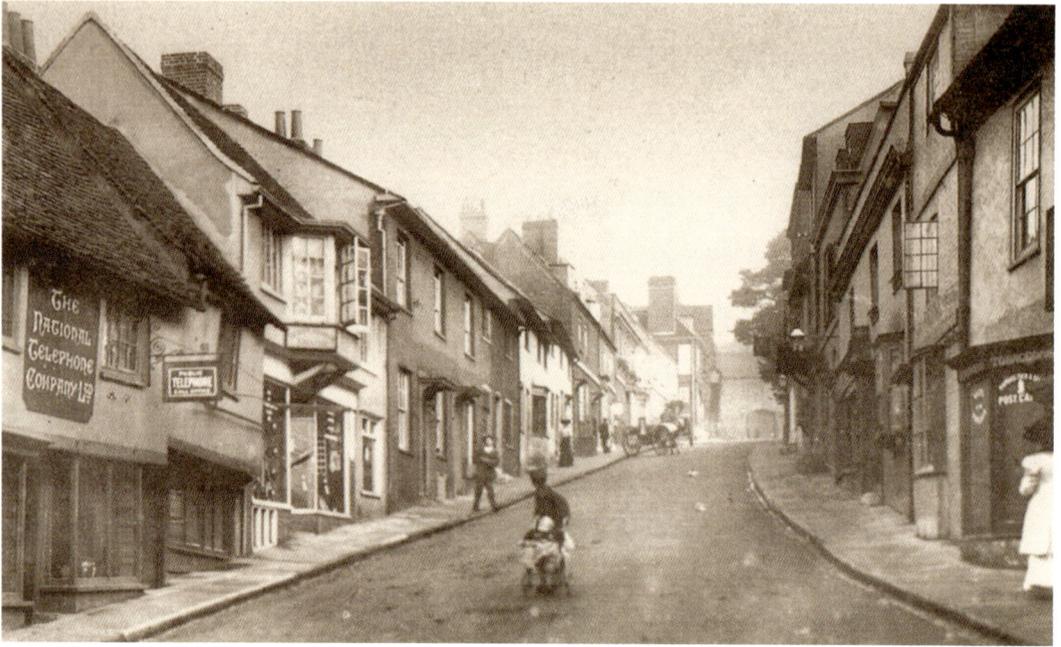

Hatfield: Fore Street

'Between the church and the main road is Fore Street, formerly the principal part of the town, where the market was held.' The *Victoria* continues, 'There are here several interesting houses, notably one of the 17th century of timber and plaster with an overhanging story and tiled roof, now converted into two shops (far left of photograph), and some late 18th and early 19th-century red brick houses, including the old Salisbury Arms.' Mee notes, 'Ending the vista of these buildings is the brick gatehouse of the palace once occupied by the Bishops of Ely ... the gatehouse has ancient beams over its archway and a fine mullioned window above it.'

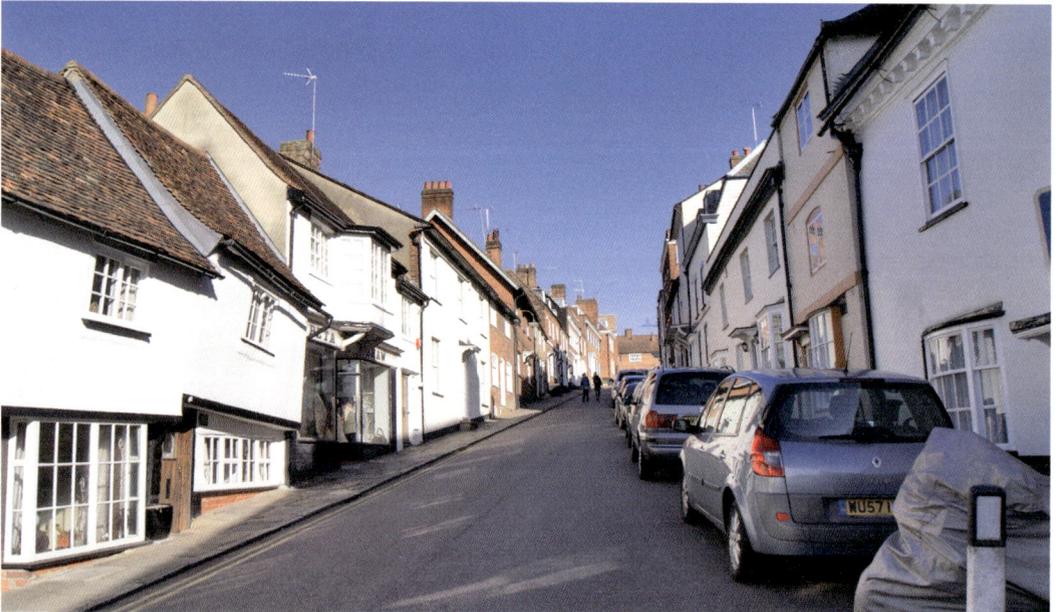

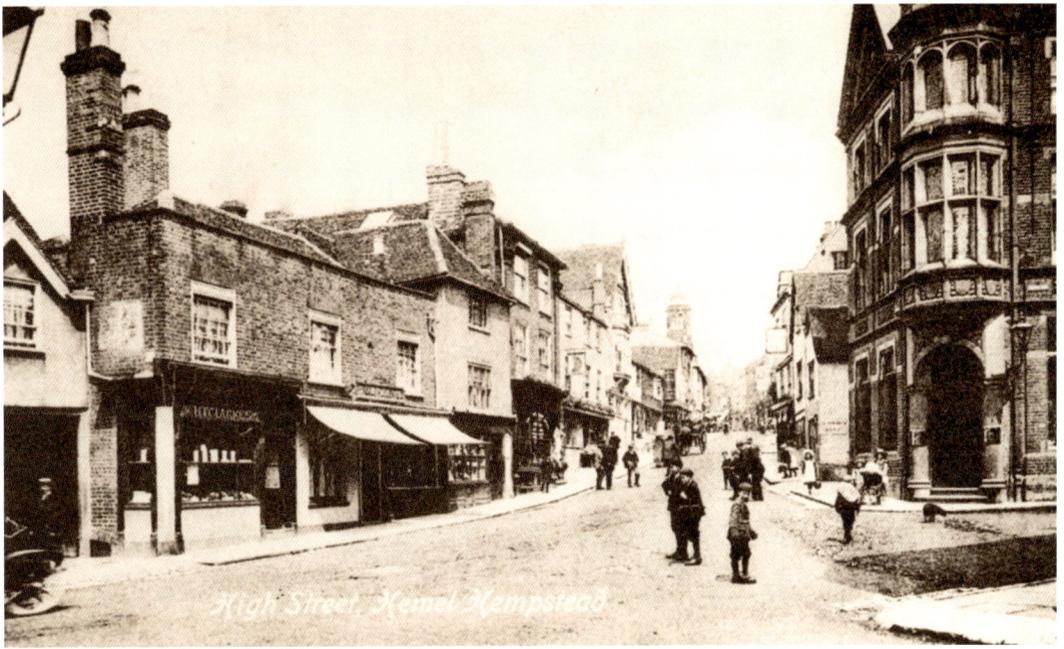

High Street, Hemel Hempstead

Hemel Hempstead: High Street

'Hemel Hempstead ... owed its name (Heanhamsted) to the high hemp-land on the east side of the town,' Tomkins explains. Pevsner was effusive: 'The High Street is one of the most agreeable streets of Herts. It rises in a gentle curve, skirting the hillside ... the most characteristic element of the street is its early 18th century houses with their typical segment-headed windows. Most of these houses are of purple brick with red dressings, but some are whitewashed.' The old town has thankfully been almost fully preserved due, ironically, to the development of the post-war 'new town' to the east, complete with its notorious 'magic roundabout'.

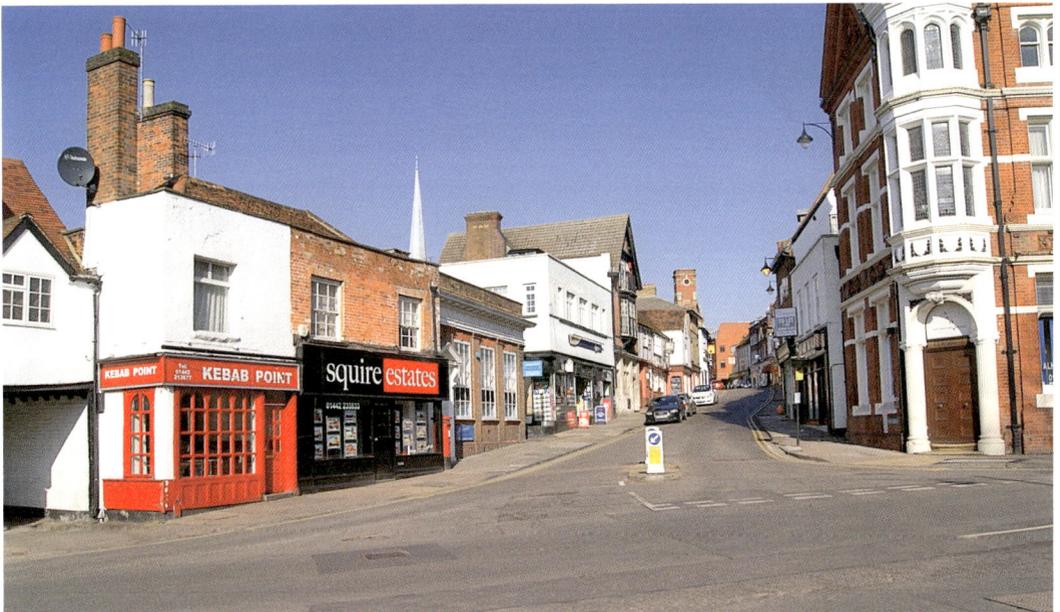

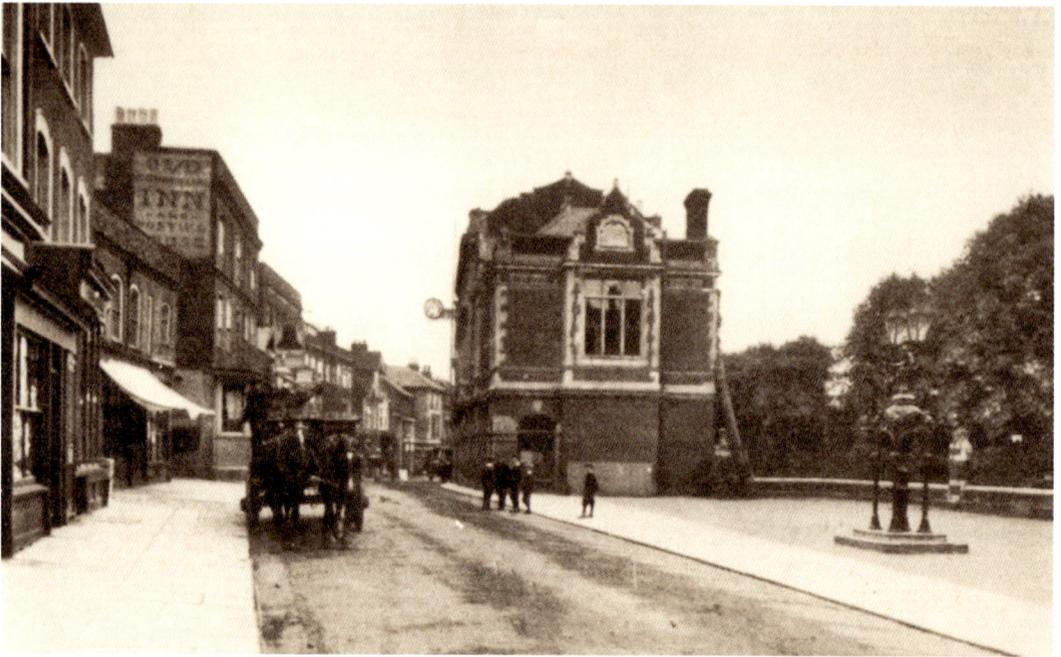

Hemel Hempstead: Market Square

The *Victoria* gives us a full description of the centre of the old 'Bailiwick', hardly changed today, except that the Town Hall has become a thriving local arts centre. 'On the west side of the High Street are the municipal buildings of red brick and stone; they include the Corn Exchange and a Literary Institute, and at the north end a Vestry Hall. The church in its large churchyard is beautifully situated a little off the High Street ... On the east side of the High Street there are many side passages through the houses into spacious yards, which are said to have been used when Hemel Hempstead was noted as a market for grain.'

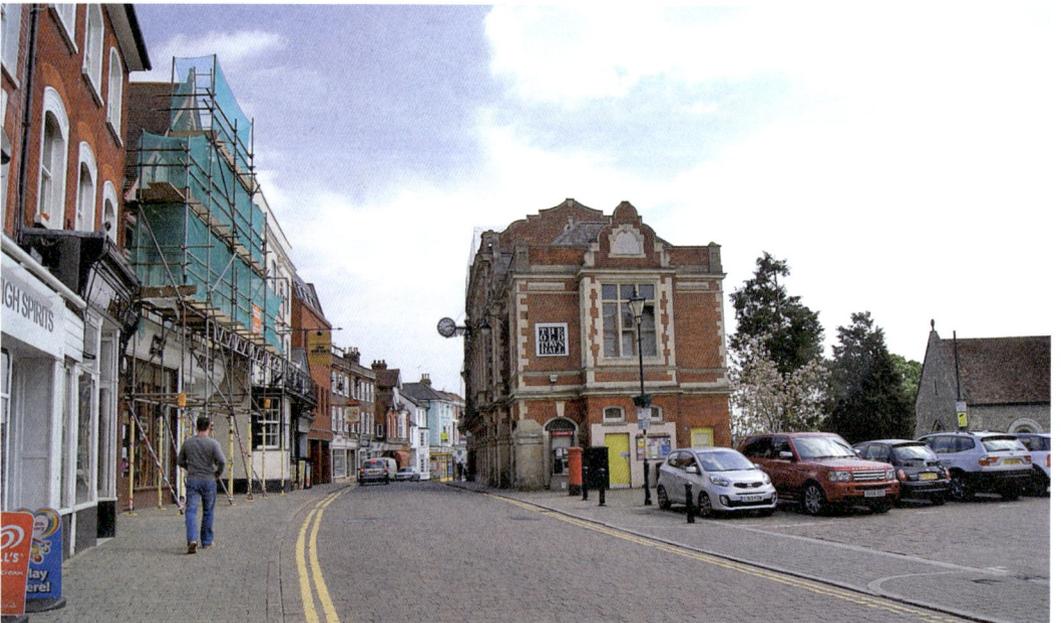

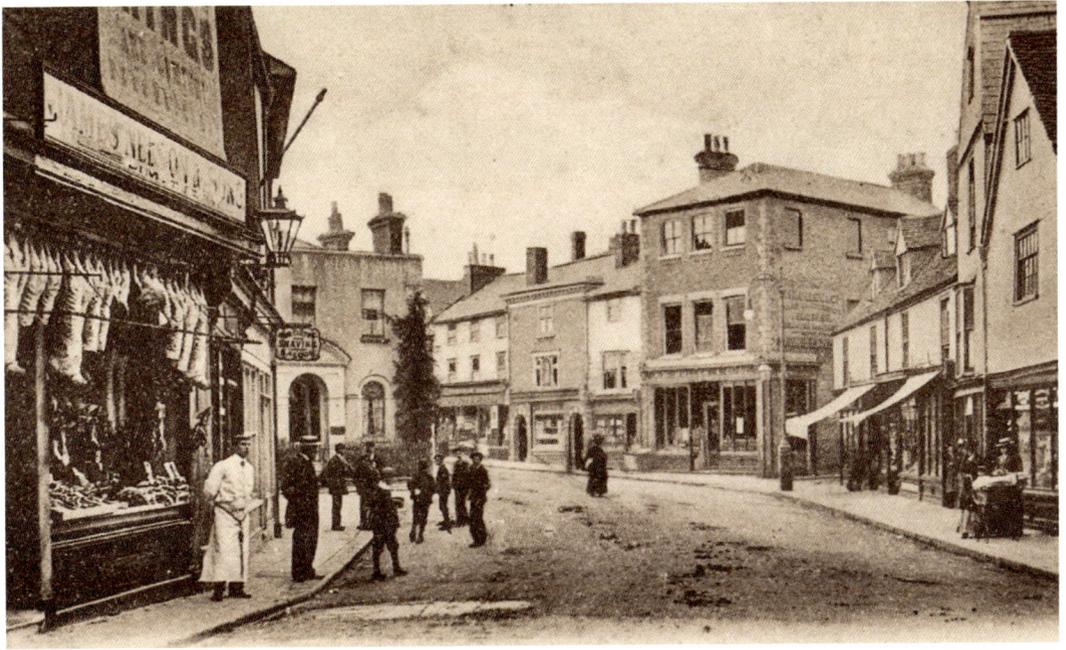

Hertford: The Wash

The *Victoria* tells of the town's earliest major historical event: 'In 673 an important council was held at 'Heorutford' or 'Herutford' ... It was the first Synod of the united English Church.' Tomkins reports the conjectures of past historians that 'the true name of the town was Hartford, so-called because in Saxon times, when the surrounding country was densely wooded, the harts crossed the river by a natural ford at this spot...' Maybe the aptly named 'The Wash' was that very place? Today, the shops and buildings on the west side have disappeared to make way for mock-Gothic castle gates – paid for by McMullen's brewery – and a municipal theatre built in the 1980s.

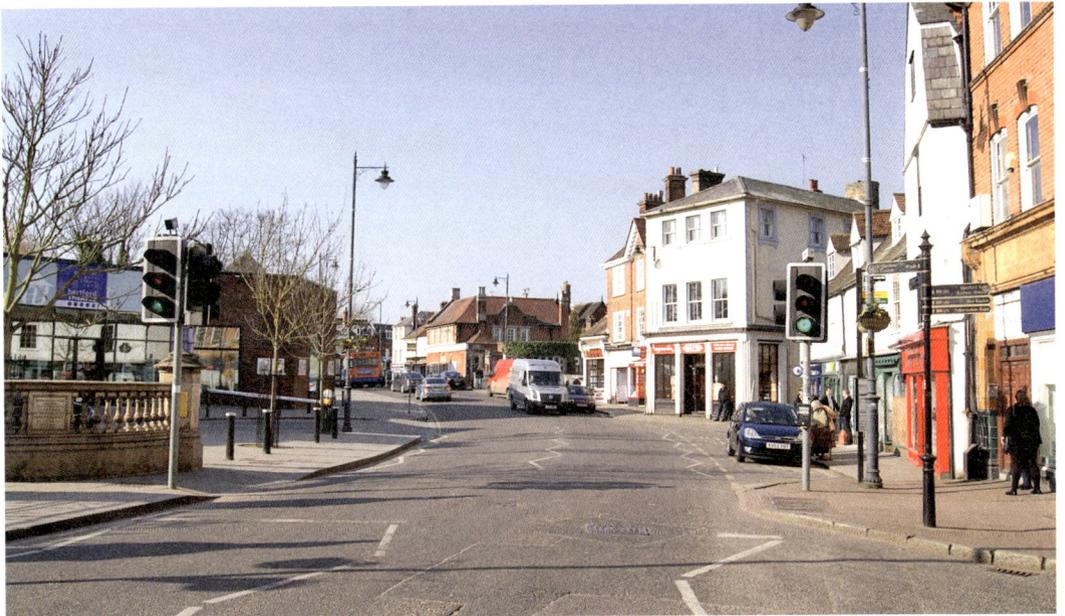

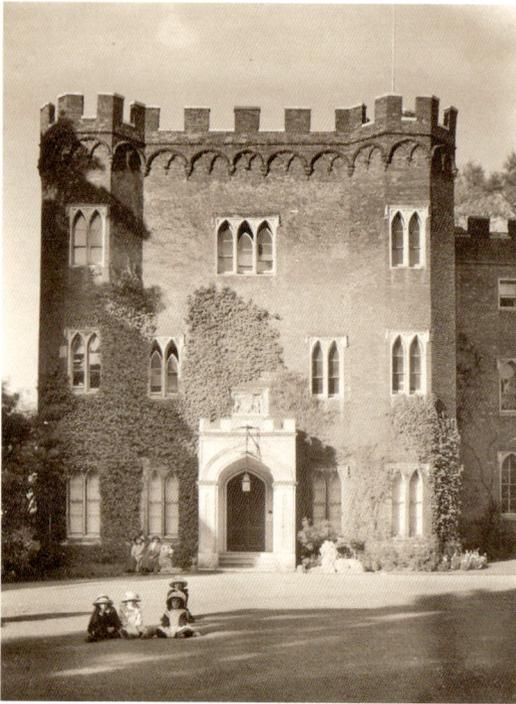

Hertford: The Castle

Tomkins writes, 'Of the castle, built by Edward the Elder in 905, there still remain several large fragments of an embattled wall, partly Norman, and a postern gate.' What locals today call 'The Castle' is, in fact, the old gatehouse – which Pevsner says 'was much altered too about 1800 when the gateway was blocked, porch made, a south wing added and the fenestration regularised. Moreover the lawns and the nice sited trees stretch down to the river to make a picture of gentle Arcadian charm.' Lydekker tells us the gatehouse was used as judges' lodgings in assize time and, according to Mee, the town paid half a crown in annual rent for the site to Lord Salisbury.

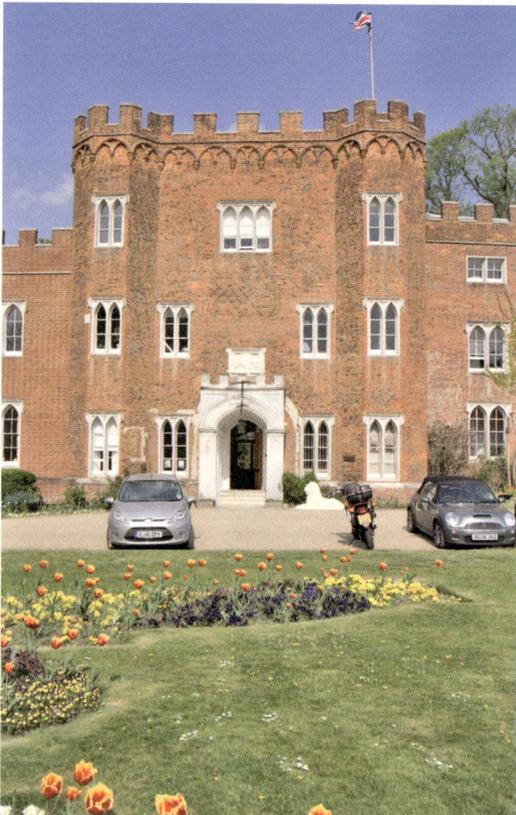

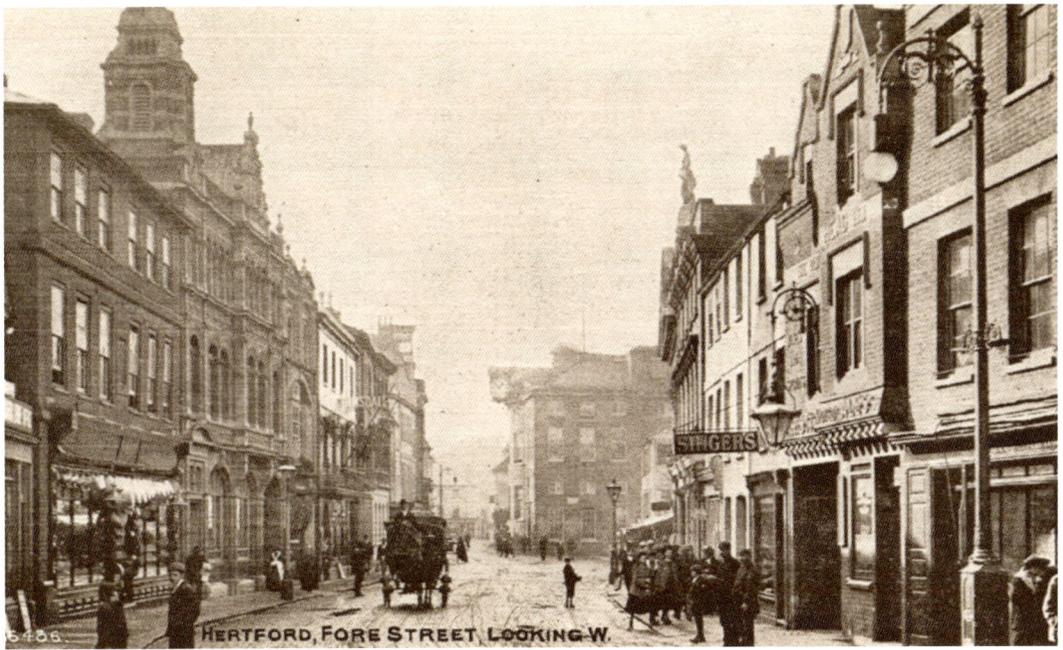

Hertford, Fore Street Looking W.

Hertford: Fore Street

With a population in 1901 of just 9,322, Lydekker states that Hertford, 'although by no means the largest town as regards the number of its population, occupies the first place, as being the county-town, and the only one in Hertfordshire where assizes are held.' The Shire Hall where the courts sat, seen here dominating the back of both photographs, is described by Tomkins as 'a large brick building of "questionable shape"', while Mee observes it was 'designed by the Adam brothers, though we should hardly believe it, for it lacks their usual grace.' The Corn Exchange on the right, which today thrives as a music venue, was built on the site of the old Butchers Market in 1857.

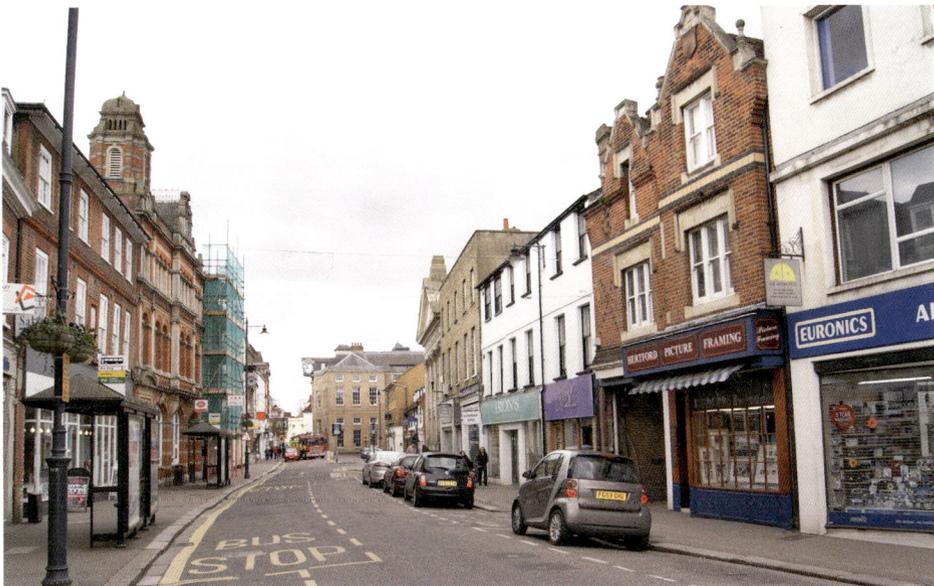

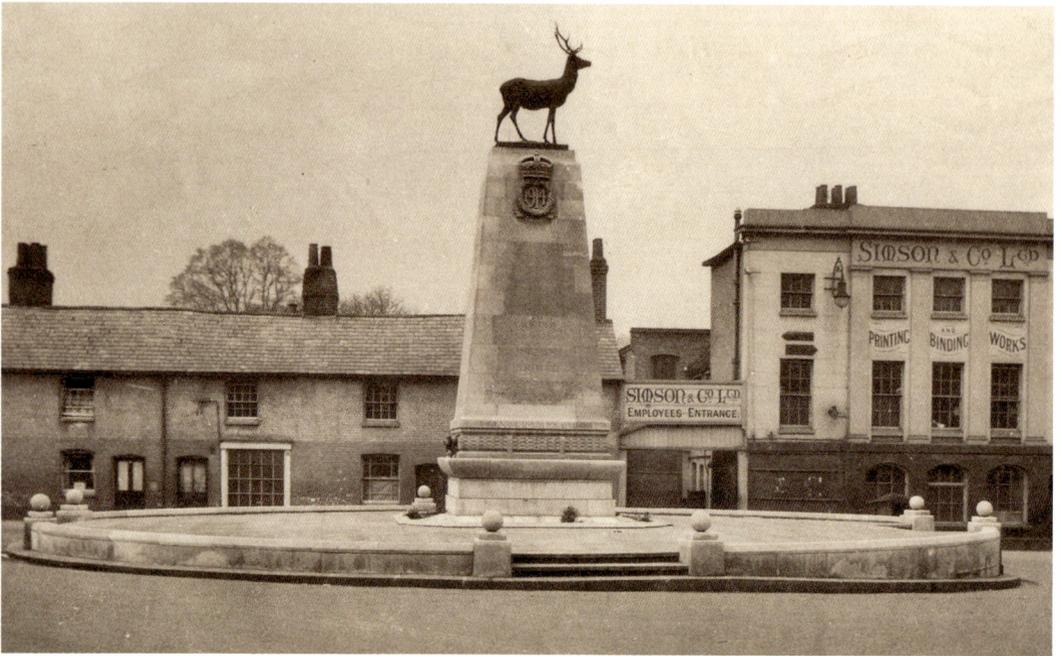

Hertford: Parliament Square

'At the meeting of the streets not far from the castle stands the most striking monument in Hertford, the memorial of the men who fell in the war. The architectural scheme was designed by Sir Aston Webb, and the bronze figure of the stag was modeled by Alfred Dury. It is very striking.' Mee informs us. According to the *Victoria*, 'From a military post it is only a step for Hertford to have become an administrative centre ... Hertford became a double market town and a mint town, at which coins were struck from the time of Edward II.' Today, the county council still holds court in monolithic splendour beyond the appalling bypass inflicted on the town in the 1960s.

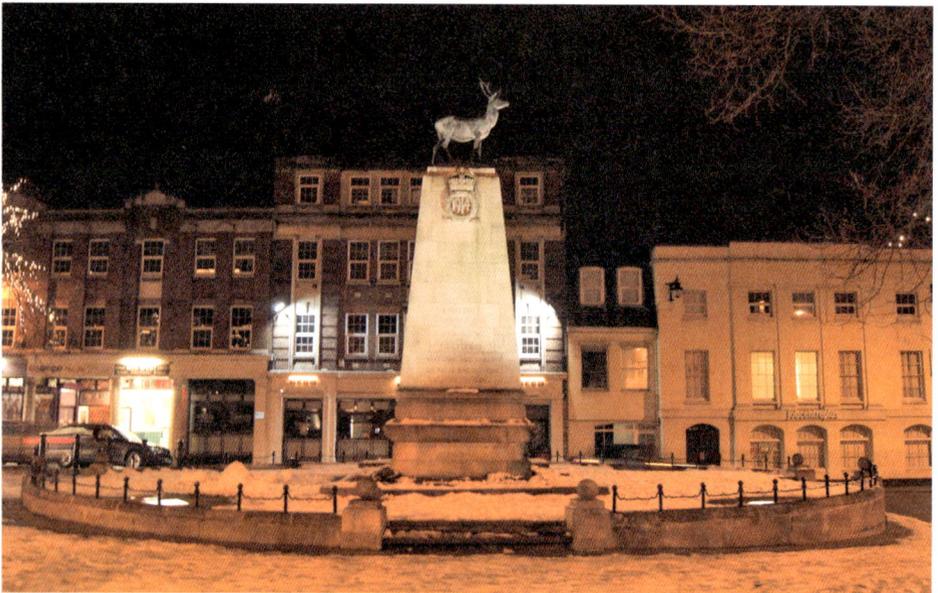

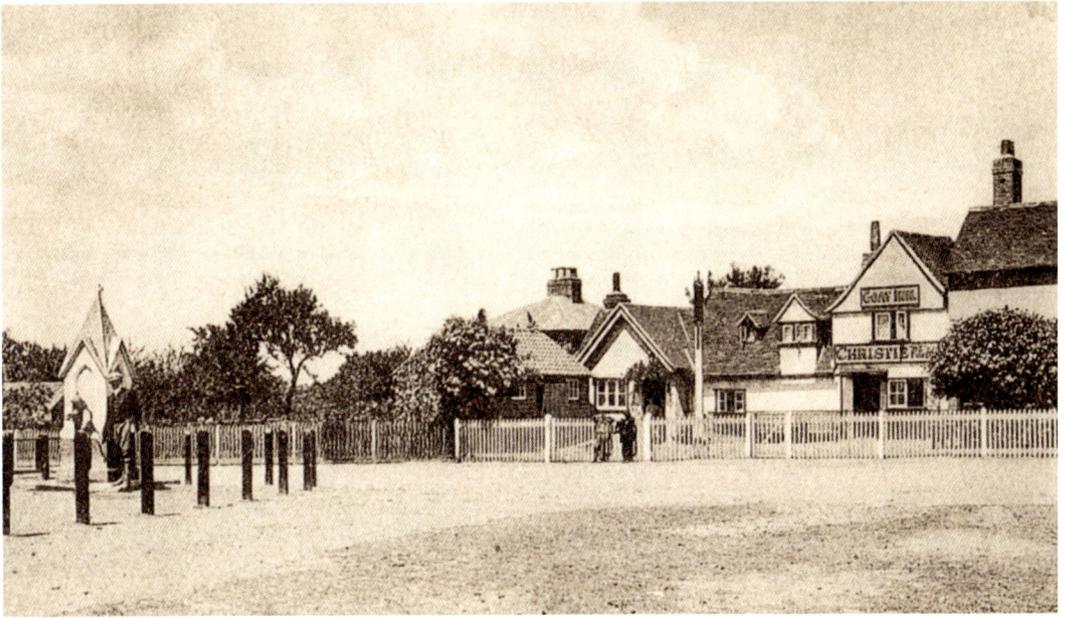

Hertford Heath

The *Victoria* contains only brief details of the village, situated in 'the beautiful woodland of Hertford Heath. The heath is crossed by Ermine Street.' The Heath was also, a century before, the notorious haunt of highwaymen, and local legend had it that an iron ring attached to a tree in Haileybury's grounds was used by Dick Turpin to tether Black Bess. The Goat Inn can be dated back to 1630 and had troops billeted there during the Seven Years' War. The grand water fountain on the left was built in 1898 to mark the Diamond Jubilee of Queen Victoria, but no longer functions. The Green remains the focus of community activities to this day.

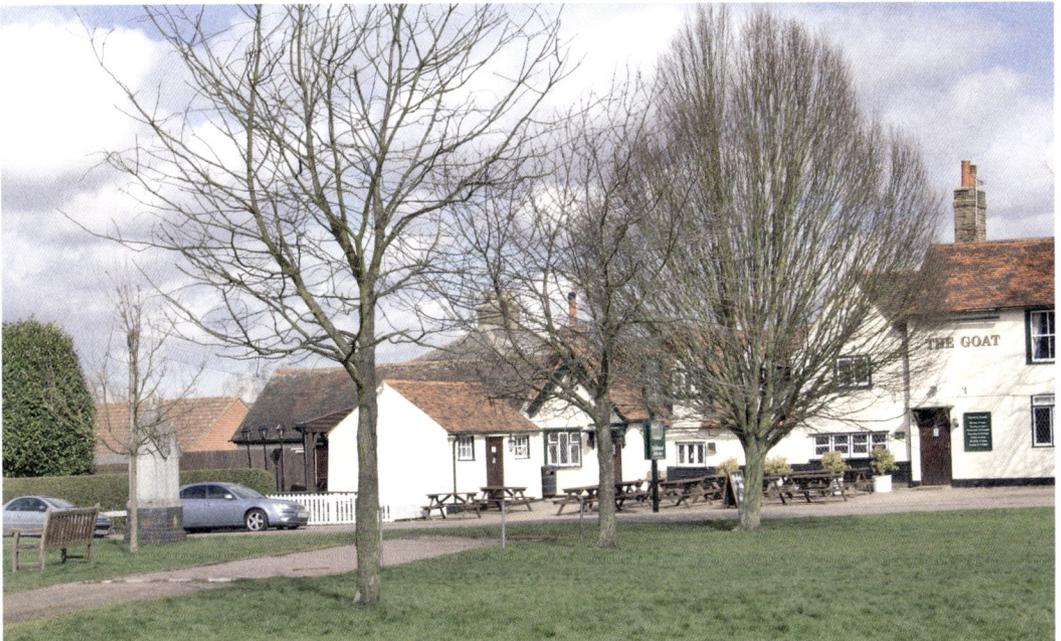

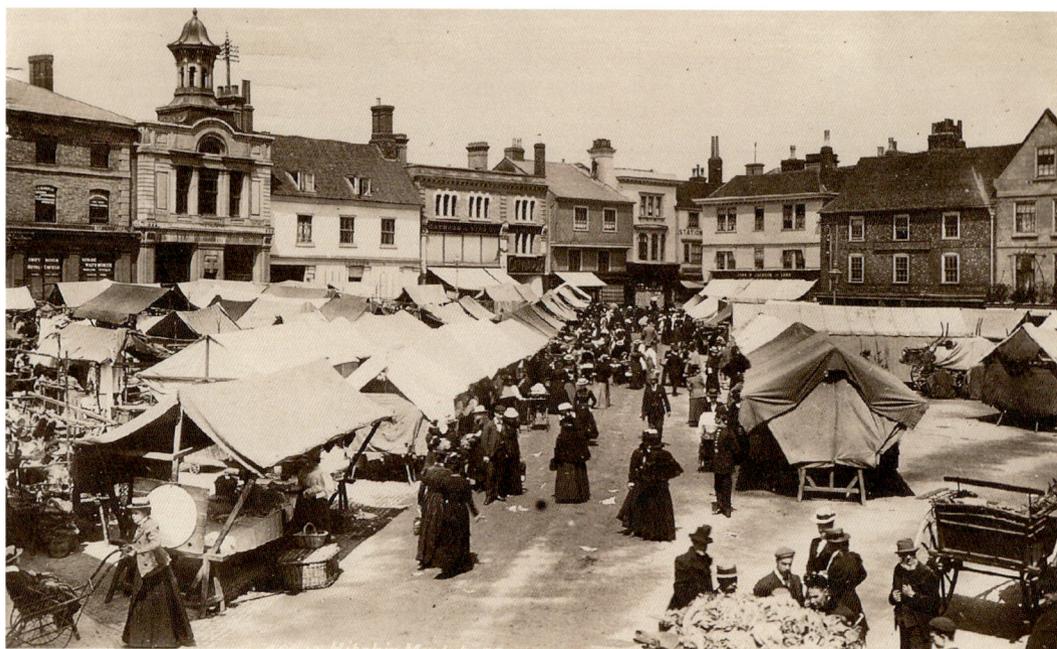

Hitchin: Market Place

Tomkins describes the town as 'one of the most ancient towns in the county ... noted for its corn and cattle market, and also as being one of the few places in England where lavender is cultivated for commercial purposes.' Mee is characteristically effusive: 'It is old-world England wherever we turn in this small town.' Pevsner calls it 'the most interesting and visually the most satisfying town of Herts. It has ... kept its medieval plan virtually without interference, a real market square (rare in the county) with parallel streets running off at the angles.' He singles out the grand former Corn Exchange dominating the square as being 'Italianate of 1851, with big Venetian window and lantern turret.'

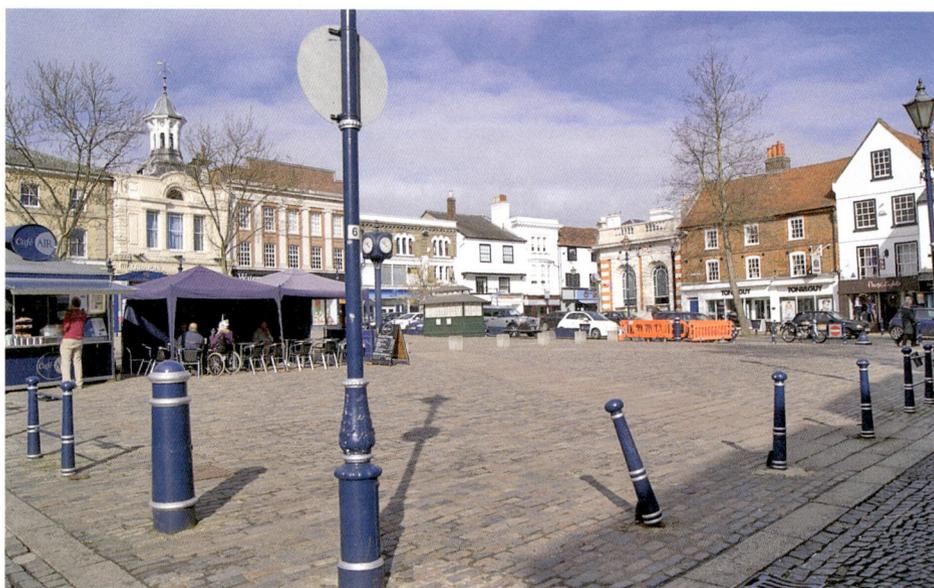

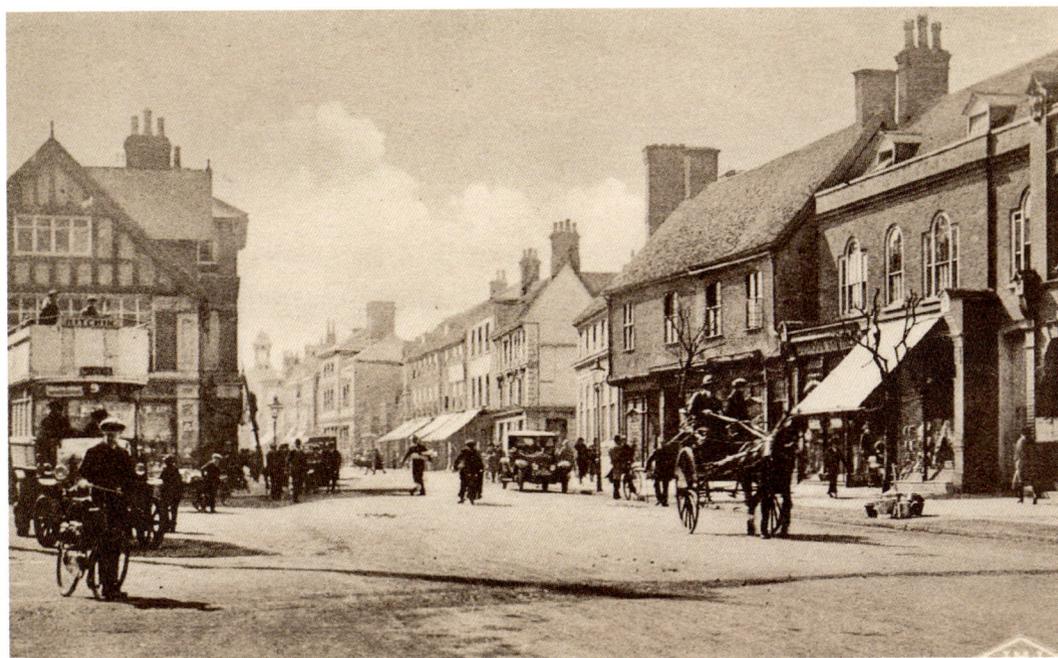

Hitchin: Bancroft

Bancroft, which runs off the north-east end of the Market Square, is 'an early ribbon development far out of the confusion of the medieval town. It is one of the best streets of Herts ...', according to Pevsner. Tomkins tells us it is 'one of the widest thoroughfares in the county. There were at one time tan-yards beside the Hiz, and the buckle-makers of Bucklersbury gave that street its name. The making-yards occupied much of the ground on both sides of Bancroft.' The *Victoria* notes, 'Hitchin is fortunate in having retained so many of its ancient houses...' Fortunately, almost all of them have survived the century of so-called 'progress' since.

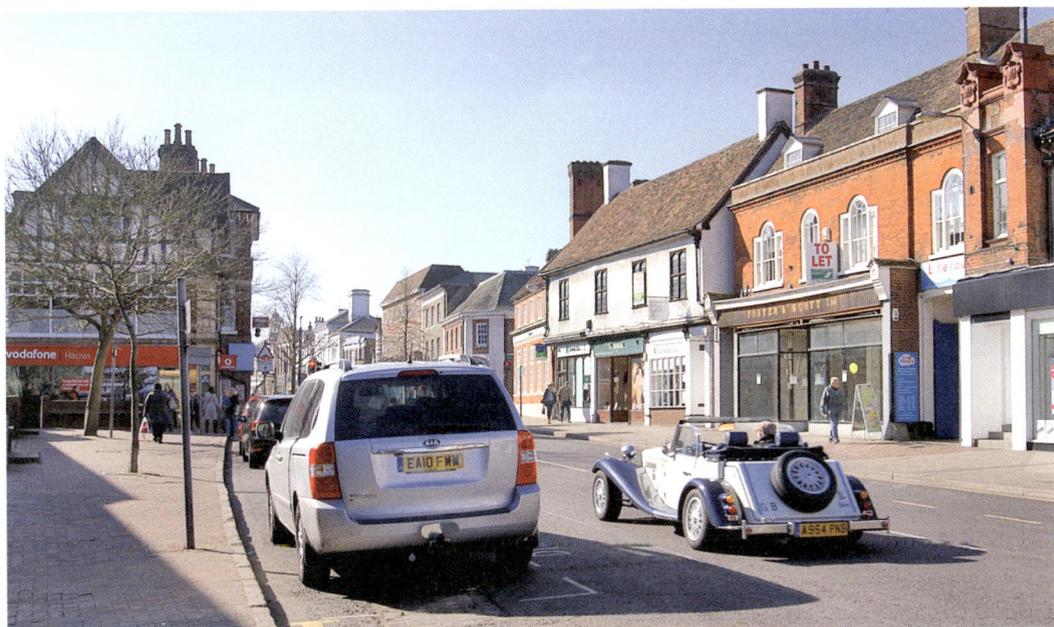

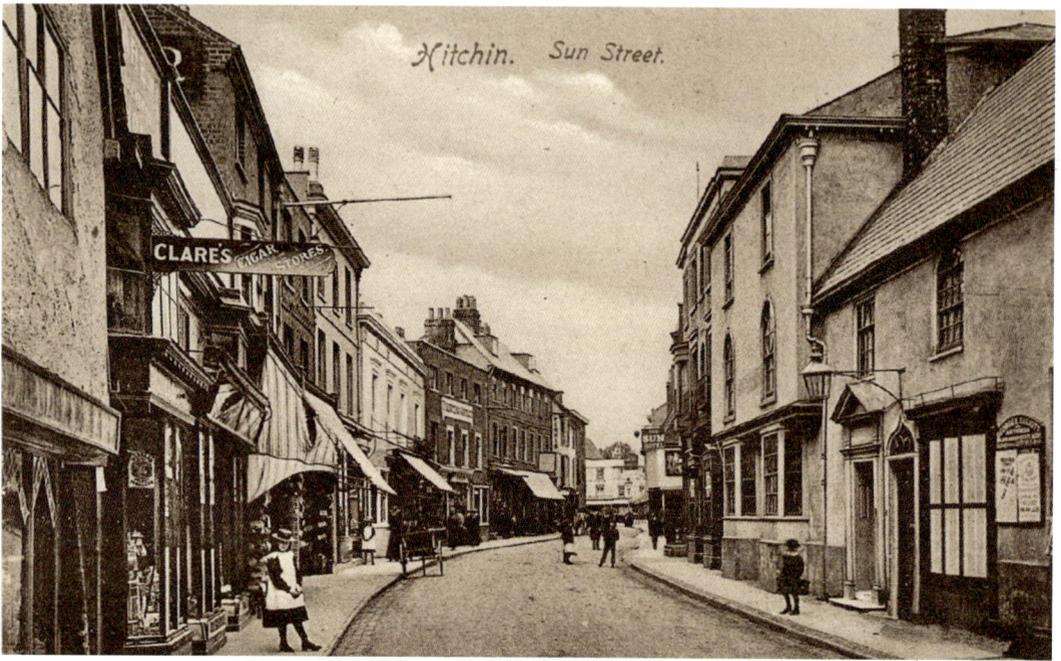

Hitchin: Sun Street

Towards the top right of these photographs, the seventeenth-century Angel Inn thrusts forward into Sun Street. The *Victoria* informs us it is 'of two stories of timber and plaster and has a tiled roof. It has remains of mediaeval work ... It was originally an L-shaped building facing on to the market-place. It may have had shops on the ground floor facing the street and a hall and small chamber over them.' We also learn that in the late sixteenth-century Sun Inn, just to the south, 'A new assembly room was built ... in 1770. At this inn, too, the courts of the manor of Portman and Foreign are still held at Michaelmas.'

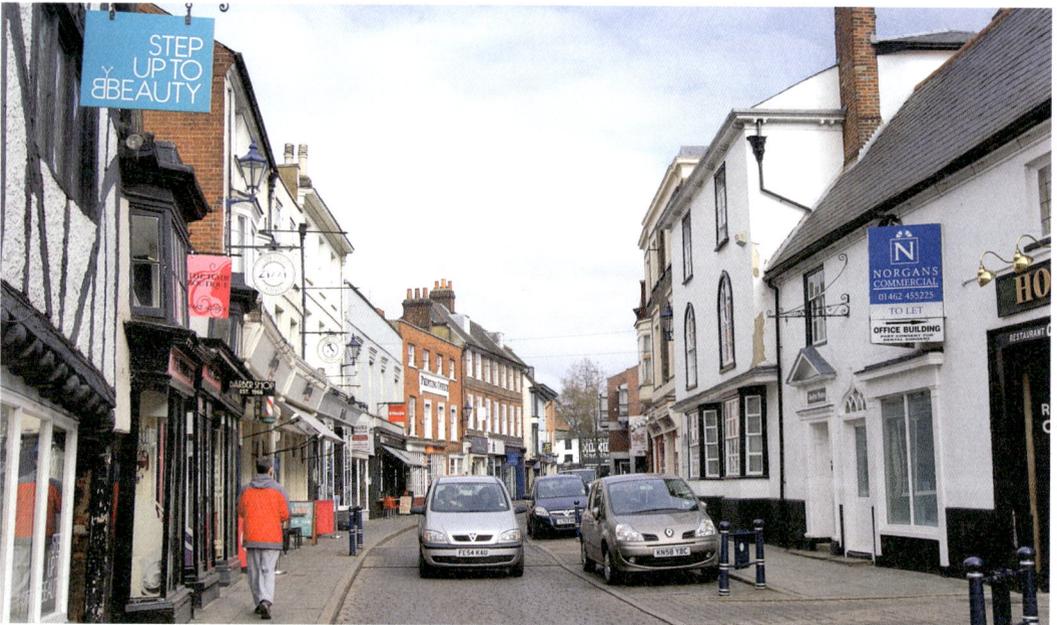

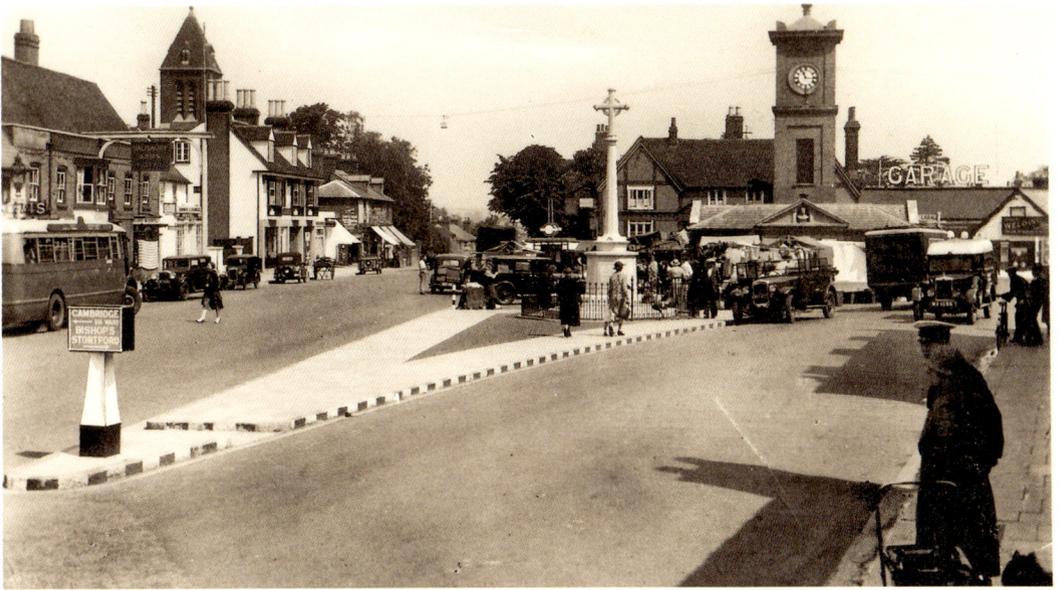

Hoddesdon: High Street

Tomkins' entry says, 'An ancient market town ... It is known, at least by name, to all readers of *The Complete Angler*.' In 1959, Pevsner detailed the many historic inns and mansions in the town. But when the second edition of his book appeared in 1977, he was scathing about the Tower Centre, which now dominated the north end of the town, calling it 'an ugly nine storey block of flats in drab grey concrete standing on stilts above a shopping precinct ... It is undoubtably the most unappealing example in the country of the 1960s craze for re-modelling town centres.' Mercifully, half of this development has been demolished, and a new Morrisons supermarket is being built on the site.

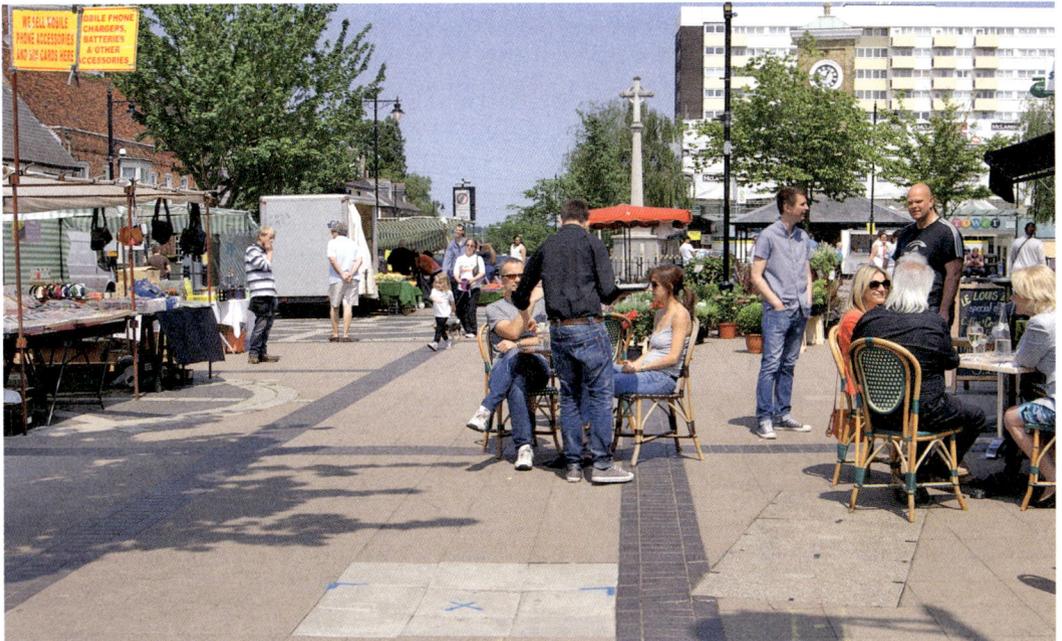

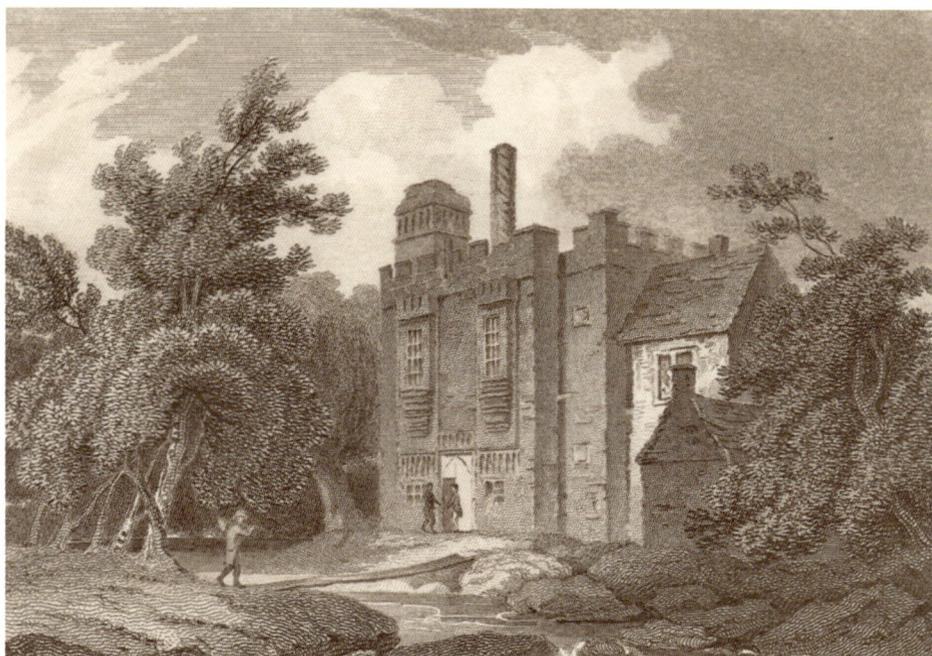

Hoddesdon: Rye House Gatehouse

'The River Lea ... fills the moat of what is left of old Rye House just a mile away – just its 16th century gatehouse with an upper room big enough to house the Great Bed of Ware, which it did house for many years,' Mee writes. This was the site of a plot to assassinate Charles II and his brother, James, returning from the Newmarket Races in 1683. Modern historians are sceptical about the seriousness of this threat, which the King cleverly used as an excuse to eliminate aristocratic opposition to a Catholic accession. In a semi-derelict state when Pevsner visited in the 1950s, the building has been restored and now forms part of the Lea Valley Park.

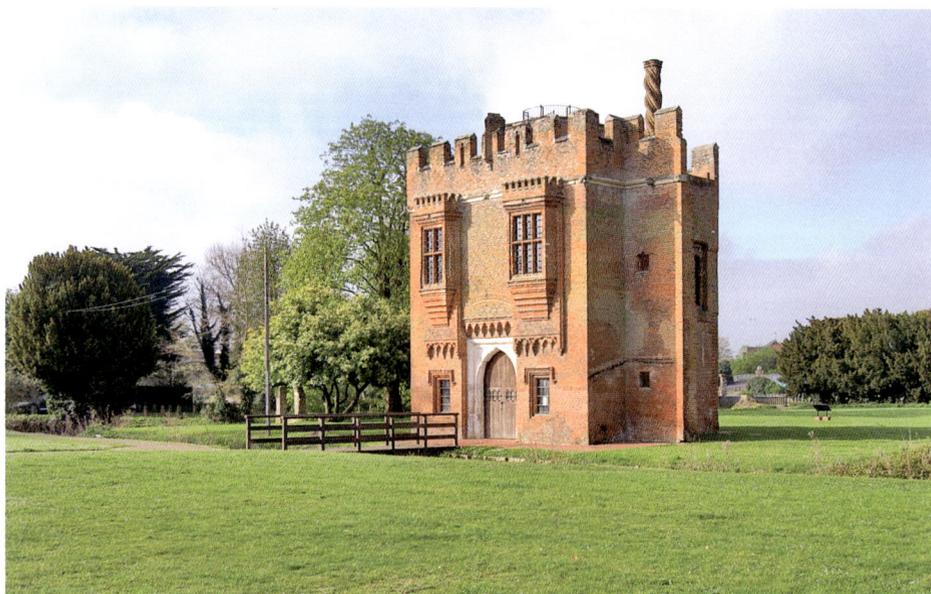

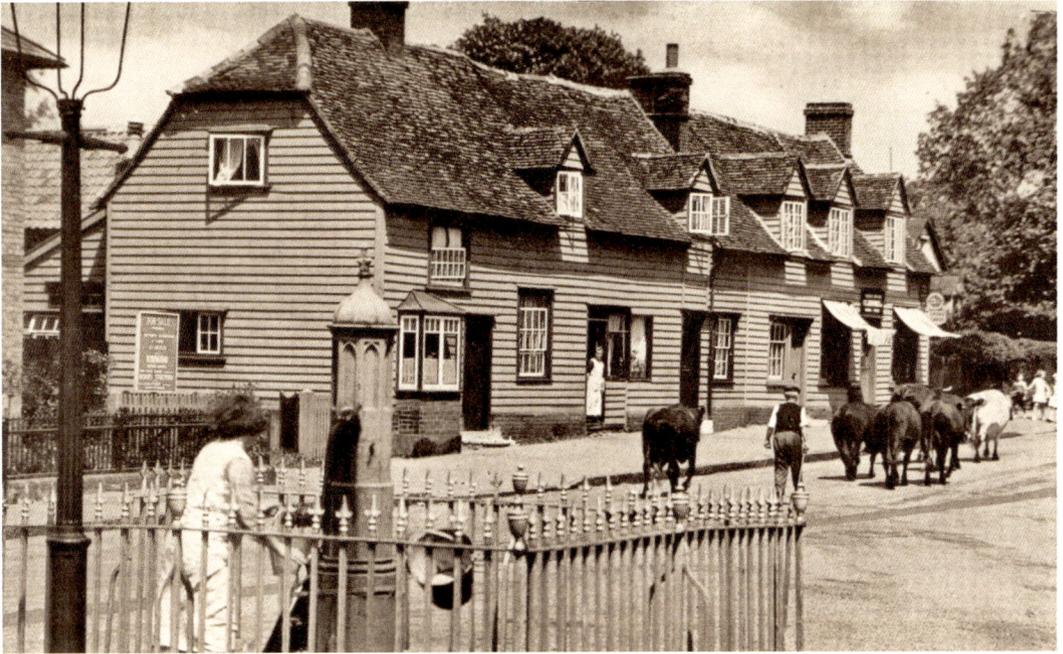

Hunsdon

'A very ancient village', the site of a former palace built by Henry VIII, Tomkins tells us, 'it is known that his children were often here, as the king had a high opinion of Hertfordshire air.' His daughter, Mary Tudor, retreated here during the political plotting that followed her father's death, before setting out to London to claim her throne. Part of the charming row of houses in the photograph dates back to 1494, and over the centuries it was extended to accommodate an inn known initially as The Angel, and later The George. During the eighteenth century it became a farm owned by the Taylor family until 1850.

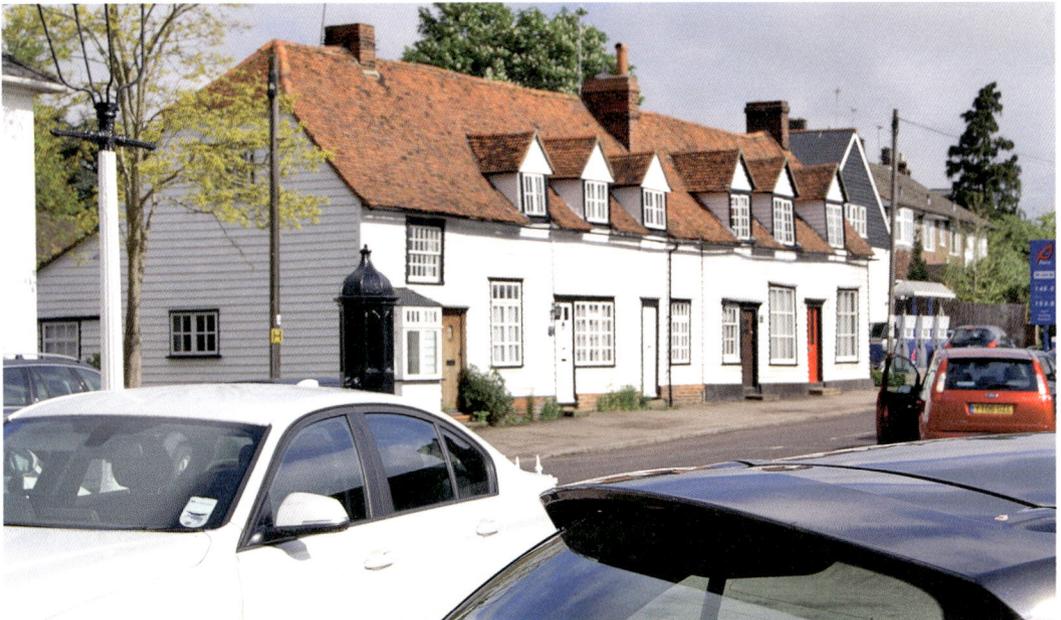

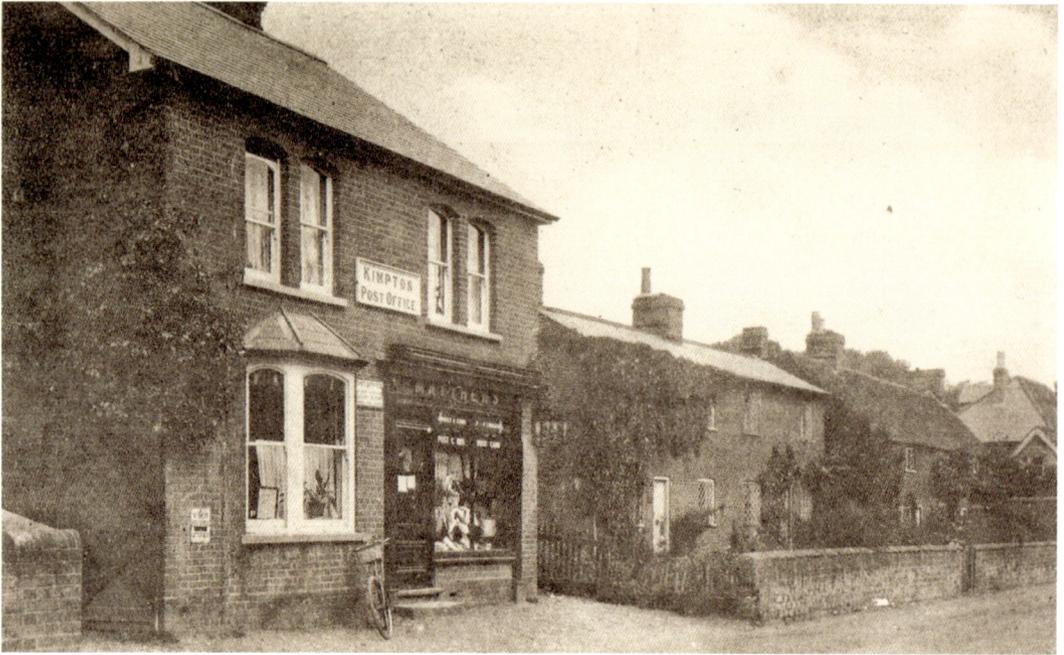

Kimpton

'The village is very ancient, and was called 'Kimeton' in Saxon days', according to Tomkins. The *Victoria* has more detailed information: 'The street has several seventeenth-century houses and cottages which retain many of their ancient features. It is about a mile long, including the hamlet of Kimpton Bottom ... The little River Mimram or Maran flows through the north-east of the parish, and adjoining it are osier beds. The soil is chalk. Nearly the whole of the parish is given up to agriculture.' In 100 years little has changed on the High Street, apart from a lot more traffic passing, and the post office having become a private residence.

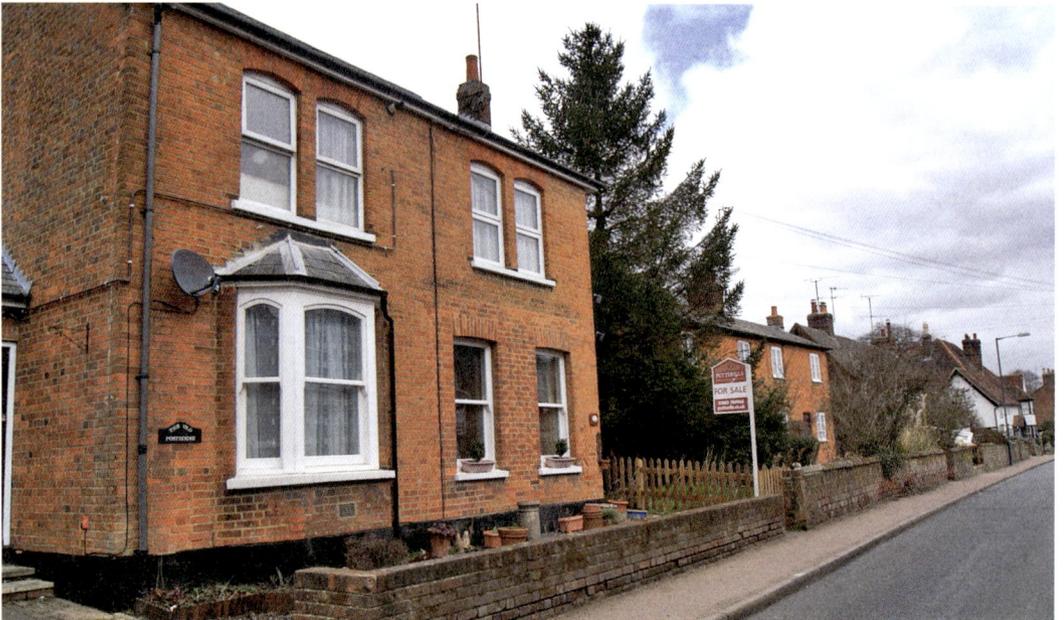

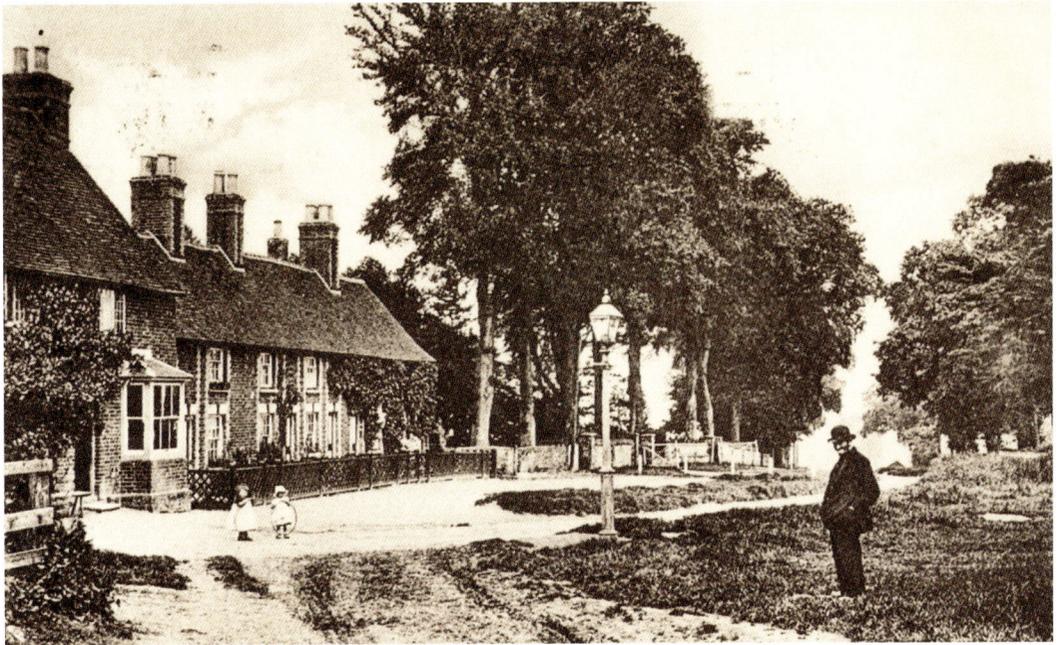

Kings Langley

Lydekker describes the village, with 1,579 inhabitants, as being 'notable as the site of the ancient Tudor Palace of Langley, and of a friary of which portions still remain. The royal palace and park date at least from 1299.' Here on the crest of Langley Hill, behind the elderly gentleman on the right of photograph, were remains of the palace where Edwards I to III and Richard II all resided. According to the *Victoria*, 'In 1347 a proclamation was made of a market to be held on Thursdays and a fair on Midsummer Day ... A market and fair had been held there before that date, but had been discontinued "by carelessness and negligence, to the king's manifest detriment".'

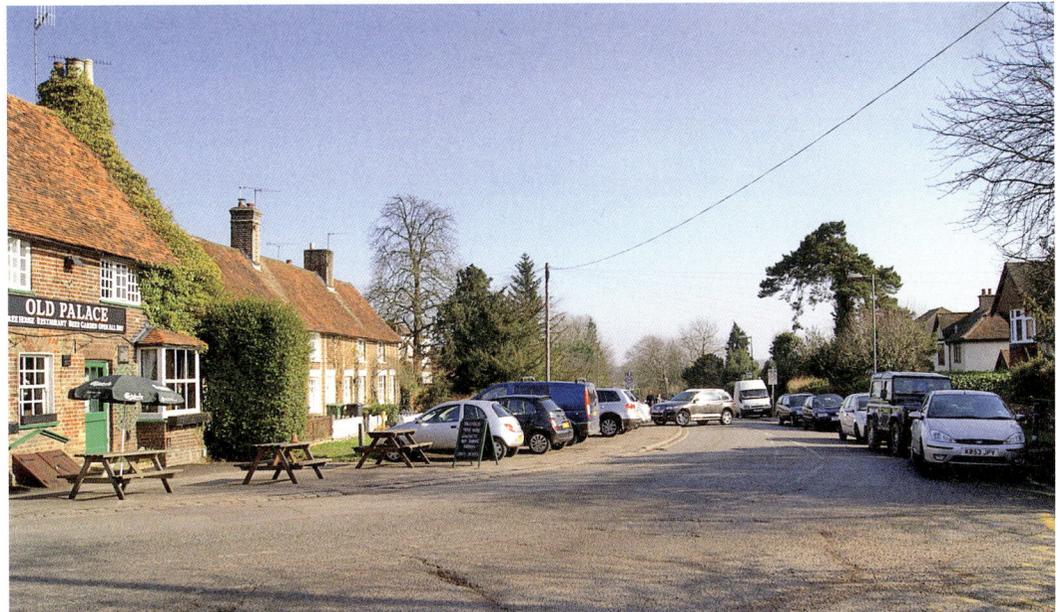

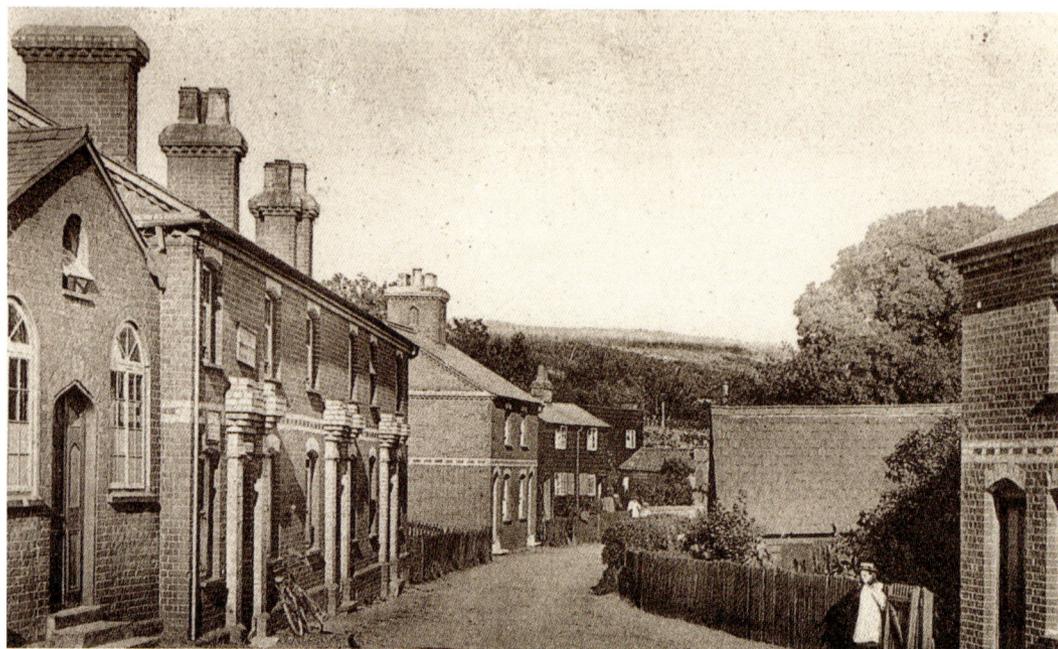

Lemsford

'It is widely known for its large mill on the river Lea,' we learn from Tomkins. The original Mill listed in Domesday collapsed in the mid-nineteenth century and was replaced by the current building in 1863, which is supposed to have inspired the popular music hall song 'Nellie Dean'. Most of the buildings on the left of this 1905 photograph, including the chapel and post office, have been demolished – making way for a larger car park for one of the two surviving village inns, The Long Arm & Short Arm, rebuilt in 1929. Immediately adjacent is Brocket Hall – 'the fine 18th century house which witnessed the death of two Prime Ministers,' according to Mee.

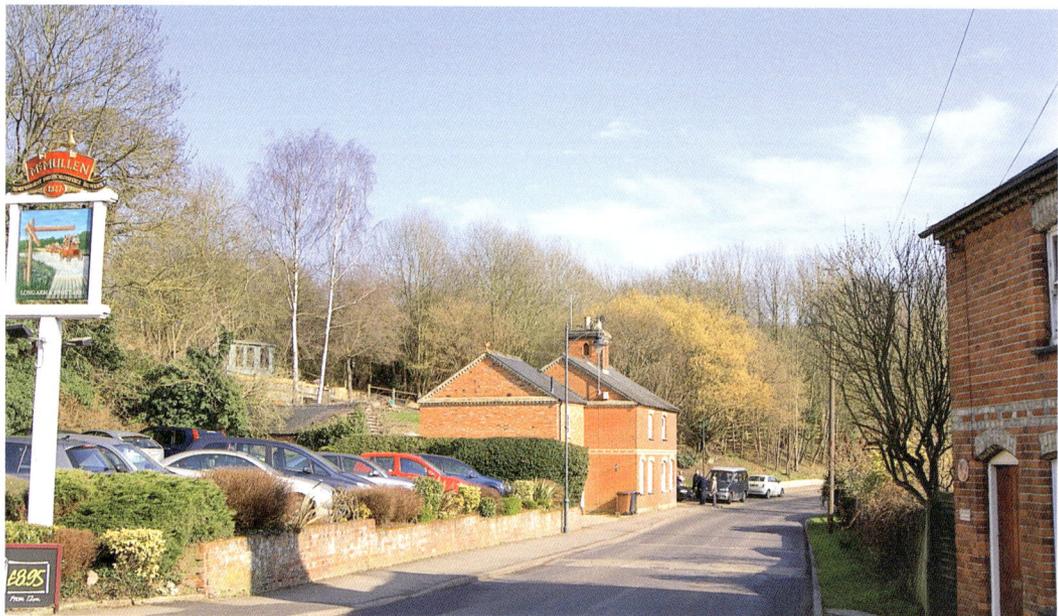

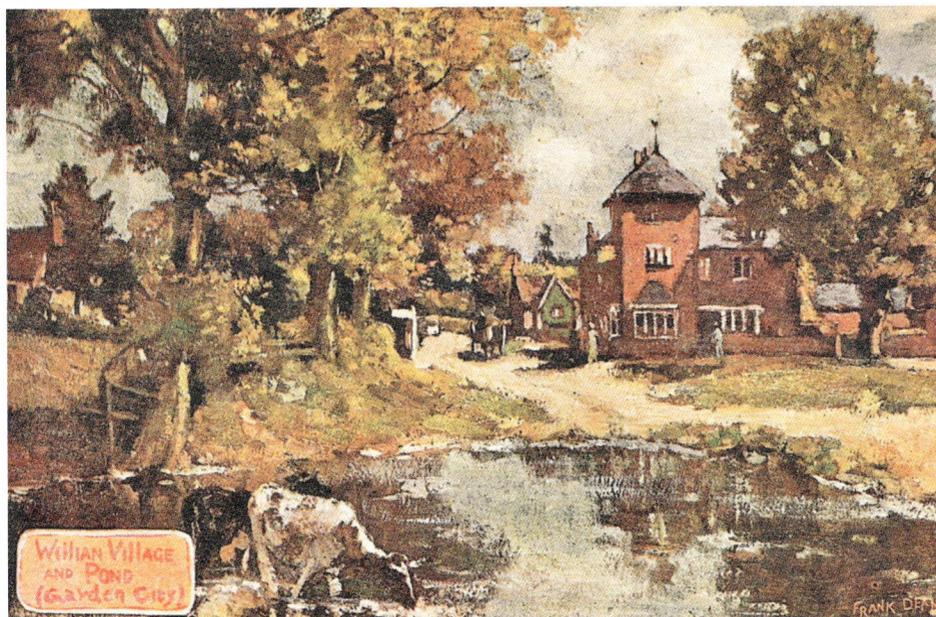

Willian Village and Pond (Garden City) — Frank Dean

Letchworth: Willian Village

One of the first areas of this new city to be developed was Willian Village, which Tomkins tells us was 'formerly Wylie ... very ancient, mention of it as a property dating from the times of the Mercian kings', Mee eulogises, 'Many who come to this homely place with its green and its ponds, its tall trees, its medieval church and its thatched vicarage 400 years old, must think it an endearing English scene, fit to be preserved forever; and so it is to be, for it stands within the green belt bought by Letchworth's Garden City.' The fact that 'early garden city' homes fetch over £600,000 in 2013 confirms the city's continuing desirability.

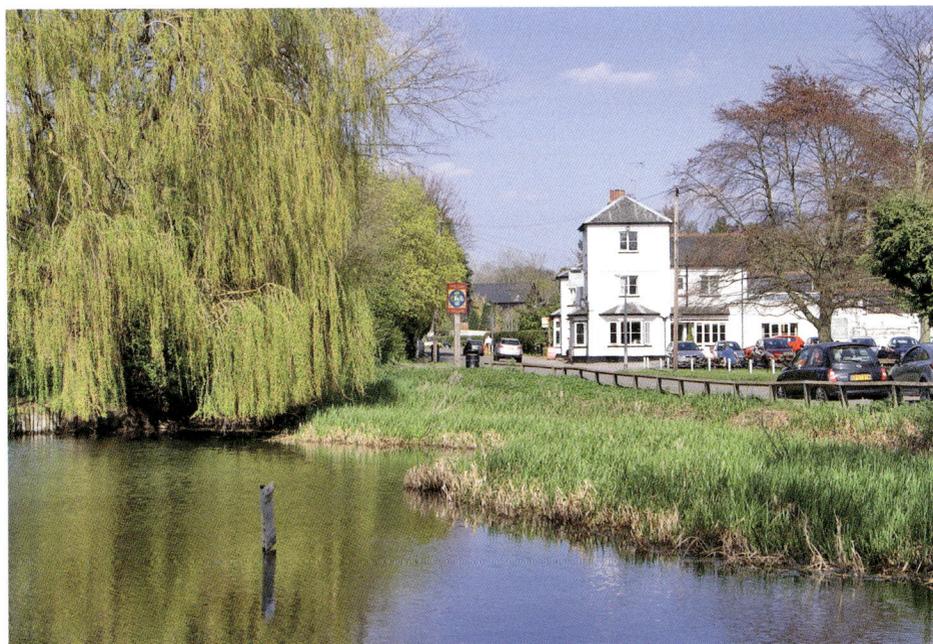

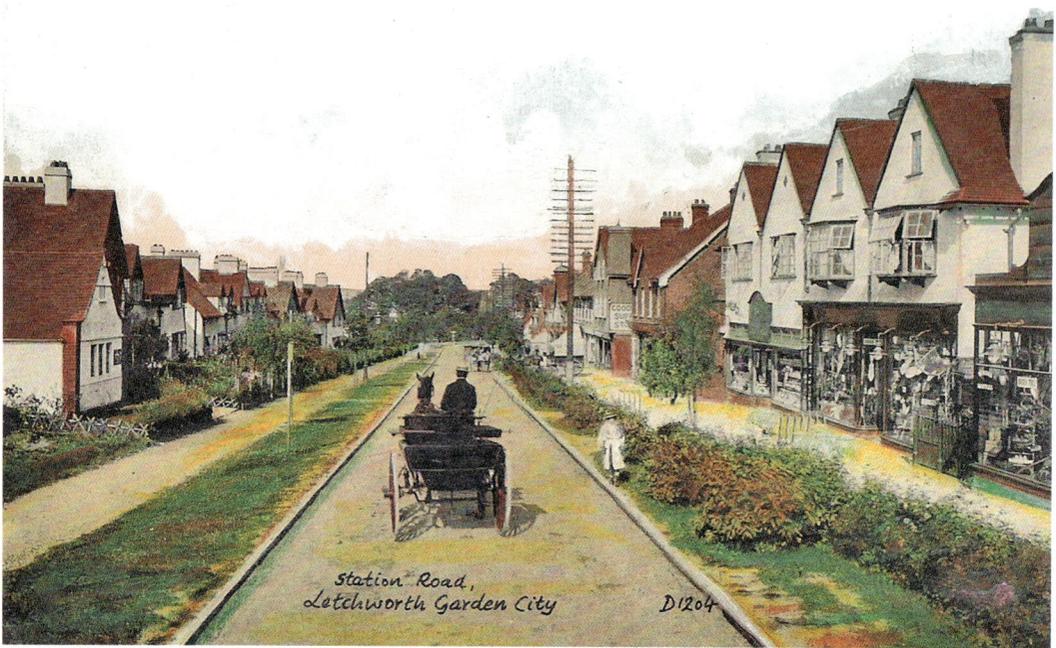

Station Road,
Letchworth Garden City
D1204

Letchworth: Station Road

With his enthusiastic lyricism, Mee asserts that Letchworth 'is the city built by dreams, the dreams of Ebenezer Howard who, while others talked of Garden Cities, went out with a spade in his hand and made one. He saw a city of the future, like a New Jerusalem in a green and pleasant land.' According to Lydekker it was 'an endeavour to aid in bringing the population back to the land.' It was certainly rare in the early twentieth century for a road adjacent to a town centre station to look this green and rural. While the inimitable motor car has banished the grass, the street scene today has not changed at all.

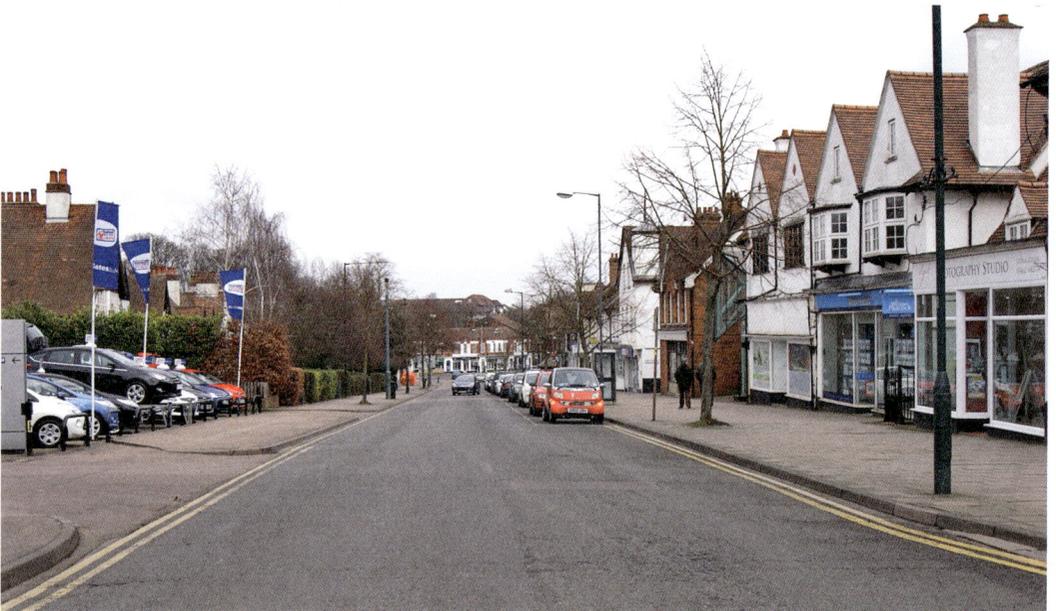

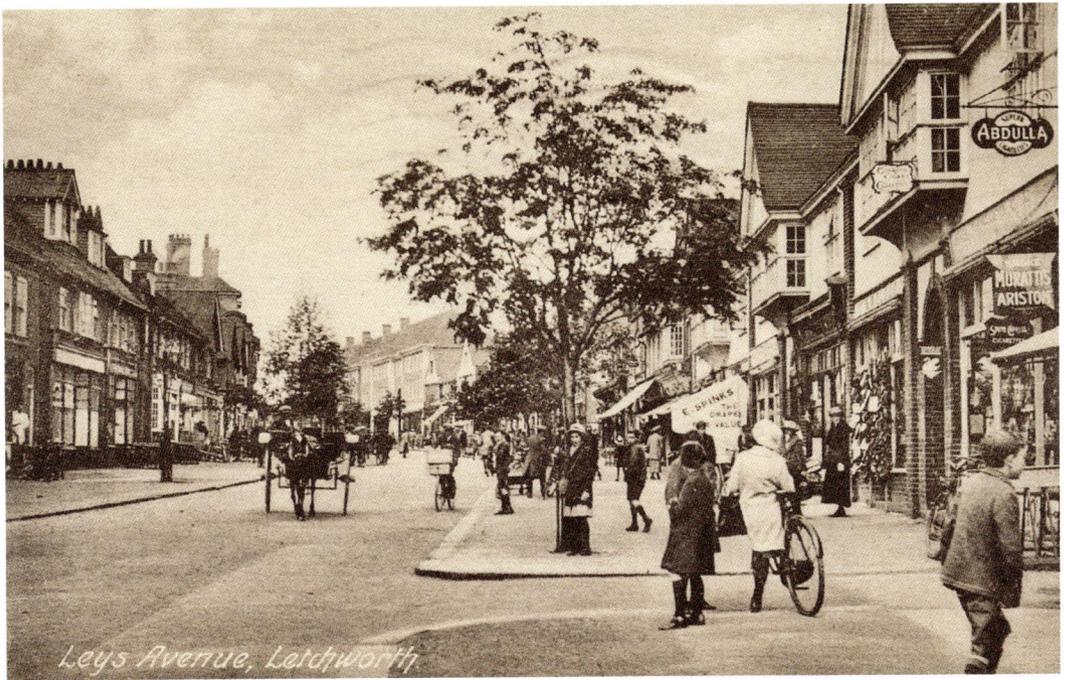

Leys Avenue, Letchworth

Letchworth: Leys Avenue

'The Garden City Pioneer Company are now the sole landowners in Letchworth parish, which is being laid out by them for residential and business purposes; it is said that over 9 miles of new roads have been made,' according to the *Victoria*. Leys Avenue's buildings have remained unchanged for a century, even if their residents have come and gone many times. Virtually no traces are left of the original village which Tomkins reports 'was once the property of Robert Gernon, a Norman warrior who fought at Hastings. There was a church at 'Leceworth' at least as early as Henry I, for during the reign of that monarch it was given ... to the monastery at St Albans.'

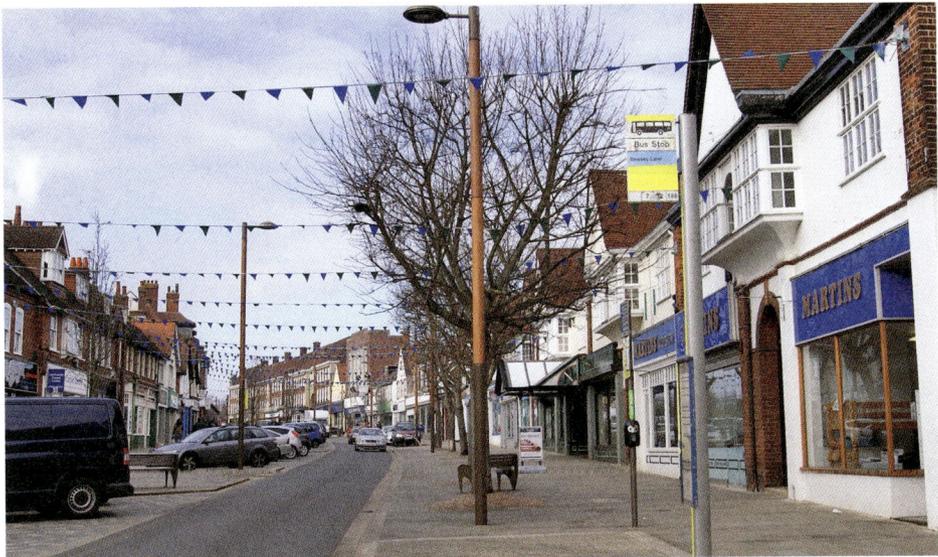

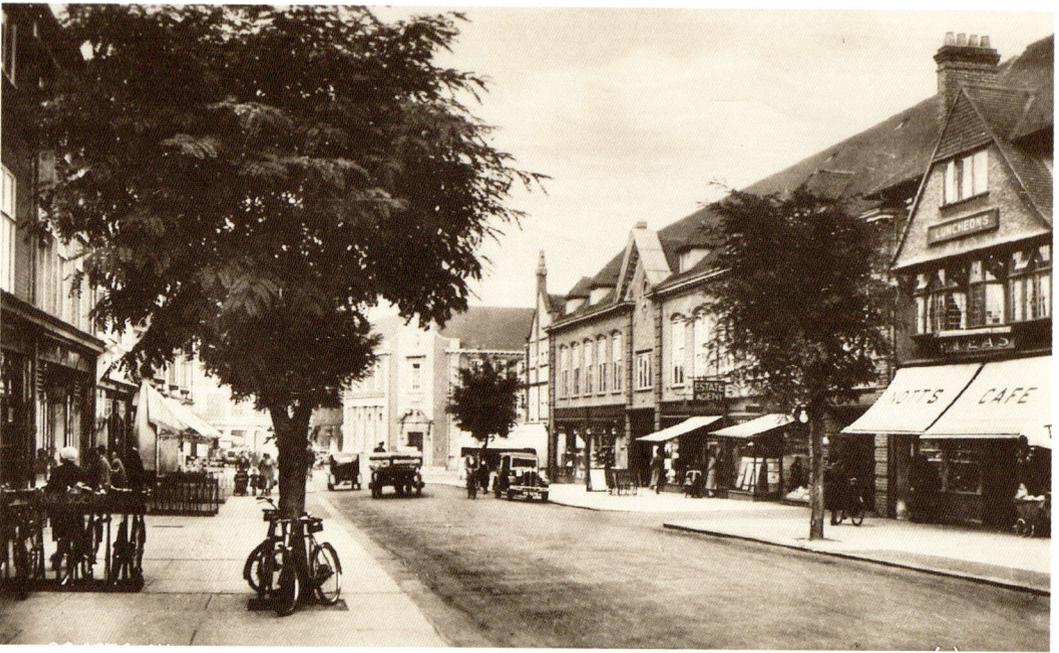

Letchworth: Eastcheap

Pevsner, ever the objective expert, is more cautious in his judgement: 'Letchworth ... as the first exploratory pioneer job, suffered from some initial faults which it has never quite overcome. The style is mostly a free and comfortable Neo-Tudor with gables. The houses are detached or in groups of four. The streets curve, apart from the main axes, existing trees are preserved, no garden walls since cut up for green – all principles adopted since for municipal estates.' Eastcheap remains a wide airy avenue for pedestrians, but is now flanked by more cars than leafy trees.

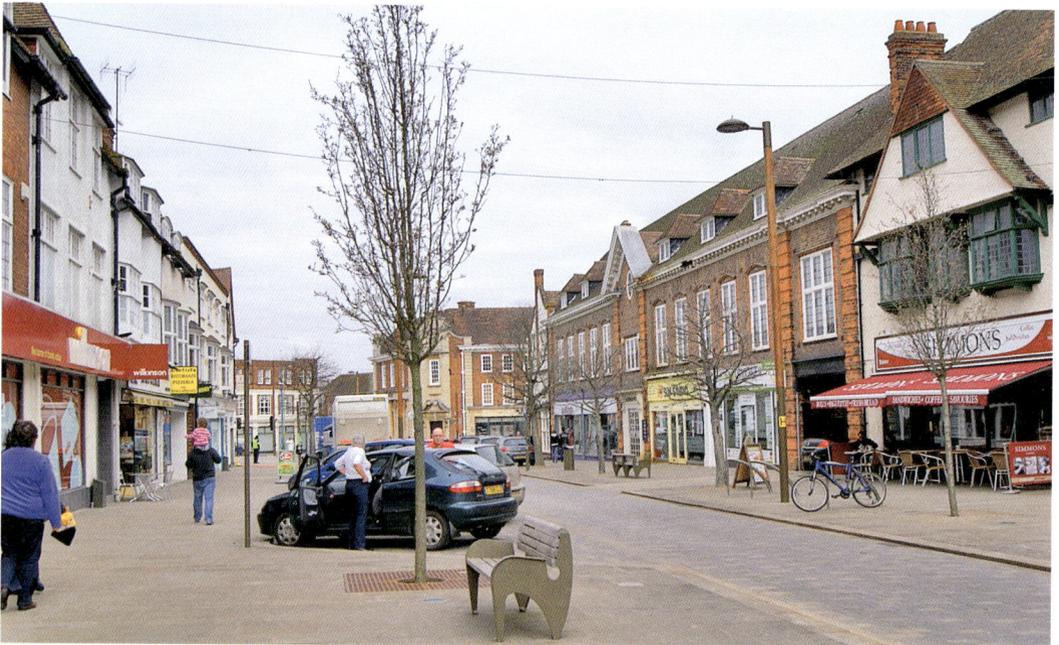

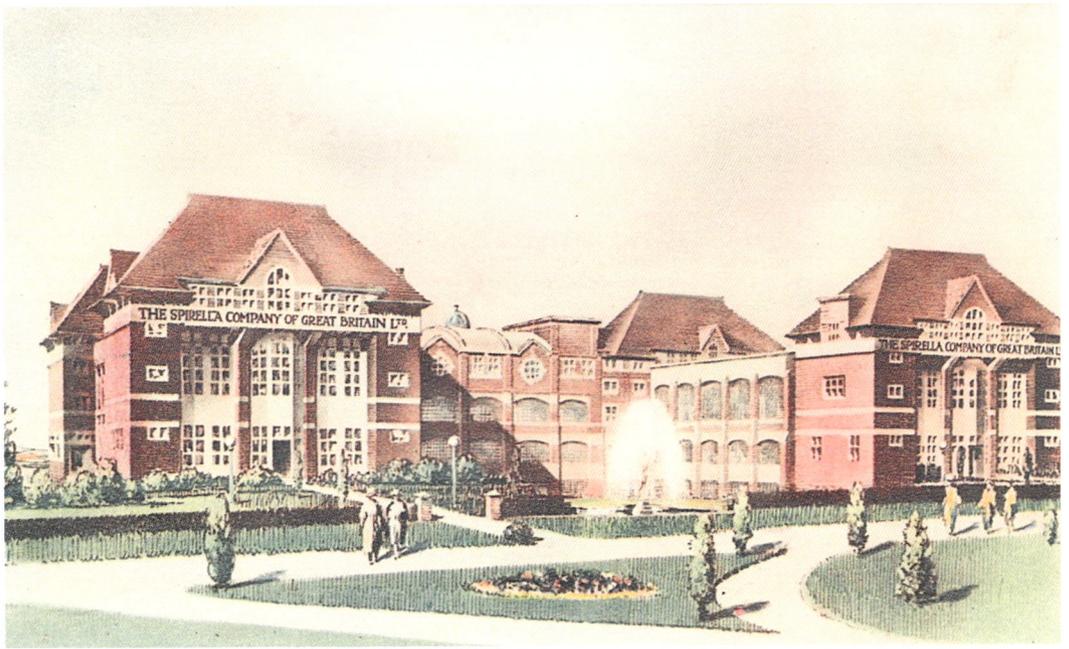

Letchworth: Spirella Building

'Planned on 1500 acres with a green belt of twice as much around it,' extols Mee, 'it is so spaced out with fine avenues, quiet walks, squares and gardens and cloisters, that 200 factories make no difference to its rural aspect.' The Spirella Building – just a short walk from the station and adjacent to the railway – still stands today as the testament to the great social philanthropists and reformers of the last century. The former corset factory was in a semi-derelict state when it was rescued by the Letchworth Garden City Corporation in the late 1990s, to be transformed into a new business centre for over twenty companies employing almost 500 people.

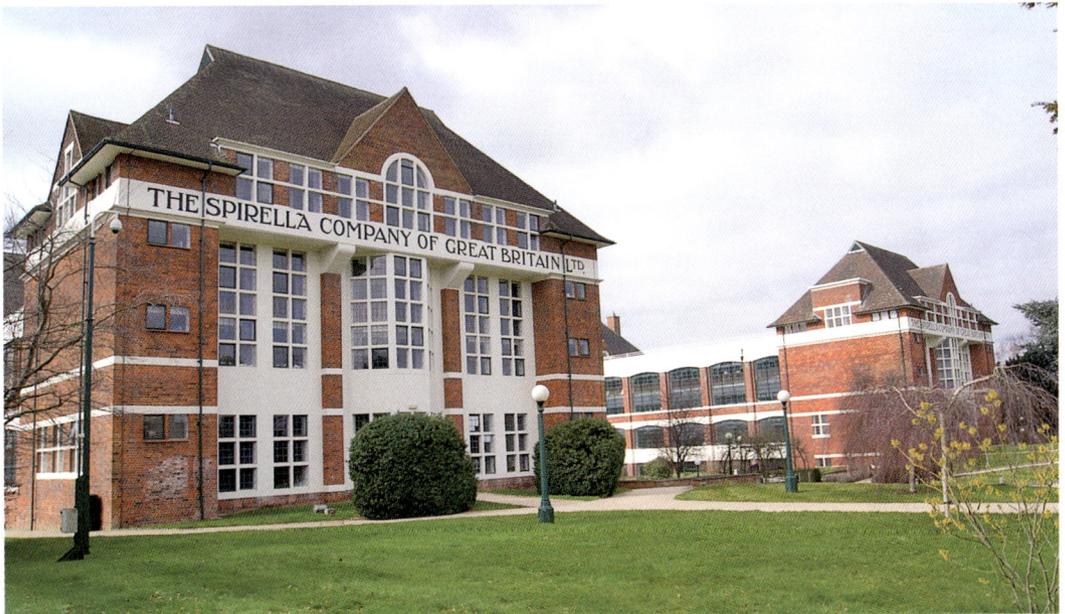

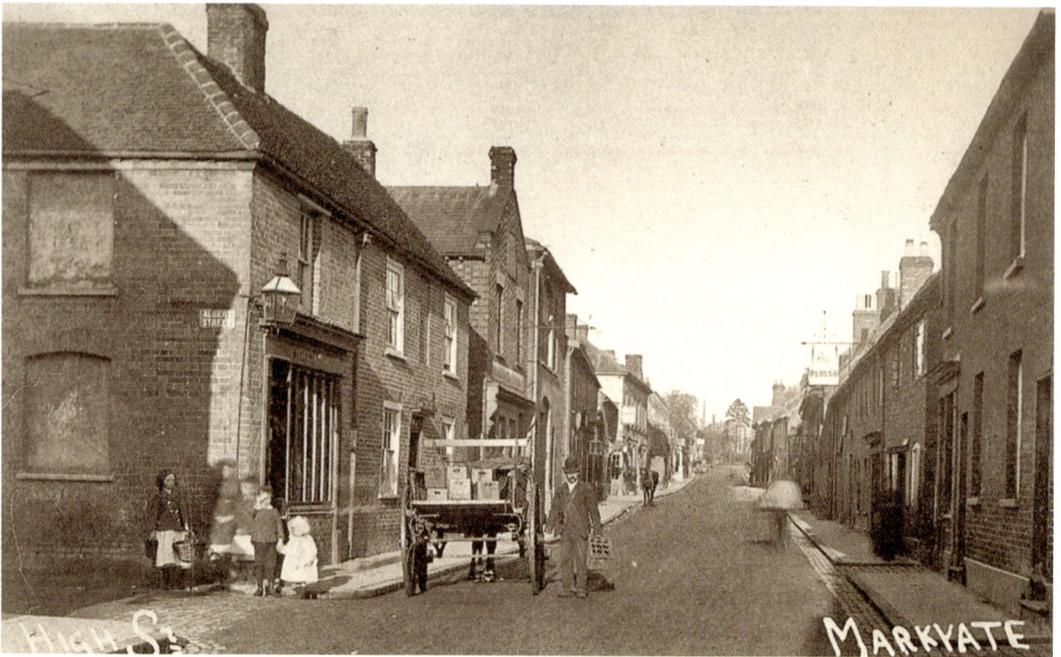

Markyate

'The River Ver rises in the parish and runs near the Watling Street. The church stands in the park of Markyate Cell at one end of the village, which consists of long rows of small houses built close to the Watling Street on either side,' the *Victoria* informs us. And little has changed in a century, except thankfully there is a bypass which takes the main traffic on the A5 east of the village. In its eighteenth-century heyday as a coaching town, over sixty coaches passed through here daily. According to Tomkins, 'Cowper the poet was at school in the village, at the house of Dr Pitman.'

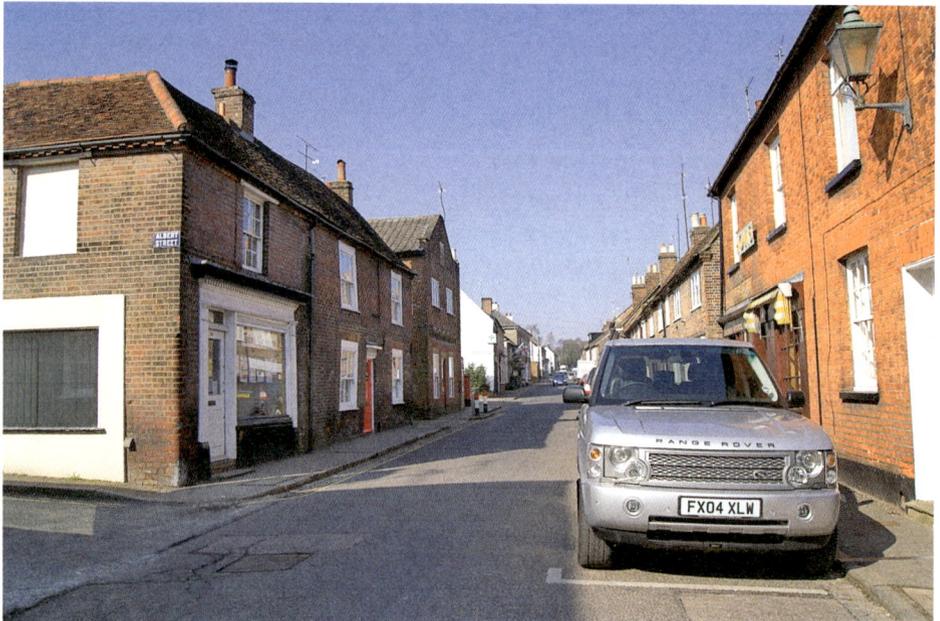

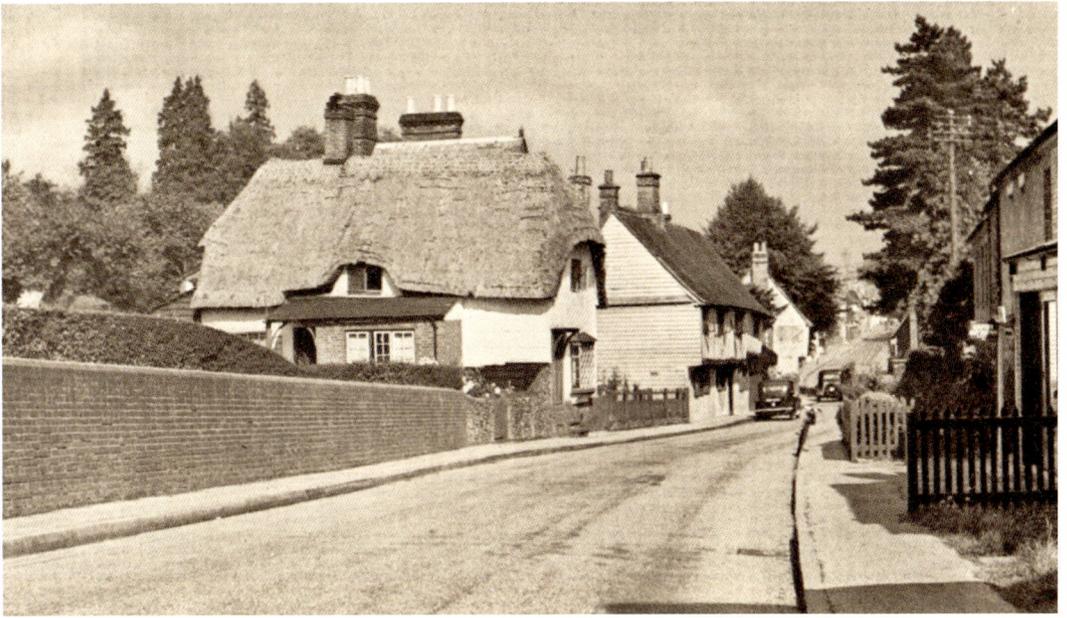

Much Hadham

Pevsner is effusive: 'Of its kind Much Hadham is visually probably the most successful village in the County. Its kind is that of the wealthy, in a way almost urban, village with big Georgian houses in contrast with the more varied 16th and 17th century cottages … The main street is a delight from beginning to end.' Mee recounts the history: 'the country home of the Bishops of London for 800 years and here began our Tudor dynasty, for Henry V's widow (Shakespeare's Katherine) gave birth in this farmhouse to Edward Tudor, whose son Harry won the throne on Bosworth Field.' Located on Watling Street, some sixty coaches per day thundered along this High Street in the eighteenth century.

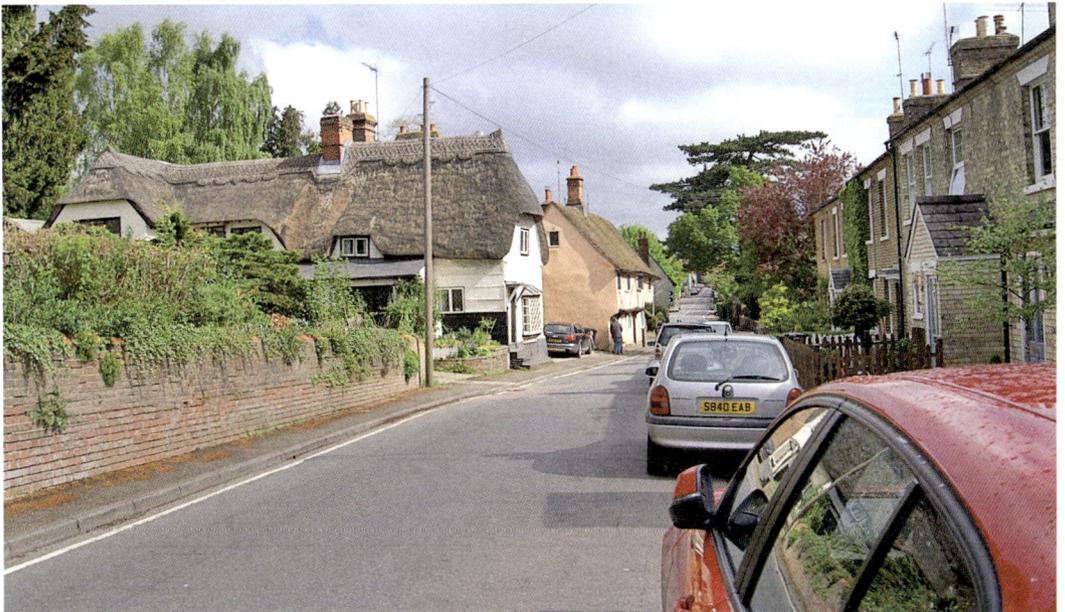

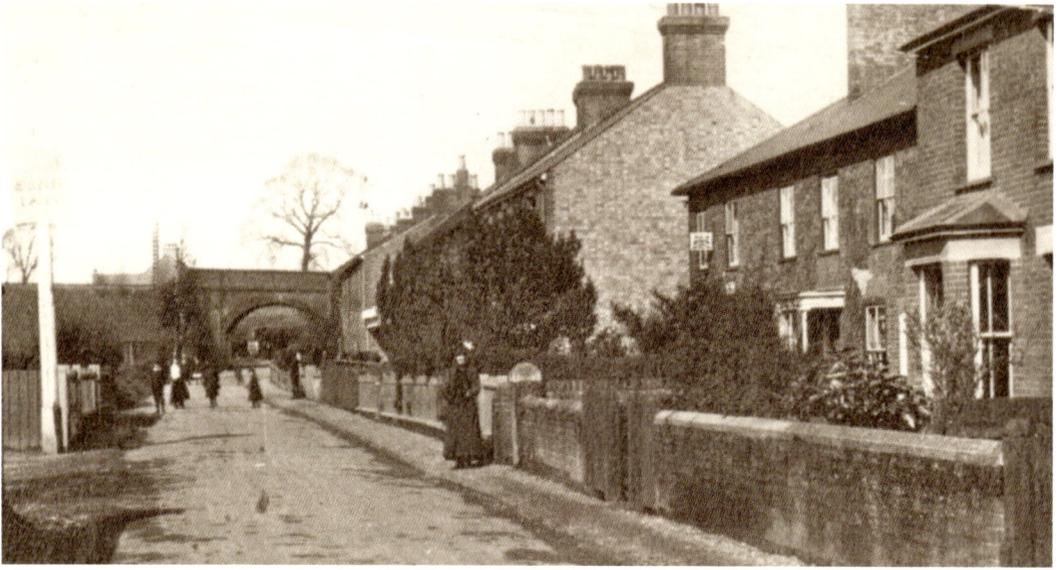

Park Street

Described by Tomkins as 'a large hamlet', when driving quickly today along the A5183, formerly Watling Street, if you blink you could miss it. However, it is of very ancient origins, having been a Belgic settlement before the Romans built tile kilns there. The Saxon village of Parkye included a pilgrim's rest on the route to the shrine of St Alban. The *Victoria* reports, 'Abbot John de la Moote rebuilt the manor-house of Parkbury about the year 1400. There are two water-mills in St Stephen's parish that can be traced back to the early part of the twelfth century, when they were called 'le Parkemyll' and 'le Moremyll'.' The former still survives in the centre of the village.

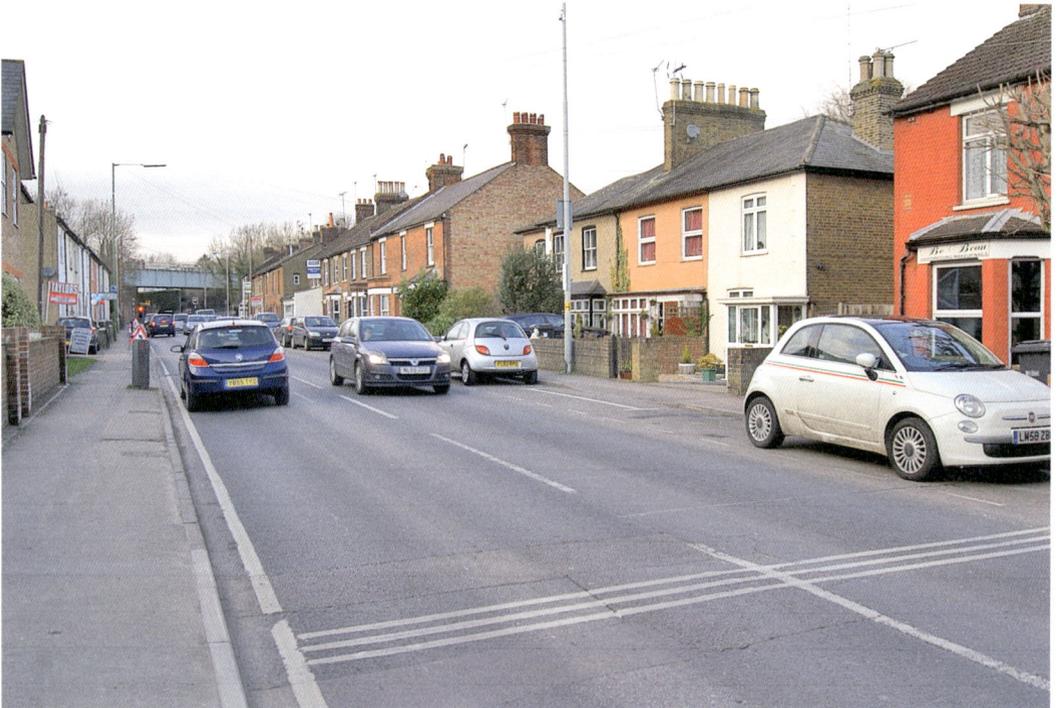

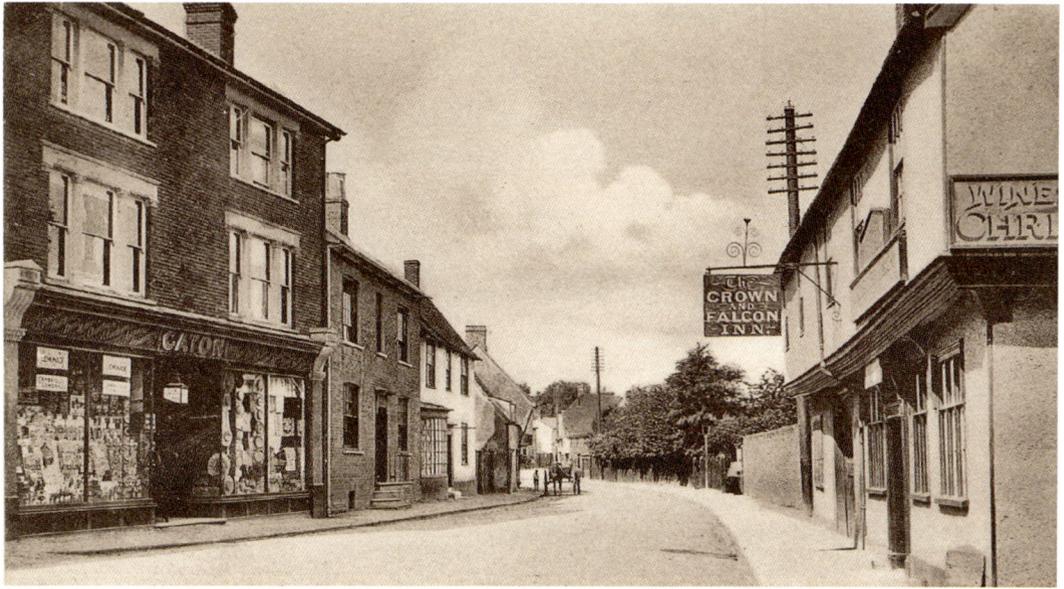

Puckeridge

'Visited by Pepys on more than one occasion,' according to Tomkins, 'the village lies partly in Standon and partly in Braughing parish. The nearest church is at Standon ... but divine service is conducted in the church schoolroom.' The *Victoria* states that: 'A grant of market and fair at Puckeridge in 1314 witnesses to the growing importance of that hamlet. Consequent on the numerous travellers along the road there were many inns in the village.' Mee adds, 'The wide timbered gateway and the old doors of the Crown & Falcon first opened to the traveler 400 years ago, while Henry VIII was disputing with Rome.' That pub is one of the only two inns remaining today.

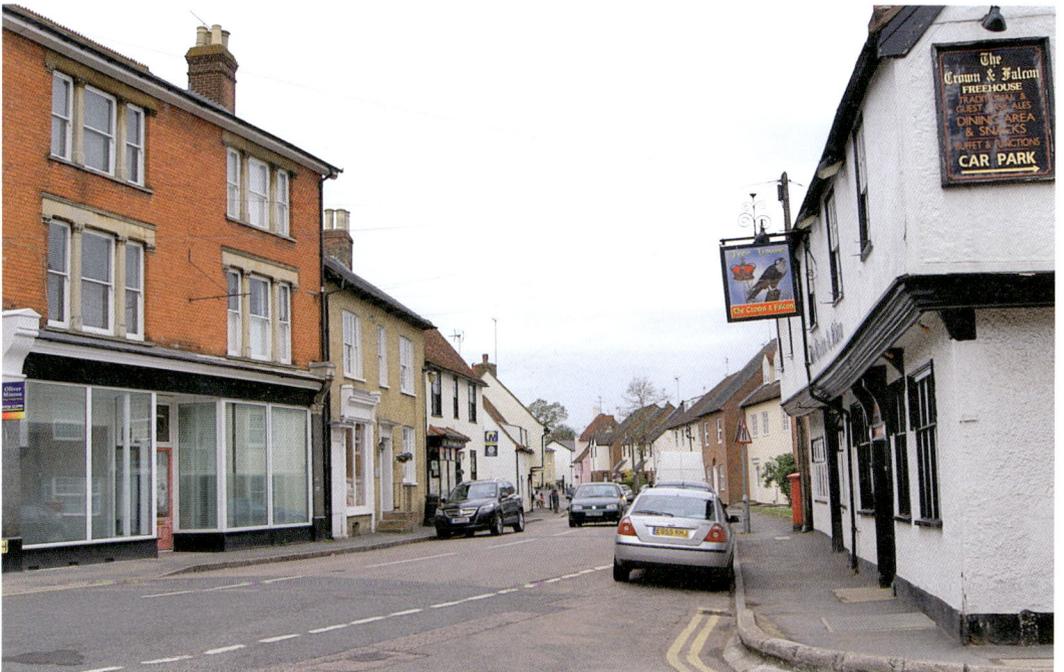

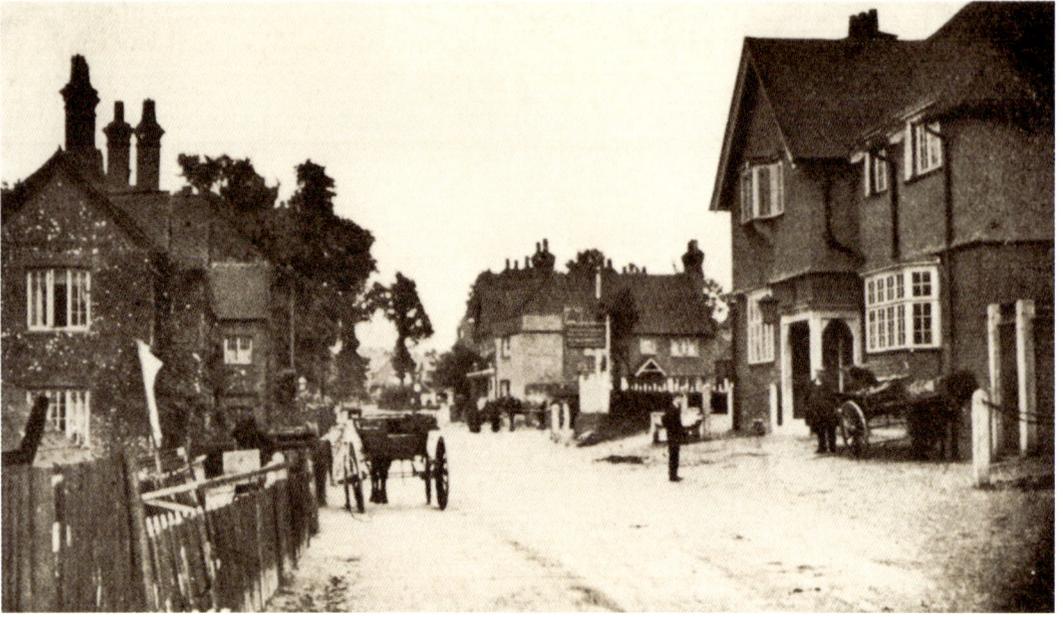

Radlett

'A station at Radlett on the main line of the Midland Railway was opened for traffic on 1 October, 1868. The improved train service and the recent development of a part of the Kendals and Aldenham Lodge Estates near to the station have brought an increasing suburban population into this district. Other than this the population consists largely of gentlemen engaged in commerce in London who have small estates here, and of farmers and agricultural labourers,' the *Victoria* reports. The village has remained a much sought after commuter-belt location to this day, but with a significant increase in traffic on the old Roman road since the original photograph was taken.

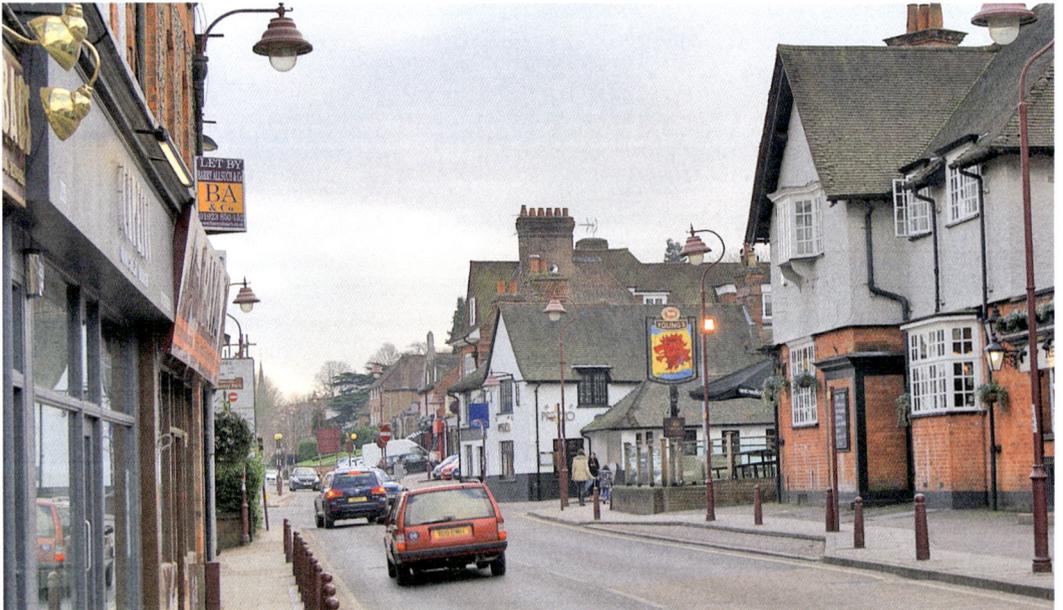

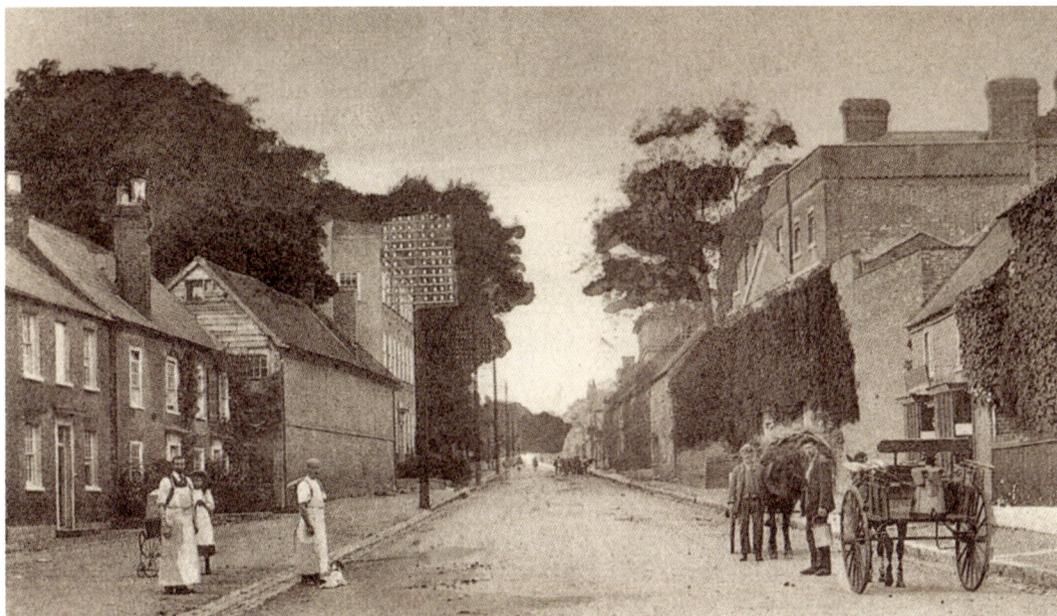

Redbourn

'The long straight village High Street, which slopes upwards towards the north, is part of the Watling Street,' the *Victoria* tells us, singling out The Priory, dominating the right side of the old photograph, as being one of the two most important buildings and 'the residence of Mr D. MacGregor.' Half a century later, Pevsner described this grand residence as 'a completely urban 18th century house which might as well stand in Grosvenor Square'. Sadly that didn't save it from the curse of redevelopment, and it has been replaced by a complete cul-de-sac of homes. However, the elegant sixteenth-century house opposite has been spared, along with most of the other more humble dwellings.

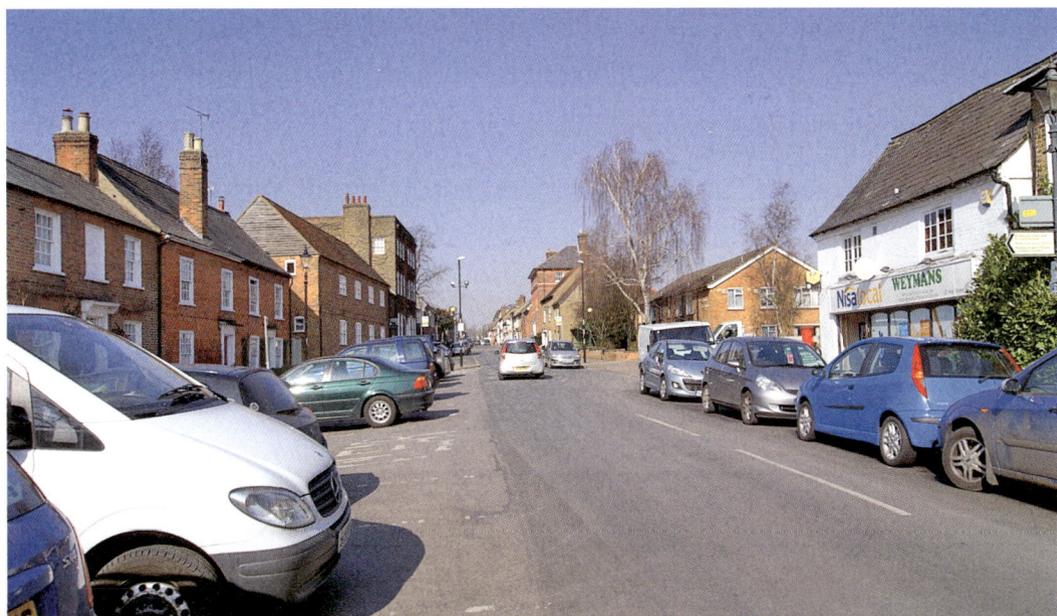

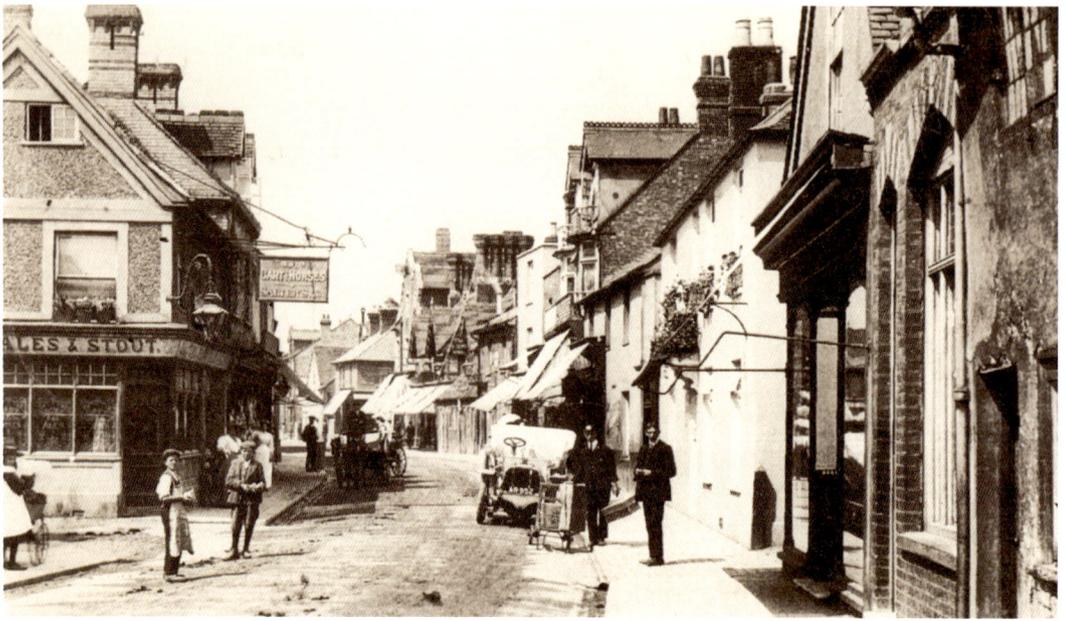

Rickmansworth

Tomkins says, 'the rivers Colne, Chess, and Gade unite here, close to the Grand Junction Canal; and it is easy to understand why the place was formerly called "Rykemereswearth", i.e., the rich moor-meadow.' Now that the High Street has been cut off by a racetrack of dual carriageways and an intractable one-way system, it is hard to imagine it hosting an annual 'statty' fair for hiring agricultural workers. The *Victoria* disapprovingly informs us this was discontinued in 1882 because 'the greater number of the labourers who resorted thither had no intention of leaving the service they were then in, and the fair simply afforded the farm labourers a time-honoured excuse for spending their harvest-money in beer.'

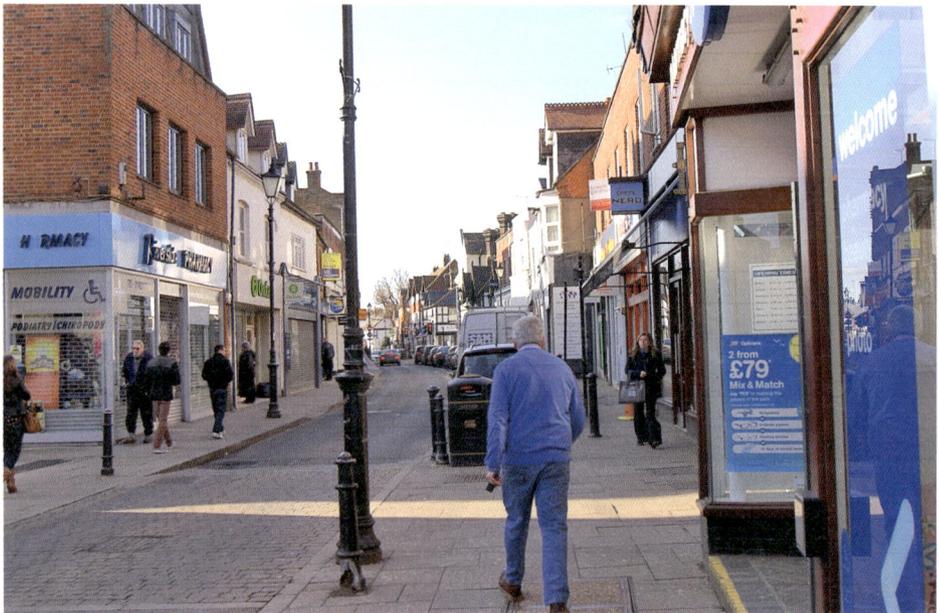

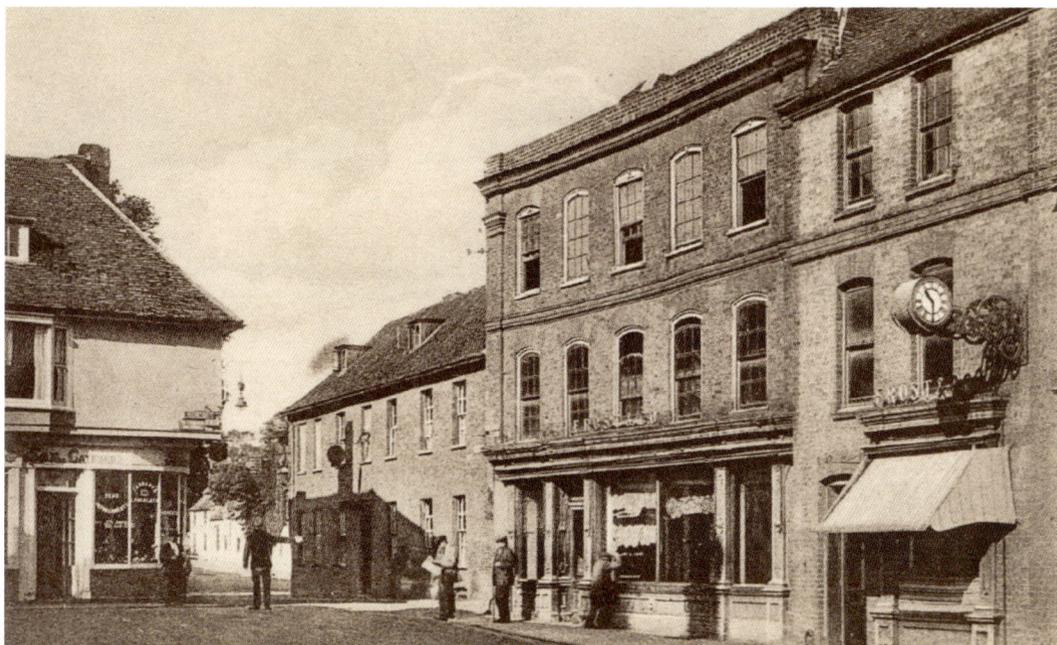

Royston: The Cross

This ancient market town, at the junction of the Icknield Way and Ermine Street, was half in Cambridgeshire and half in Hertfordshire until 1897. 'It is supposed to owe its name to a Dame Roesia who placed a cross here on the highway,' Tomkins says. A large boulder of red sandstone, said to be the base of that cross, is located just to the left of the modern photograph, which bears witness to the destruction of the historic townhouses which stood on that site. The *Victoria* tells us, 'The great corn market ... is frequently noticed in the writings of seventeenth-century travellers, one of whom describes Royston as a "dry town good for the utterance of cattell, barley and malt".'

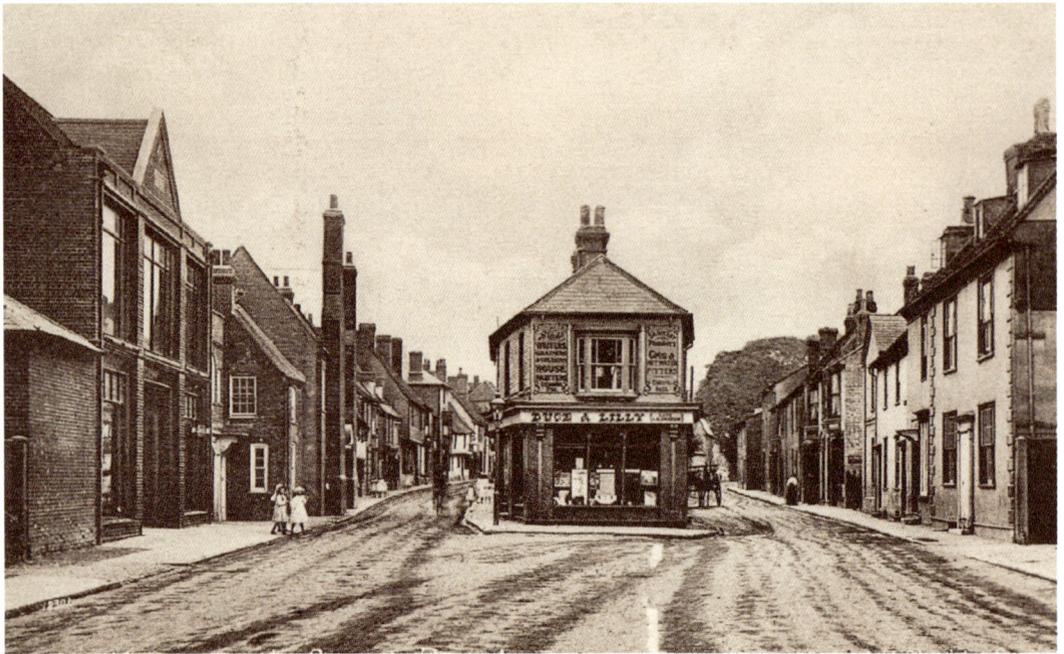

Royston: Kneesworth Street

According to the *Victoria*, 'Back Street and Kneesworth Street are still divided by 'Middle Row'. The whole of this neighbourhood is associated with the house and lodgings occupied by James I and Charles I and their court. A building in Kneesworth Street is all that remains of the eastern part of the 'King's Lodgings', the rest having been demolished probably early in the 18th century ... The front is on the east side facing the garden, the back facing the street.' This is the red-brick house with two tall chimneys on the left of both photographs. Although Duce & Lilly's sanitary ware emporium is gone, the rest of medieval Middle Row behind has survived.

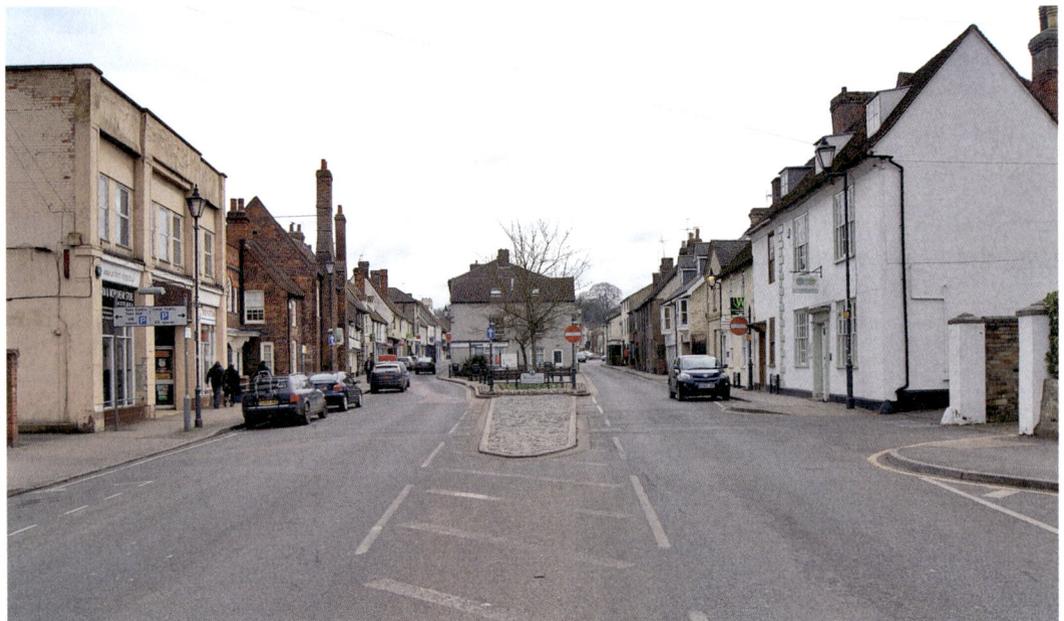

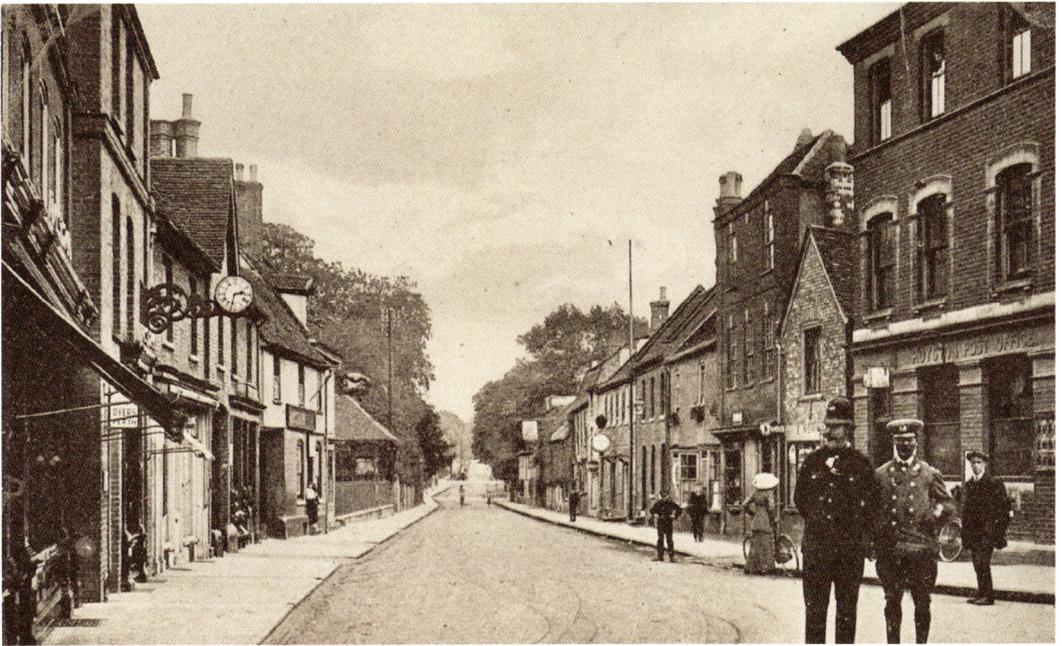

Royston: Melbourn Street

The policeman and chauffeur loitering in the road in the Edwardian photograph would today be mown down by traffic in seconds. Through the archway on the left side of the street is the famous Royston Cave, which the *Victoria* describes as 'a large dome-shaped hole, about 28 feet deep and 17 feet in diameter at the bottom, cut out of the solid chalk ... The walls of the cave are rudely sculptured with figures in low relief, among which are figures of St Christopher, St Katherine, the Cross of St Helena, the Holy Family, Conversion of St Paul, and many others ... The figures were probably carved in the 13th or 14th century.'

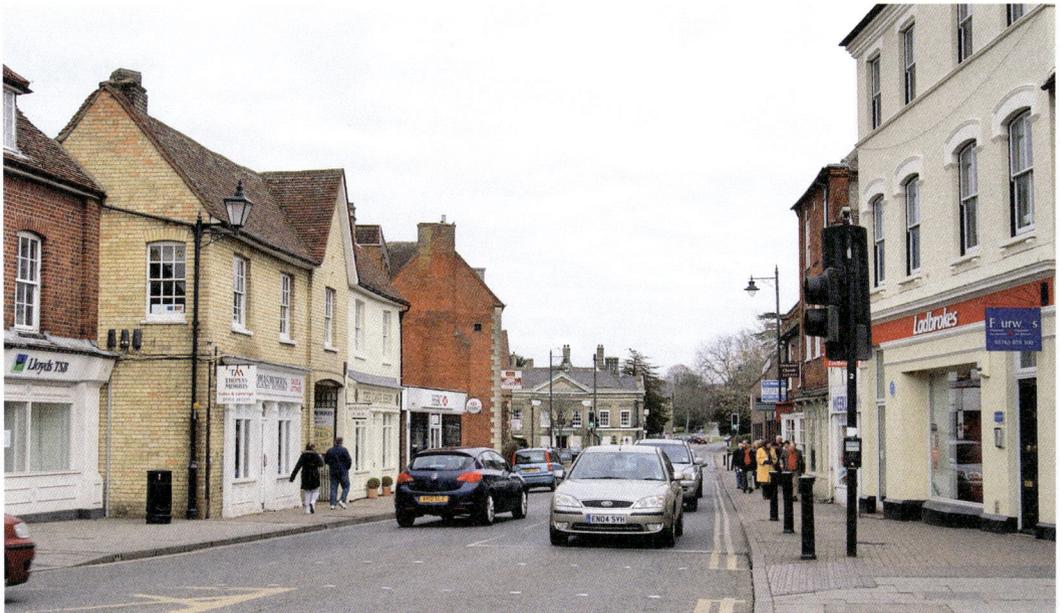

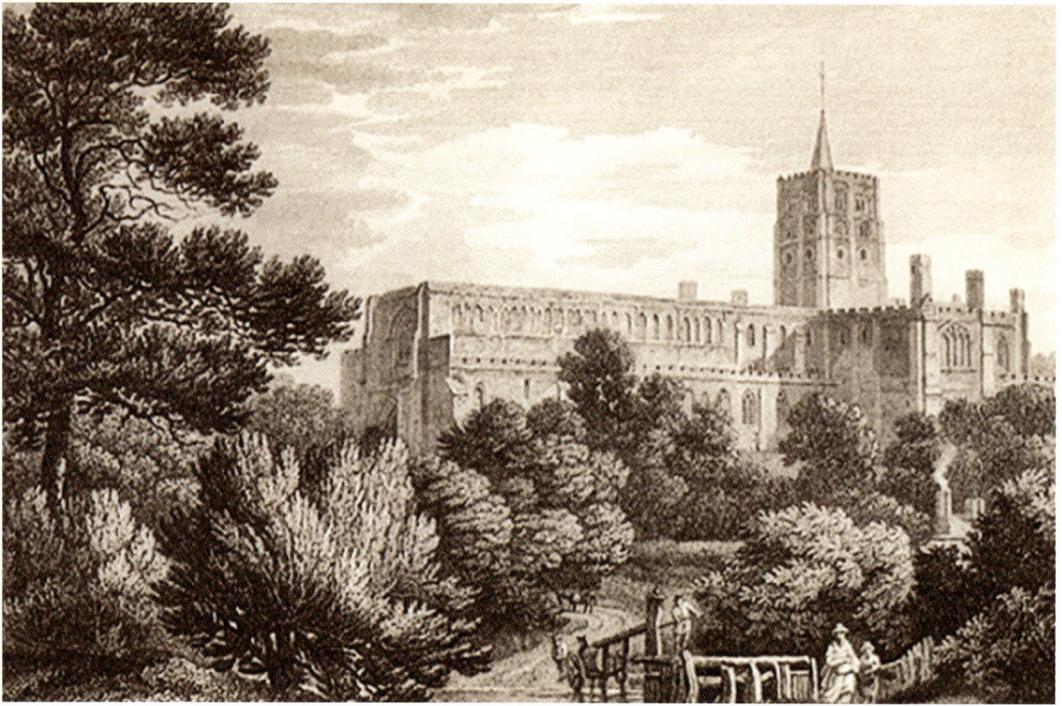

St Albans: The Abbey

Pevsner observes, 'As one approaches St Albans, one's first sight from miles away is a long ship-like nave and stumpy tower on a hill. It is a typically English sight.' Mee enthuses, 'It is in towns like this that the history of the world is made; there is no more thrilling town within an hour of London unless it is Windsor.' Lydekker summarises the facts: 'It is the direct modern successor of the Roman city of Verulamium ... and itself dates from Saxon times, its ancient monastery having been founded by the Mercian king Offa II in 793, in memory of Alban, the first English Christian martyr.' In 1553 the abbey was sold to the town as its parish church.

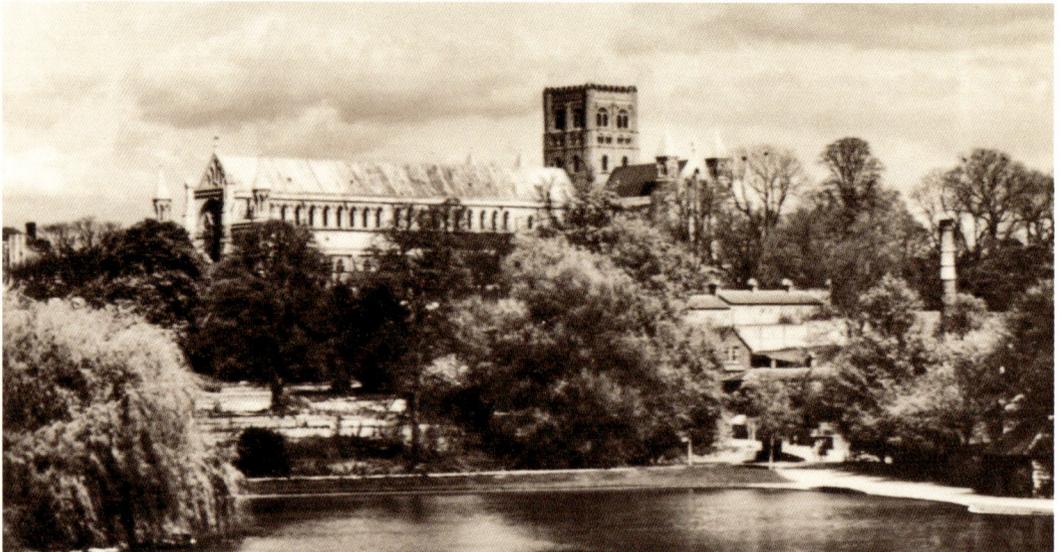

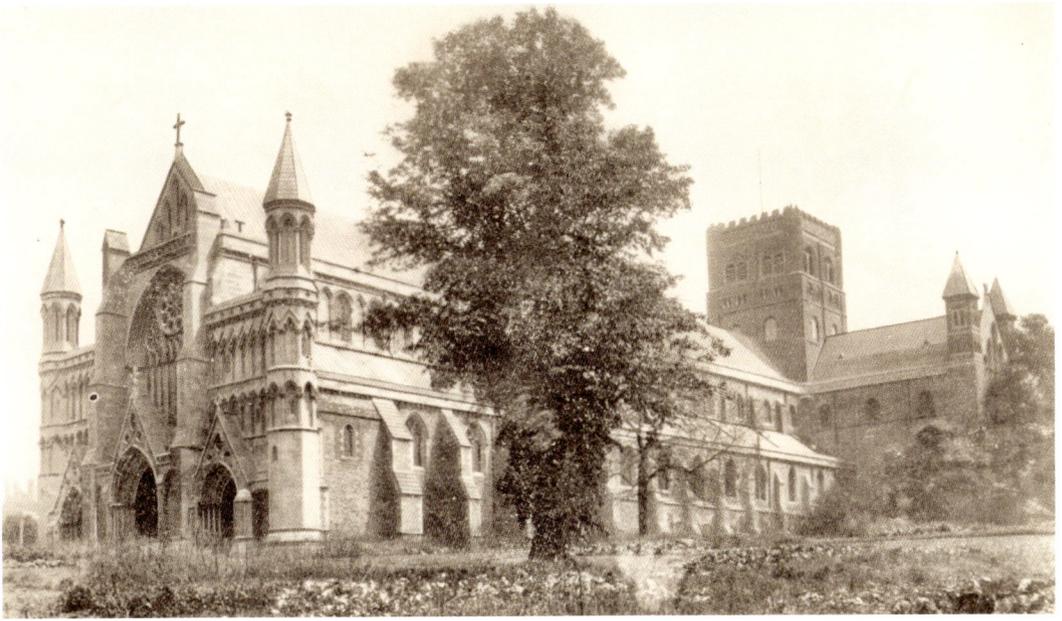

St Albans: Abbey West Front

'The Abbey has been so repeatedly altered and restored that it may be said to illustrate every style of ecclesiastical architecture from Norman to the present time,' Tomkins reports. However, by 1856 it was in such a derelict state that a national committee was set up to restore it. That failed, leaving local grandee Lord Grimthorpe to fund the work 'in substantial but drastic style', according to Lydekker, which included 'the complete rebuilding of the west front in a peculiar style, the repointing of the tower, and the replacing of its brick turrets by stone 'pepper-pots'.' Mee admits 'the exterior is impressive for its size rather than its beauty,' while Pevsner sums up, 'It is aesthetically a most unfortunate story.'

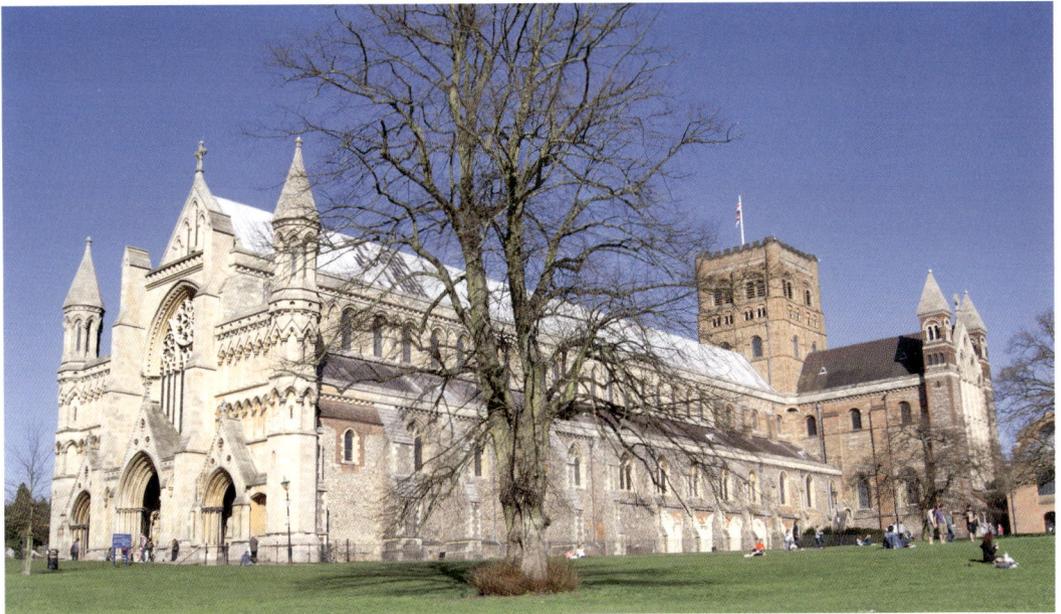

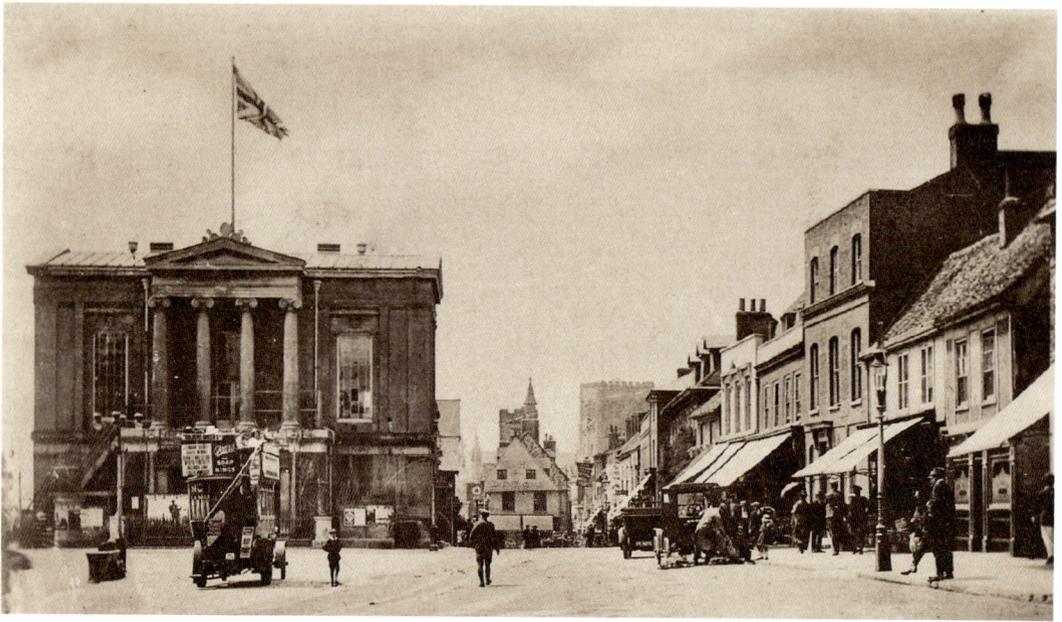

St Albans: St Peter's Street

The heart of this city, Tomkins tells us, was the scene of the 'First Battle of St Albans. On May 23rd 1455 the forces of King Henry VI assembled in the neighbourhood of St Peter's Street, and were attacked by those of the Duke of York and Warwick the Kingmaker.' He goes on to highlight 'The Town Hall or Court House ... an Italian structure dating from 1826.' 'All in the best Georgian taste,' Pevsner agrees, 'the visual urban charter of St Albans. Until then the town had the appearance of a mere country town; now it staked the claim to urban qualities.' This grand building is earmarked to become the new home for the city's museum.

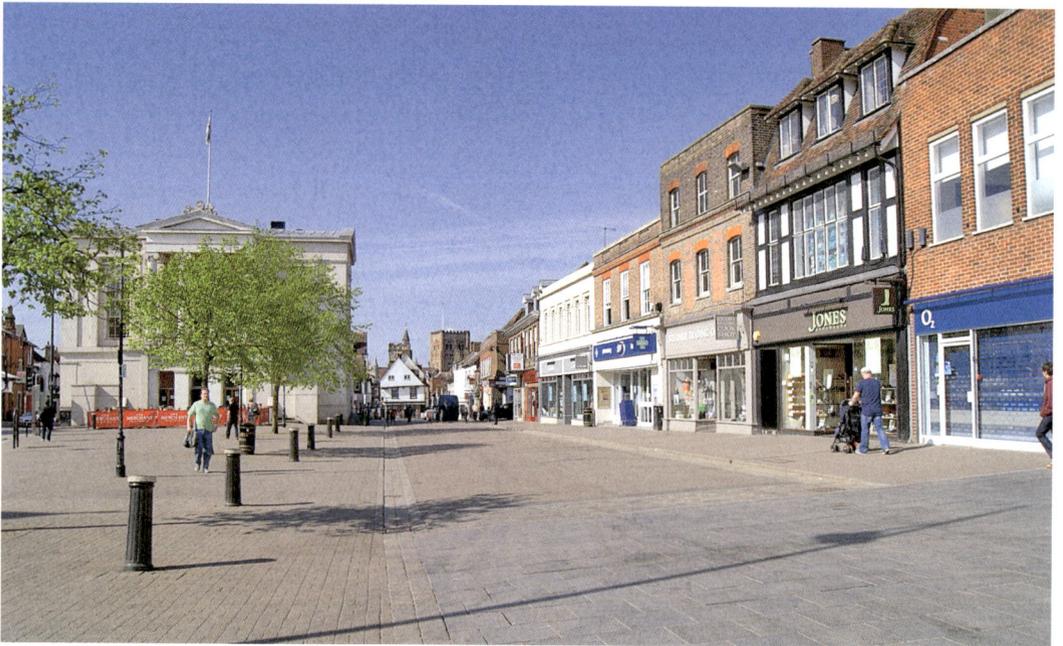

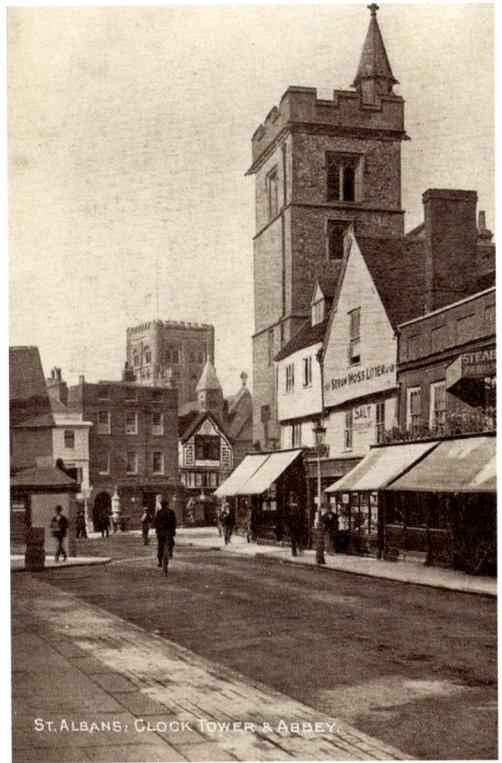

ST. ALBANS: CLOCK TOWER & ABBEY.

St Albans: Clock Tower

'The centre of medieval St Albans was the clock tower ... built in 1403–12,' according to Pevsner. 'Near the clock tower was the Eleanor Cross ... pulled down in 1703 and a market cross built instead. This in its turn was replaced by the fountain by Worley in 1874.' Mee continues, 'The city clock now strikes the hour on ... a curfew bell cast 600 years ago. It weighs a ton, and on it is the Latin inscription: "I have the name of Gabriel sent to Heaven". It used to ring at four in the morning to summon apprentices to work, and at eight in the evening to close the market and the shops.'

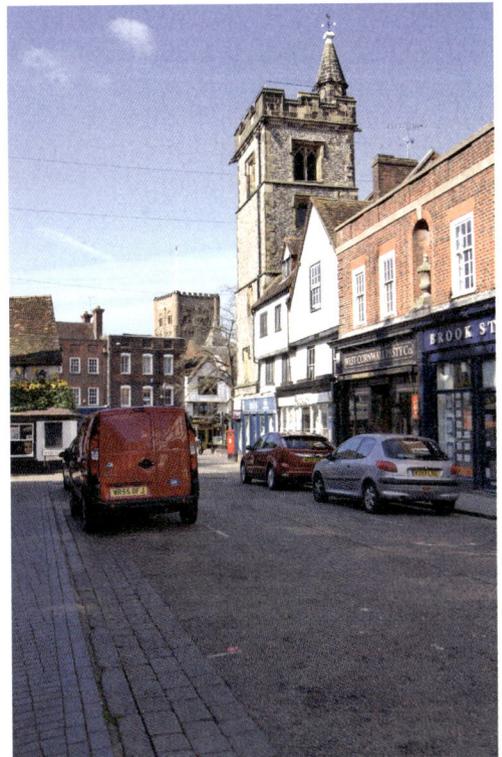

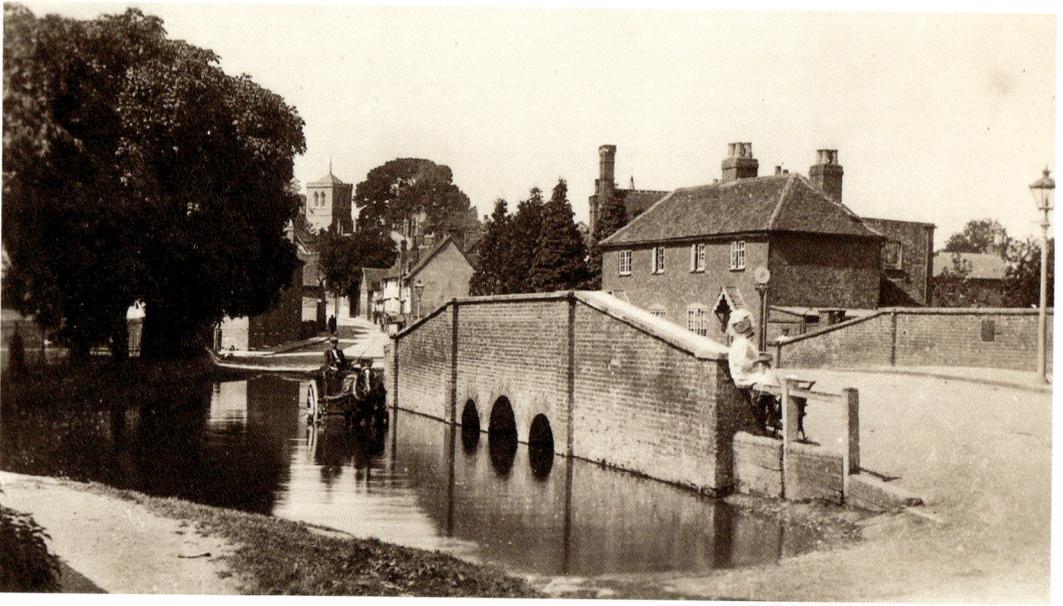

St Albans: St Michael's Village

This medieval village on the city's western flank remains virtually untouched today. To the right of the bridge is ancient Kingsbury Mill, which originally belonged to the abbey. In the background is St Michael's church, which Tomkins informs us 'is believed to occupy, approximately, the centre of what was the ancient city of Verulamium and to mark the site of a Roman temple.' 'The first building on the site was due to Wulsin, abbot of St Albans in the middle of the tenth century.' And the *Victoria* describes that the famous monument to Francis Bacon, who lived in nearby Gorhambury, 'though coming rather near the theatrical, is a fine and striking piece of work.'

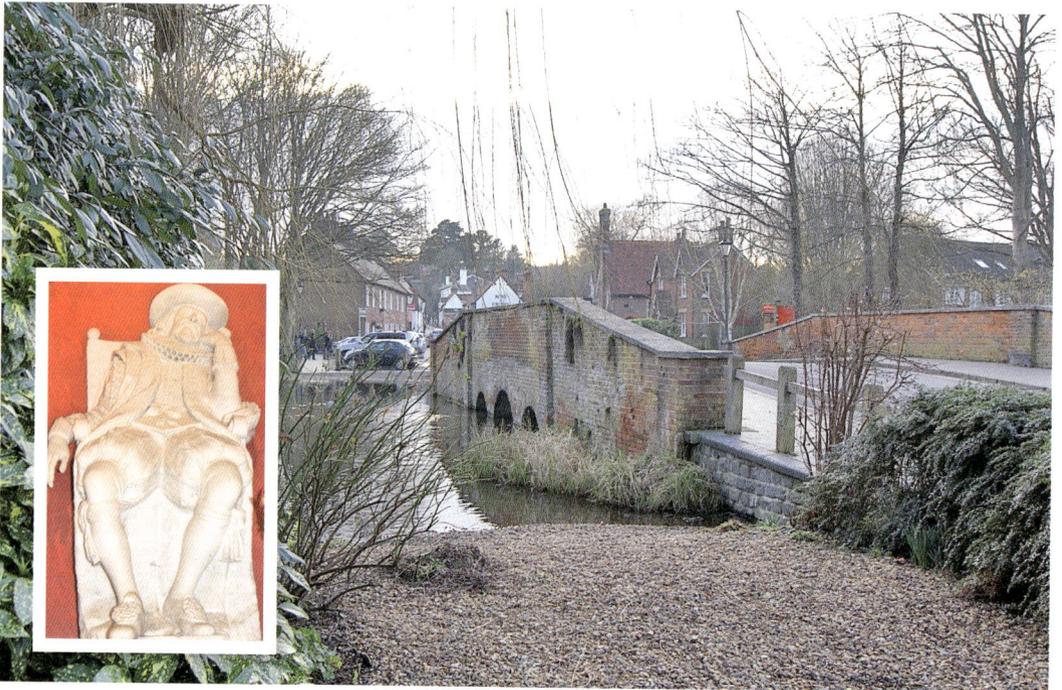

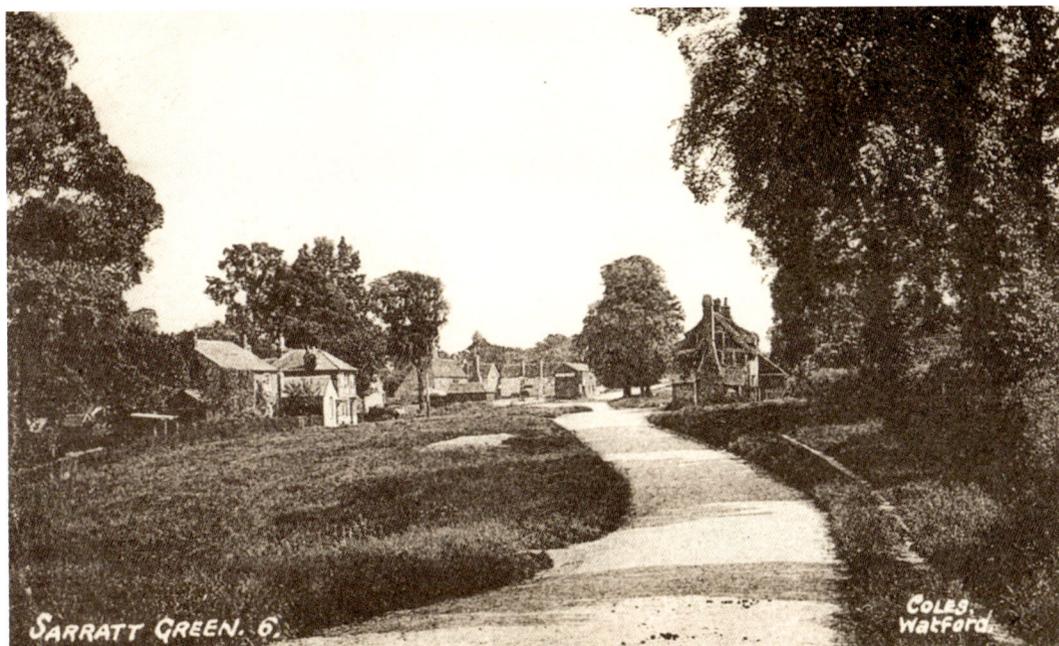

Sarratt Green. 6. Coles. Watford.

Sarratt

'We remember it for its long village green, running between an odd assortment of houses for about a quarter of a mile, with 17th century farmhouses in the background,' Mee records. Forty years earlier, the *Victoria* says, 'Orchards of cherry trees are the chief feature of the village, and in good years they are a source of great profit to the inhabitants. Some of the trees are of an immense size. Formerly paper-making, straw plait, and bead-work were carried on here. There used to be a corn-mill, later a paper-mill on the Chess.' All that remains of the Wheatsheaf Inn on the far left is the post for its sign, the building being a private home today.

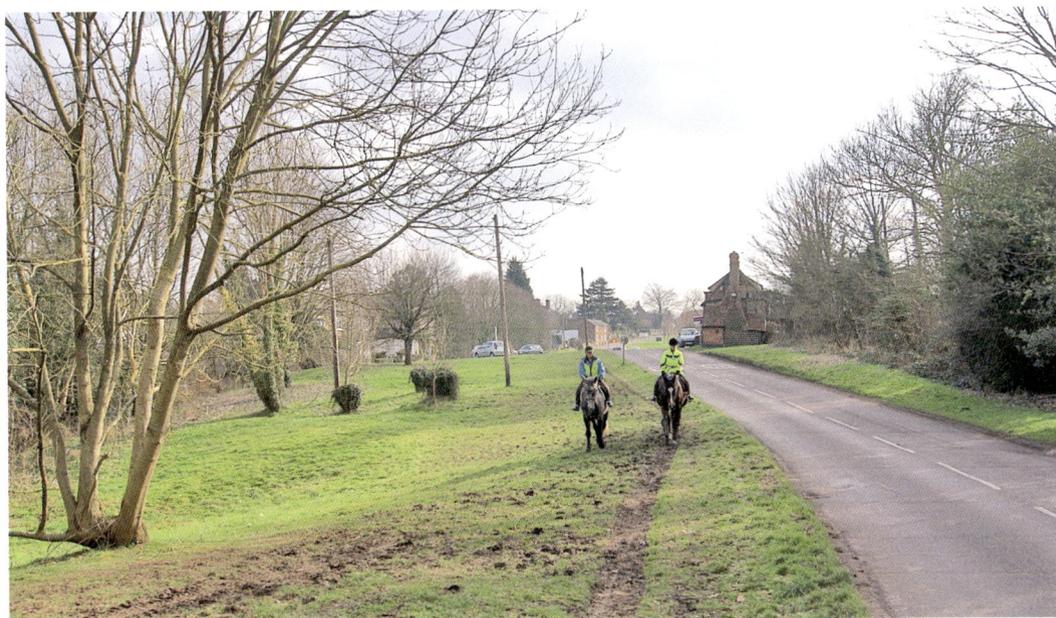

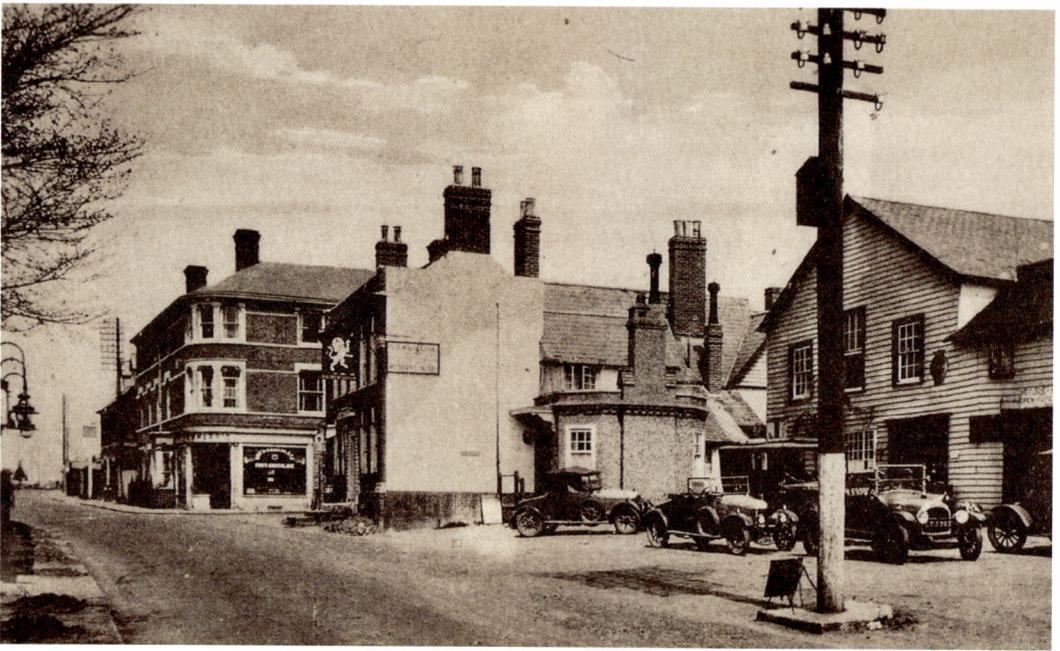

Sawbridgeworth: Cambridge Road

Lydekker's guide informs us that the town, with a population of 2,085, is 'pronounced Satsworth ... originally known as Sabricstworth, being the seat of the family of Say, or de Say. It has a history dating from the Conquest.' Half a century later, Pevsner describes it as, 'One of the best small towns of Herts, built not along a High Street ... but within a square of main streets all quite small ... the rusticated door, pilasters and segmented headed windows of the early 18th century. The same type exactly as the White Lion Inn in London Road.' The garage appears to be doing good business – perhaps petrol costing around 1/6d (7.5p) a gallon in the 1920s helped?

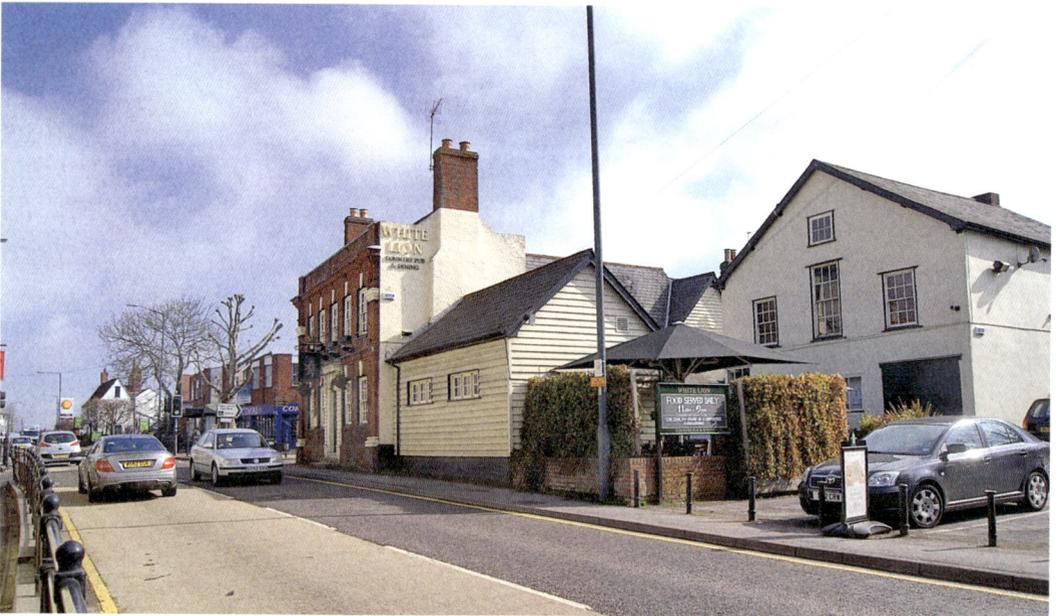

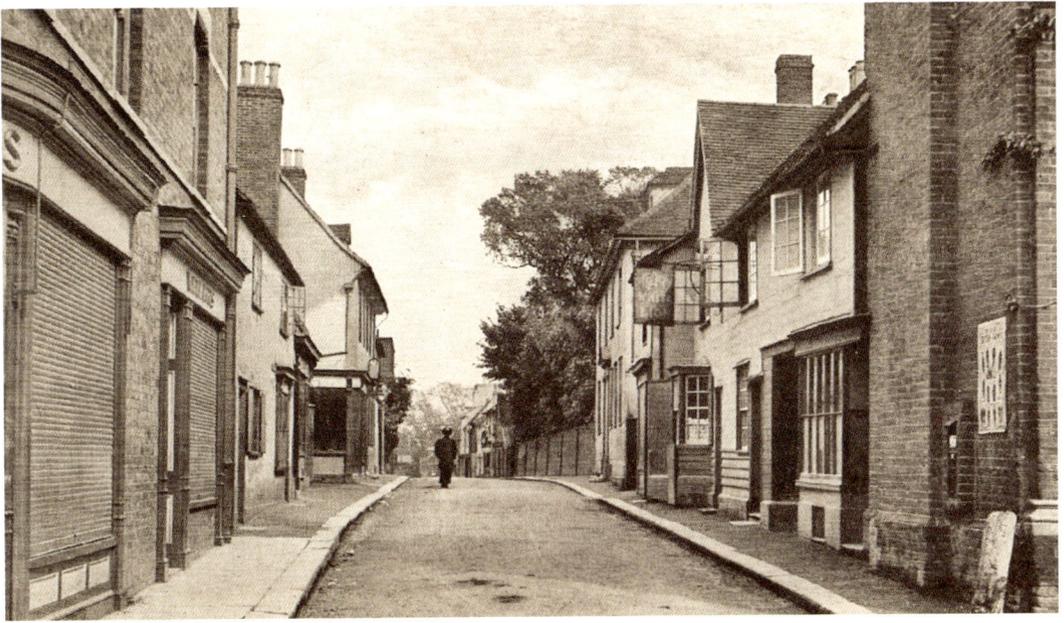

Sawbridgeworth: Bell Street

Immediately north of The White Lion, 'we turn from the Cambridge Road into Bell Street, and it is like going back 300 years,' Mee enthuses. 'The old plastered cottages of timbered and plastered brick overhang the street on either side.' The same is true in the twenty-first century. This was originally called Cock Street as early as the sixteenth century, according to the *Victoria*, which continues, 'Successive grants of market ... have never resulted in making Sawbridgeworth a commercial centre. Probably the neighbourhood of a flourishing market at Bishop's Stortford interfered with the success of the Sawbridgeworth market.' However, there is today a thriving antiques market in the old Maltings on the eastern side of town.

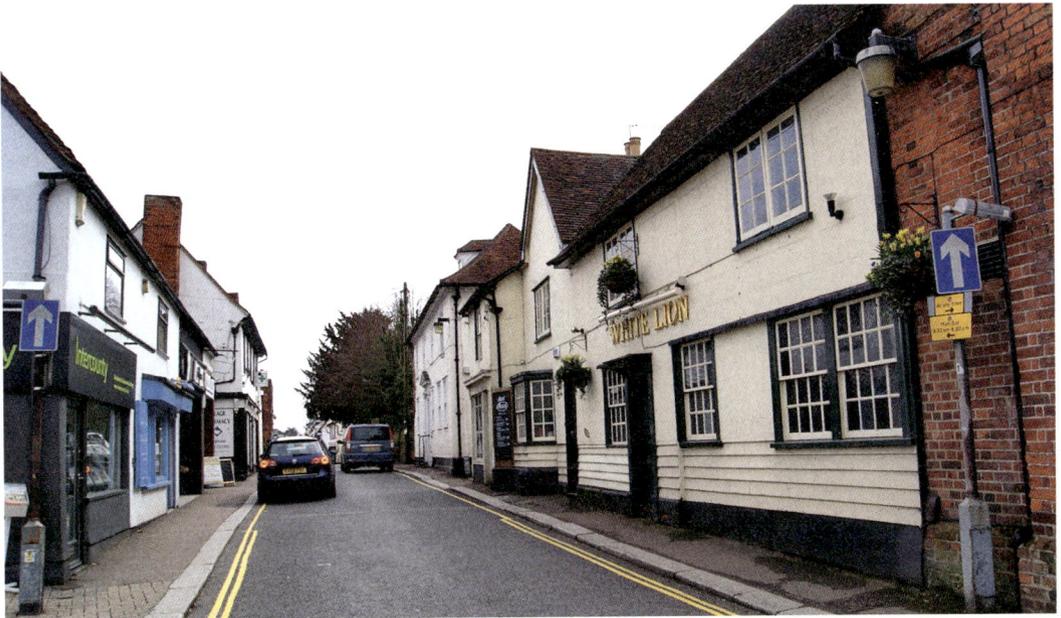

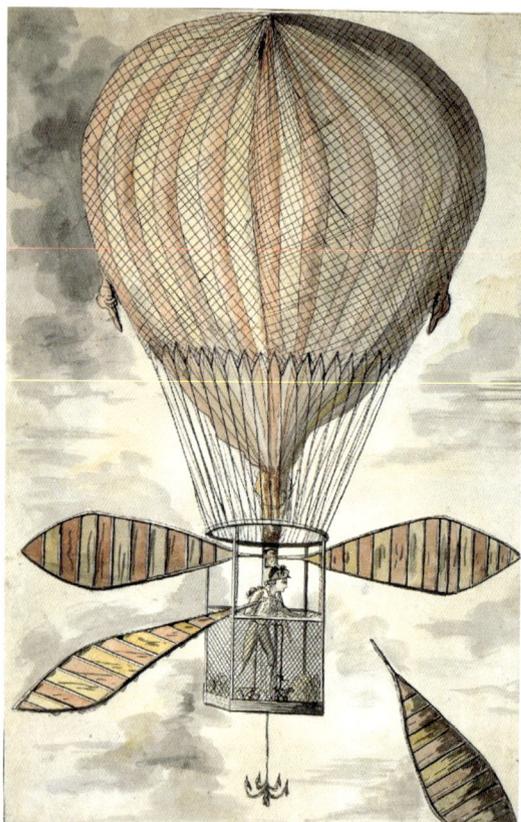

Standon Green

Mee describes the dramatic event that took place in this small hamlet in 1784: 'It must have seemed a fearful thing to these villagers who were looking up that September afternoon at a great spherical object floating through the sky, slowly descending in a field nearby. Out of it, from the car suspended beneath the great silk ball, stepped a man and a dog. The man was Vincenza Lunardi.' This first manned balloon flight is celebrated as a 'wondrous enterprise successfully achieved by the powers of chemistry and the fortitude of man,' on a special monument, which languishes today, rather inaccessibly, in the middle of a field.

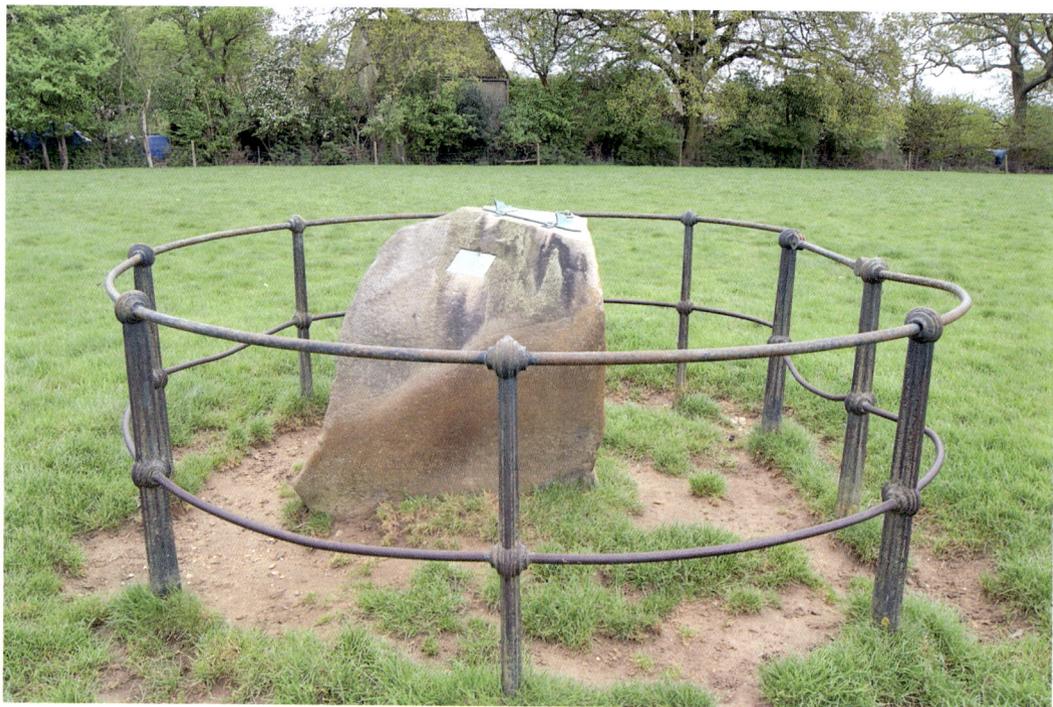

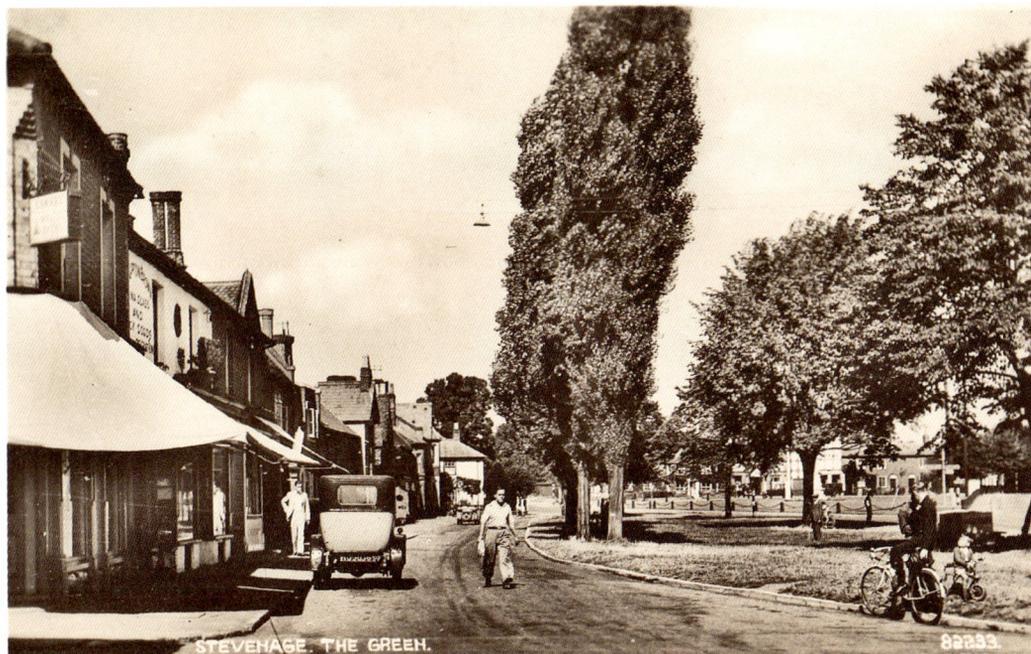

STEVENAGE. THE GREEN.

Stevenage: The Green

Mee informs us, 'It lies on the Great North Road which widens as it passes the six little hills ... from which the Saxons named it Stevenage meaning Hills by the Highway.' 'It once stood farther N.E. and close to the church; but after a terrible fire which destroyed a large proportion of its houses the village was gradually rebuilt more directly on the famous old coaching road,' according to Lydekker. In 1959, Pevsner enthused: 'The attraction of Stevenage High Street is the haphazard tree planting and the fact that at the north end it widens into a triangular green.' Sadly, today the green has been marooned in the centre of a one-way system and circled by fast-moving traffic.

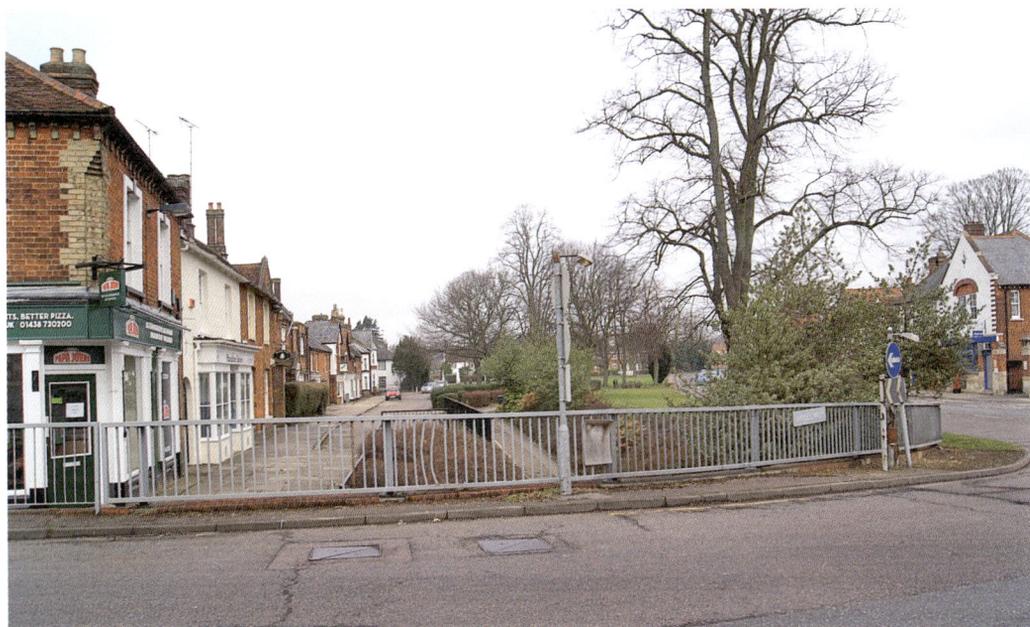

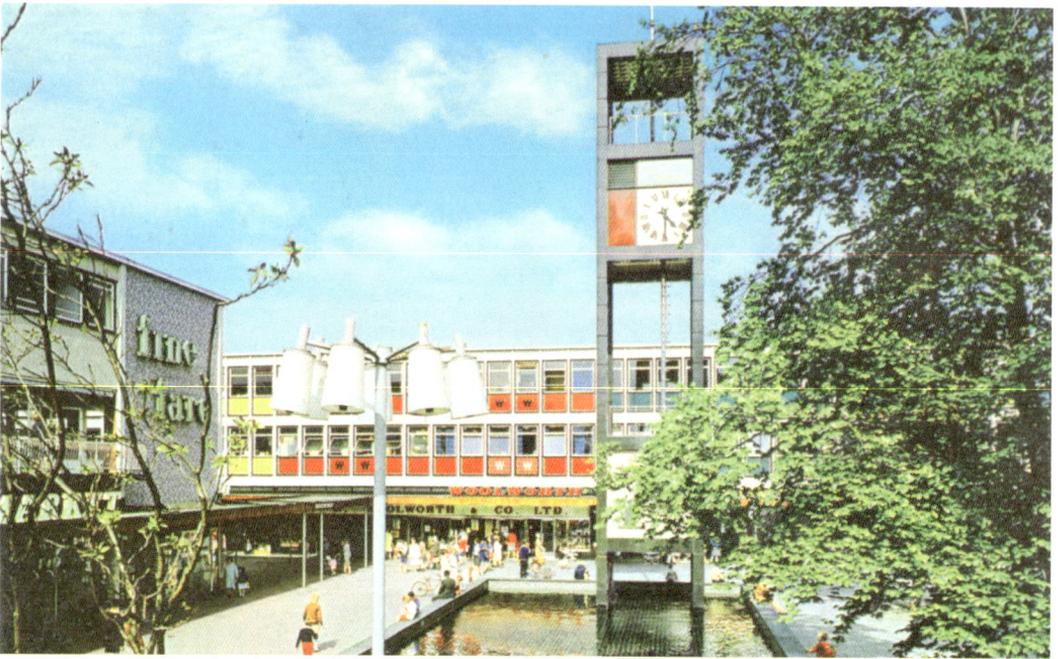

Stevenage: New Town Centre

When Pevsner arrived in 1959, another major urban planning experiment was just getting under way: 'the New Town ... is growing. It will have its centre south of the present town, industry chiefly to the west of the railway, and residential areas mainly to the east.' We see here, in glorious technicolour, the new shopping centre that sprang up in the 1960s, with a special plaque to the civic leadership who had built this brave new consumer world. It has not stood the test of time too well, hemmed in by the vast metal sheds of modern retailers. But the town has continued to mushroom, growing from 3,957 souls in 1901 to 84,651 in 2007.

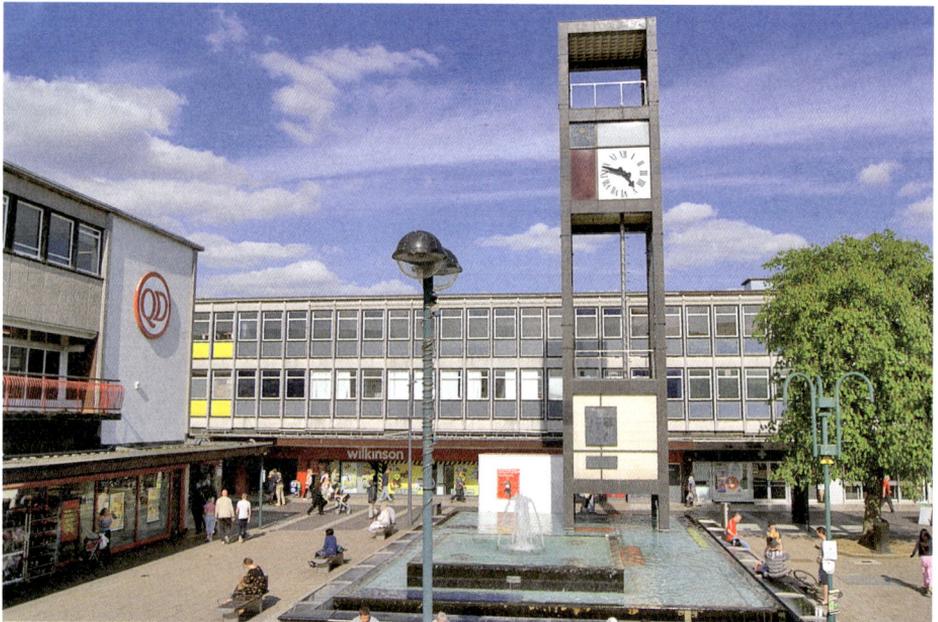

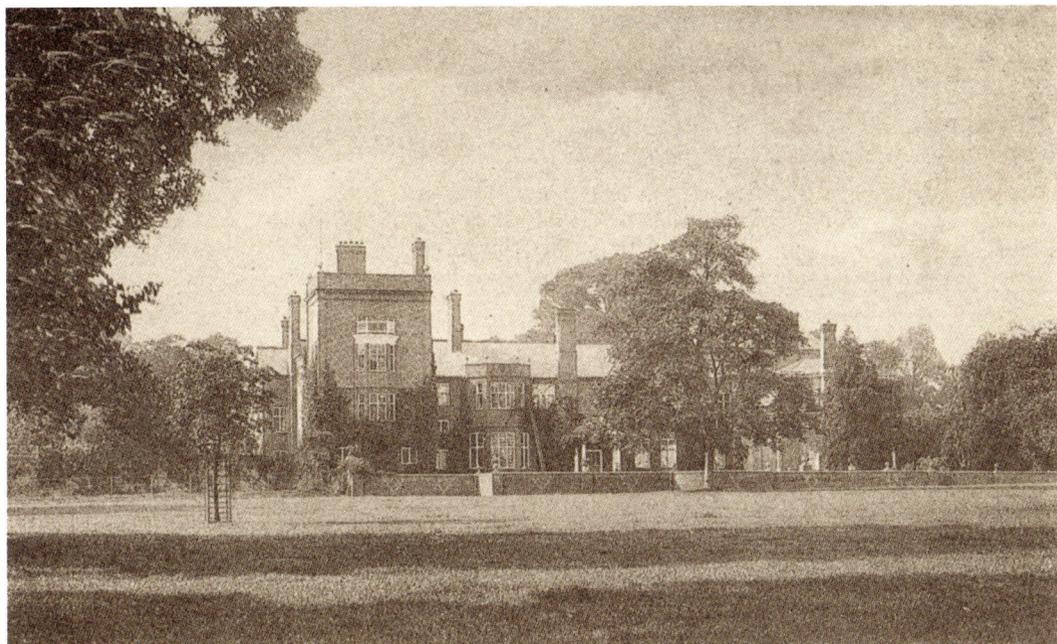

St Paul's Walden Bury

'The Queen's Village,' Mee calls it, 'a proud little place, with a distinction never dreamed of when our century began.' At the Walden Bury on 4 August 1900 a daughter named Elizabeth Angela Martuerite Bowes Lyons was born to the Earl and Countess of Strathmore. 'Lord bless you, I can see her now ... galloping across with the groom behind all out of breath, and her laughing,' one of the old villagers told Mee. As wife to the Duke of York, she became Queen Elizabeth in 1937 and later, in her daughter's reign, the much-loved 'Queen Mother'. The early eighteenth-century landscape gardens are open for charity during the summer months and can be hired for wedding receptions.

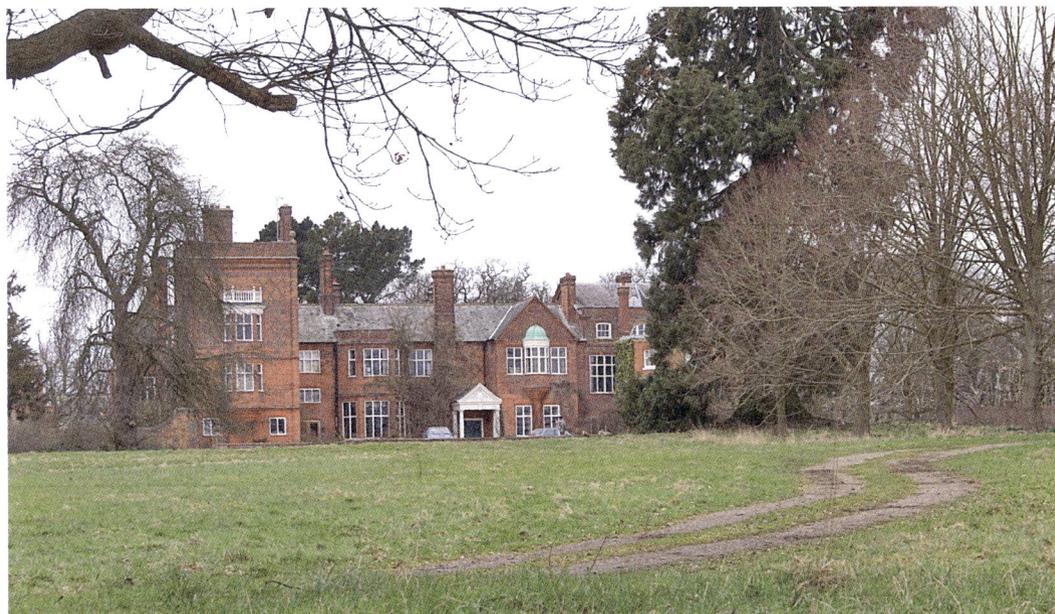

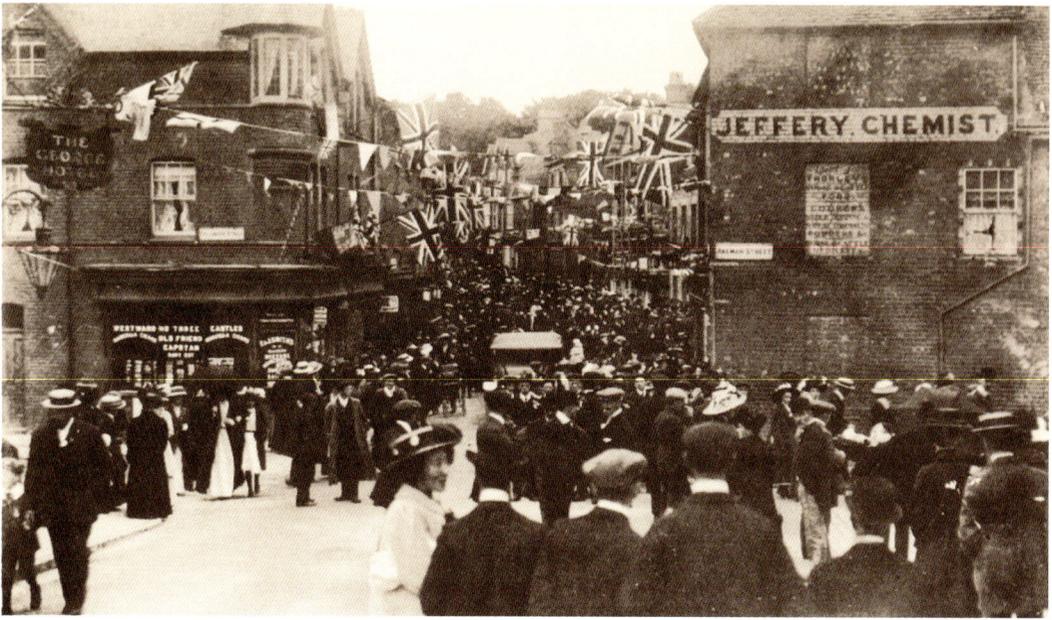

Tring

Tomkins says, 'The place is of great antiquity, 'Treung' hundred dating from the days of Alfred the Great. A large number of the inhabitants are occupied in agriculture and dairy-farming. Trade is not flourishing. A silk-mill was set up in Brook Street in 1824 ... but the mill is no longer worked. Tring was once noted for its canvas and straw plait, but these industries also belong to the past,' reports the *Victoria*. The workers are at least enjoying a royal celebration in this postcard. The High Street, formerly Roman Akeman Street, is virtually unaltered and, while one has to agree with Pevsner that 'there is not much of architectural importance', the town does still have real period character.

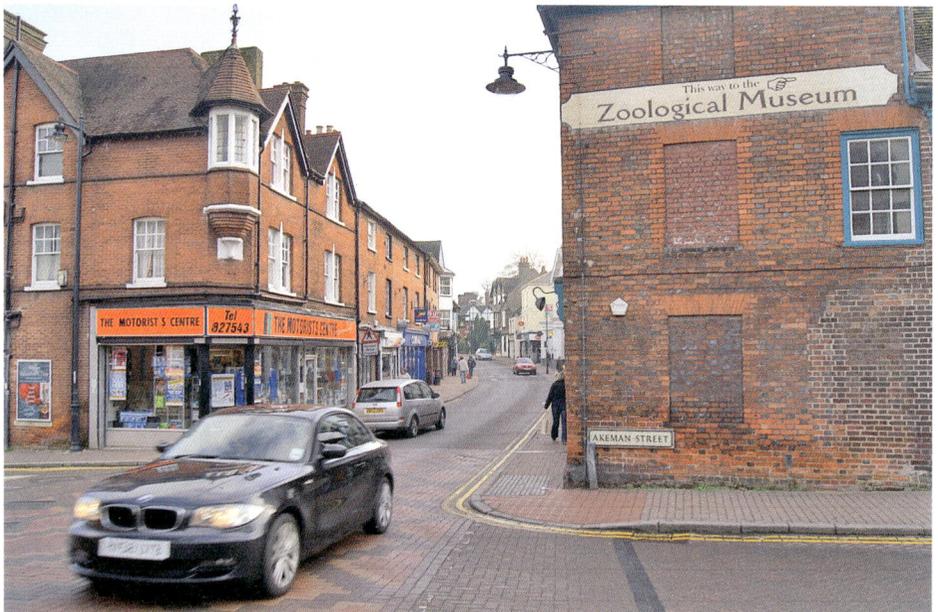

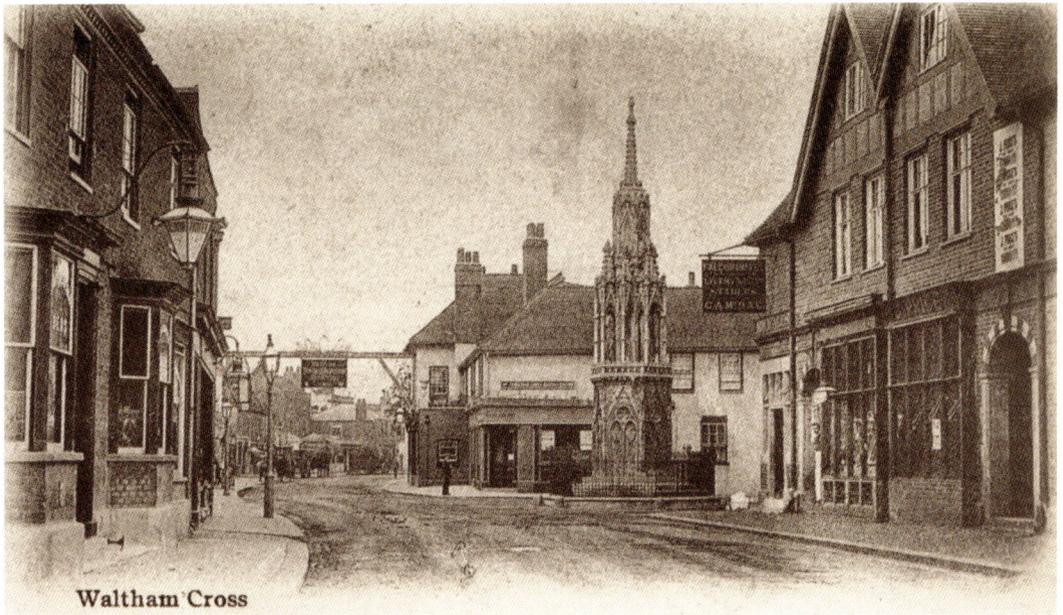

Waltham Cross

Waltham Cross

The town, Tomkins explains, 'owes its name, as is well known, to the Cross which Edward I erected to the memory of Queen Eleanor Although frequently restored it is perhaps even now more complete than any other Eleanor Cross still existing ... It is hexagonal in shape, of three stages, diminishing from basement to summit.' Construction began in 1291, the *Victoria* tells us, 'the stone was brought from Caen and the total cost was £95.' All that remains of the seventeenth-century Four Swans Inn behind is the restored sign on a beam across the now-pedestrianised roadway, leaving the monolithic Pavilions shopping centre to dwarf the delicate tracery of the cross.

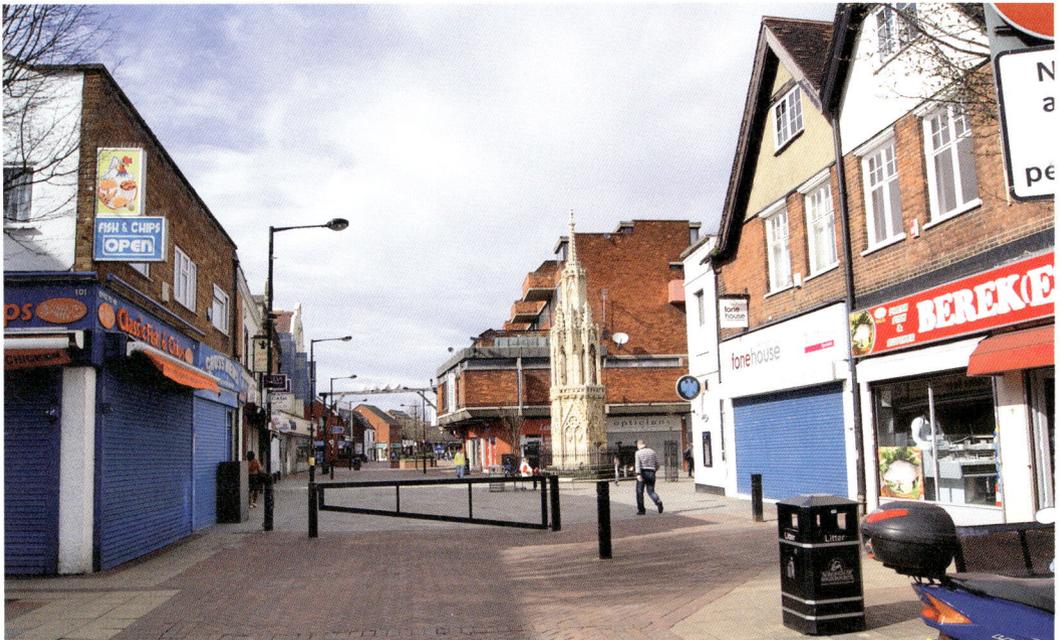

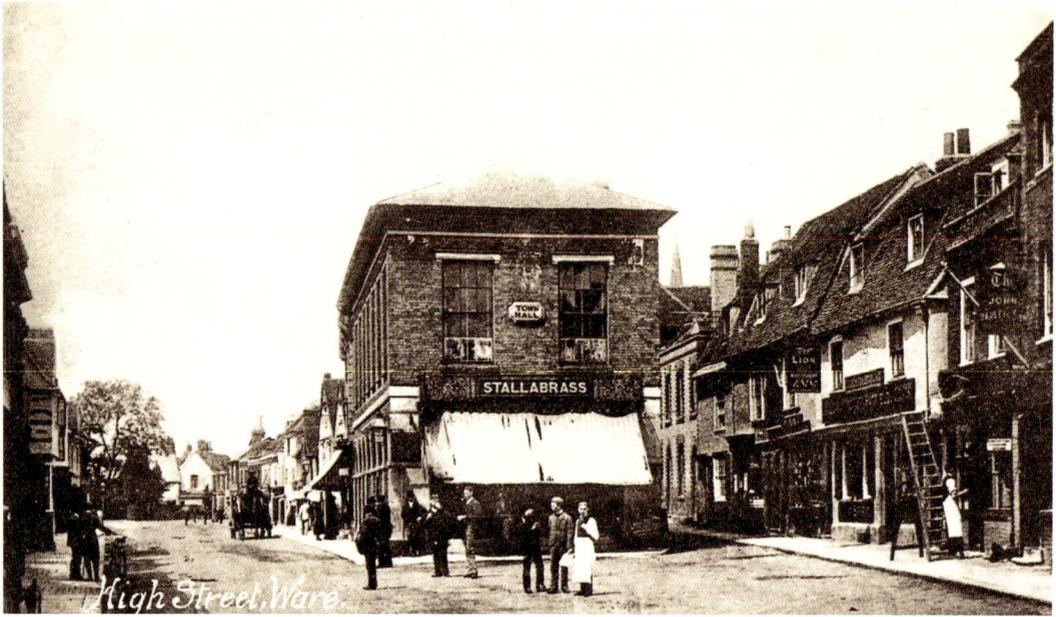

Ware: High Street

'It was known to the Danes, who are said to have bought their ships up the river Lea, and to John Gilpin on his famous ride, and it was important enough 600 years ago for the county town to be referred to as Hertford-by-Ware,' says Mee. Tomkins recommends, 'by turning into the smaller byways visitors may find quaint cottages and picturesque nooks and corners.' The *Victoria* informs us, 'About forty years ago an attempt was made to establish a corn market ... and a house was built for a corn exchange. The project failed, however, and the house is now used as the Town Hall.' Accommodating an estate agent's, it still dominates the charming historic High Street today.

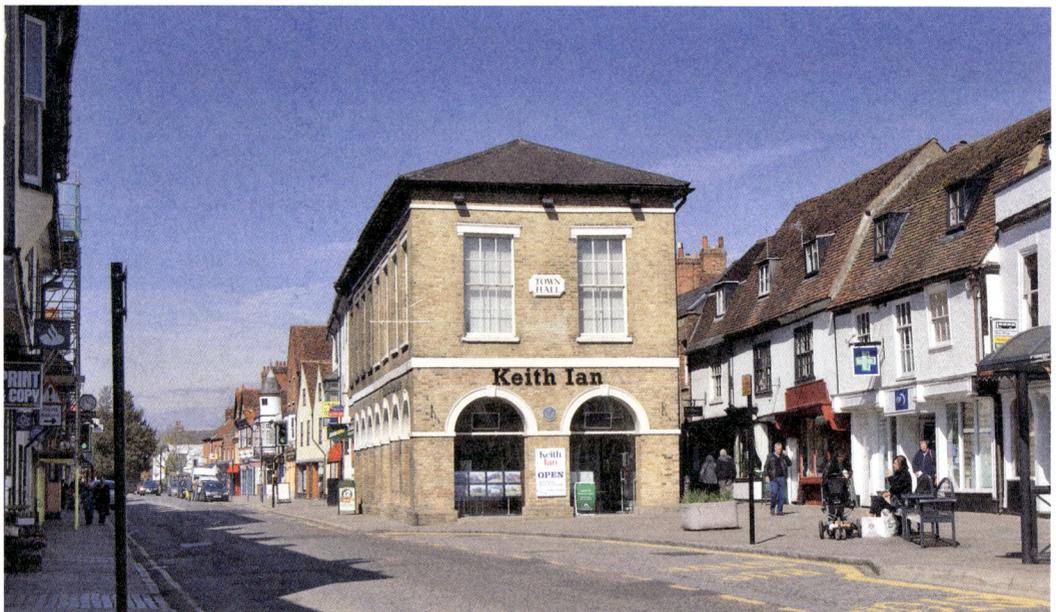

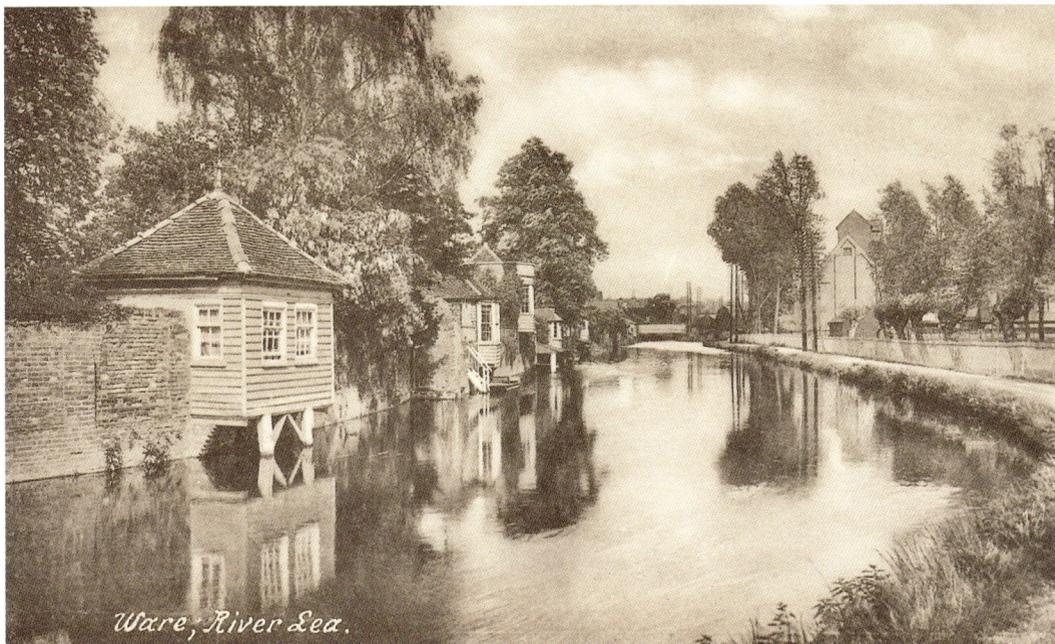

Ware, River Lea.

Ware: River Lea Gazebos

The *Victoria* tells us, 'Malt-making has always been the principal industry, and Ware one of the chief malt-producing towns in England.' This trade, which thrived until the late nineteenth century, was reliant on the River Lea being navigable all the way down to London. Mee points out, 'There is a pleasant tree-lined walk along the towpath on this side of the town, and the gardens of the houses have quaint gazebos along the north bank.' The eight surviving gazebos (previously called 'Dutch summerhouses') were restored by the Ware Society in the 1980s, and the riverside is now packed with local residents, tourists and visiting pleasure boats and barges during the summer.

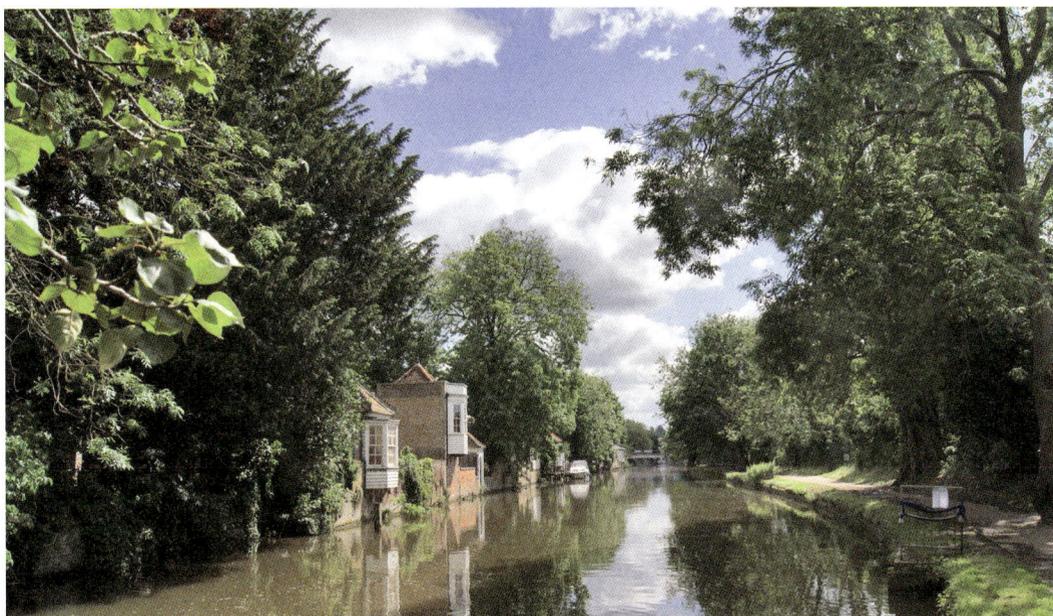

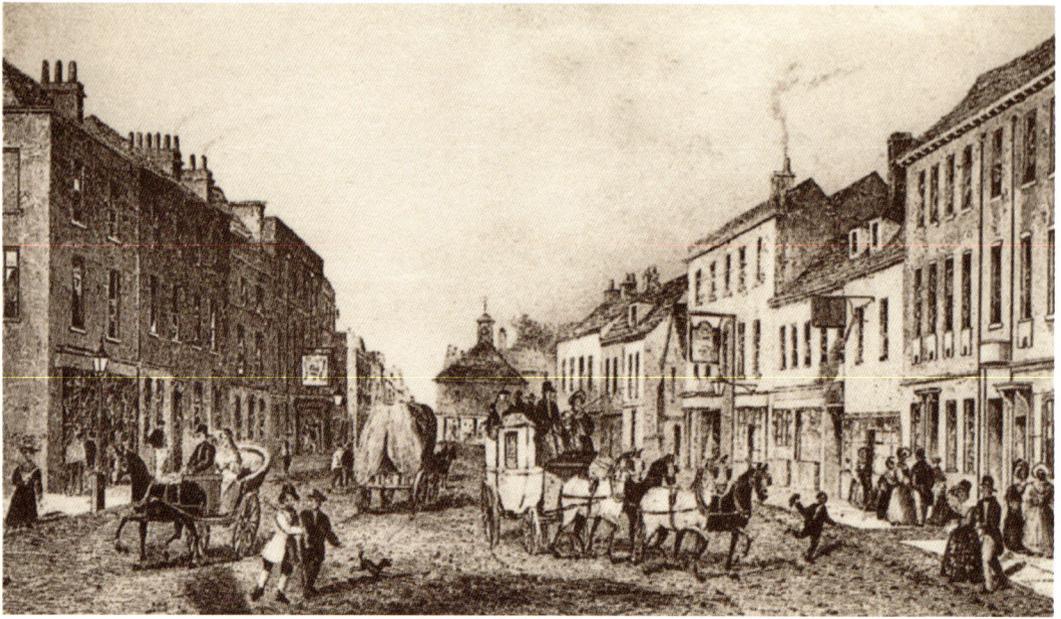

Watford: Market Place, 1830 & 1909

No other town in the county has undergone such a transformation in the last 150 years. The *Victoria* starts the tale. 'During the 17th century Watford had attained sufficient importance to have a service of carriers to London, though at that period the Colne had to be forded ... the water being sometimes up to the saddles of the riders.' Defoe in his *Tour* (1778) describes Watford as being a 'genteel markate town ... very long, having but one street, ...' The population of 6,500 in 1850 almost doubled in the next twenty years, largely fuelled by the arrival of the railway. In 1909, Tomkins described it as 'by far the largest town in the county,' with almost 30,000 residents.

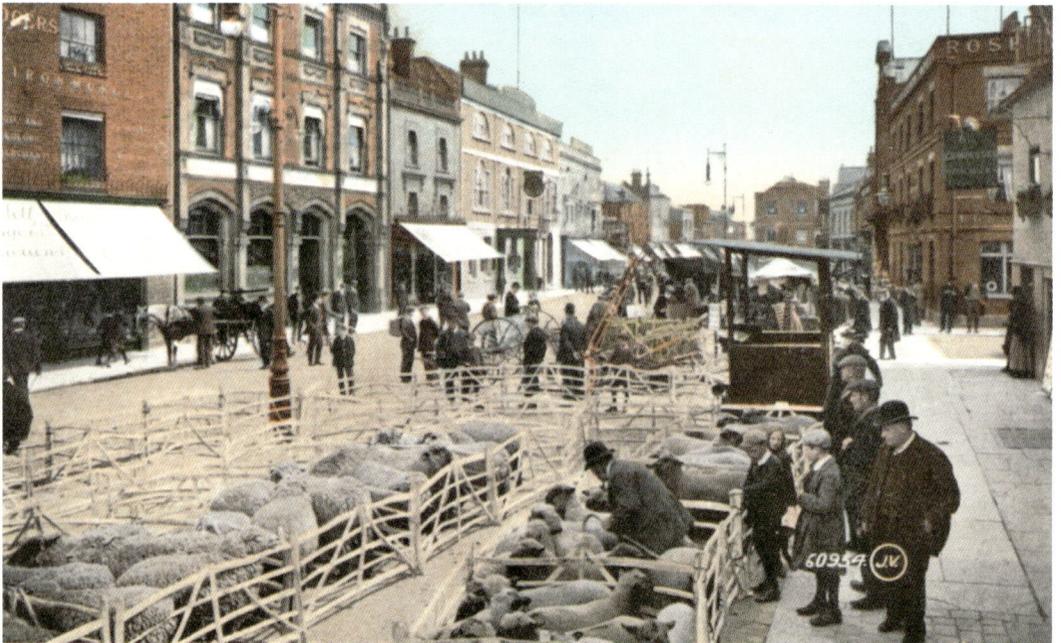

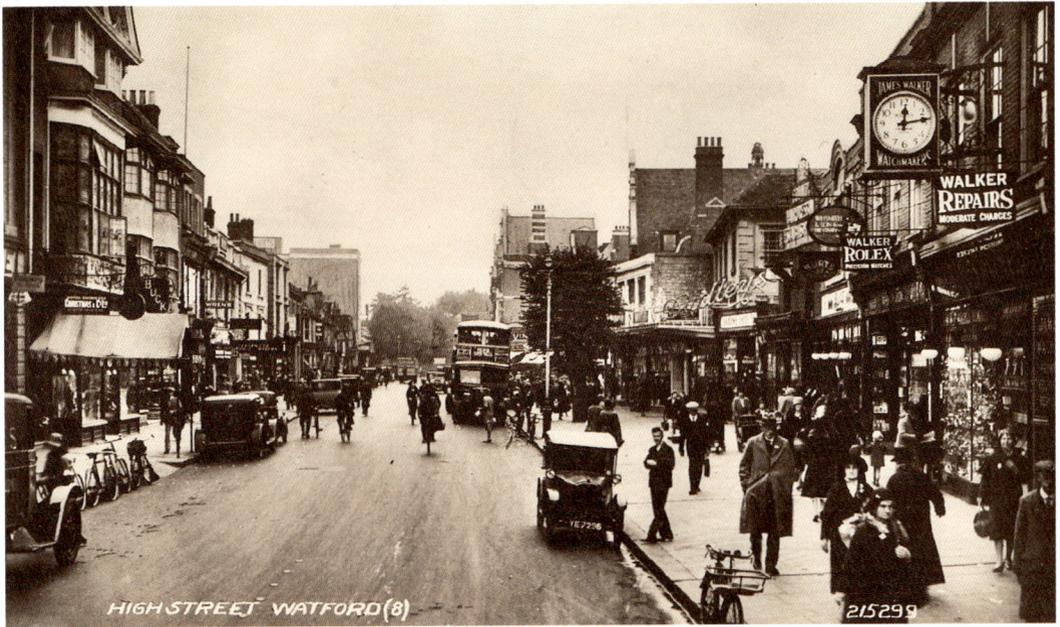

HIGH STREET WATFORD (8) 215299

Watford: Market Place, 1946

'A market has existed since the time of Henry II, and is stated to have been granted by Henry I,' according to Lydekker. In 1939 Mee observed, 'though it is fast losing its old buildings ... it has kept something from its ancient days.' Even after the war Pevsner wrote, 'The old Watford of pre-Victorian days is still easily discernible. To the north the prevalent character of the High Street is 20th century urban. To the south there are still stretches of small old houses of quite a country town character.' After half a century of keeping up with the demands of modern consumerism, the same certainly cannot be said of the town today.

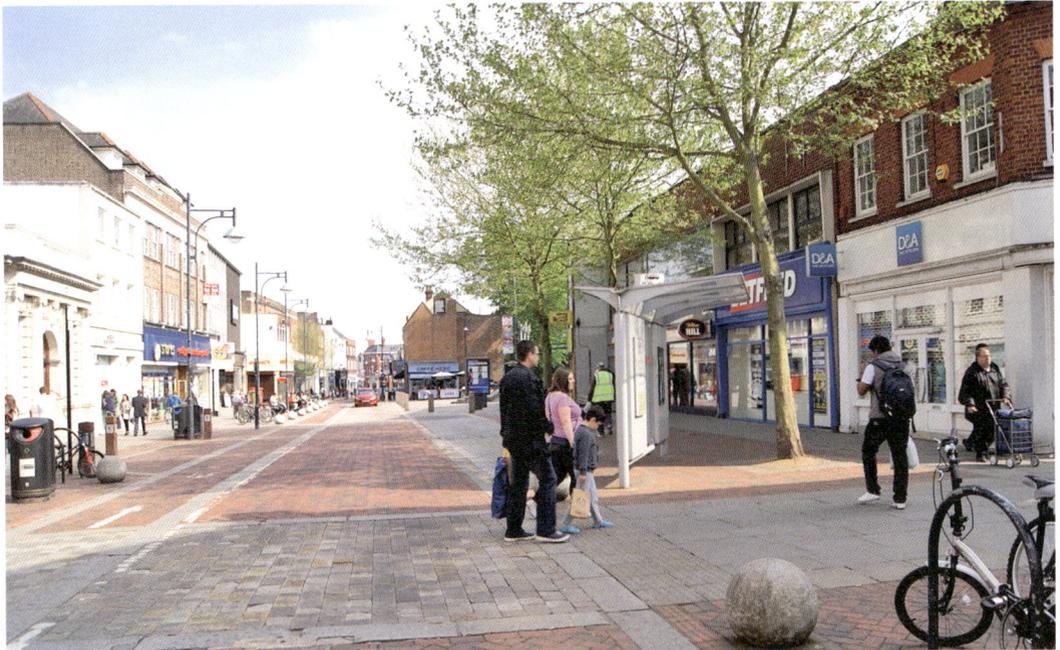

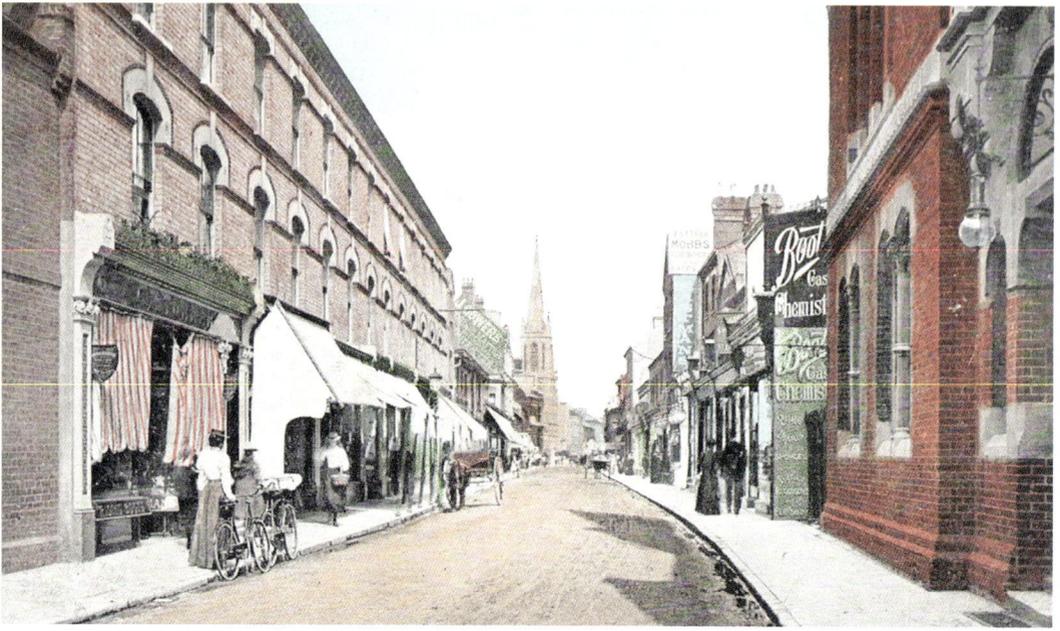

Watford: Queens Road

'The area built on has been steadily extending, most of the houses being of the smaller description, and these have attracted a large number of workers engaged in London,' the *Victoria* reports, 'while the comparative cheapness of the land, and the good railway facilities, have resulted in the erection of a number of factories and works.' In 1871, it continues, 'a building was erected in Queen's Road, by private subscription with a grant of £500 from the Science and Art Department, as a public library and school of science and art.' Other facilities for the burgeoning population in the Edwardian era included a school of music, Masonic hall, Roman Catholic church and an orphan asylum.

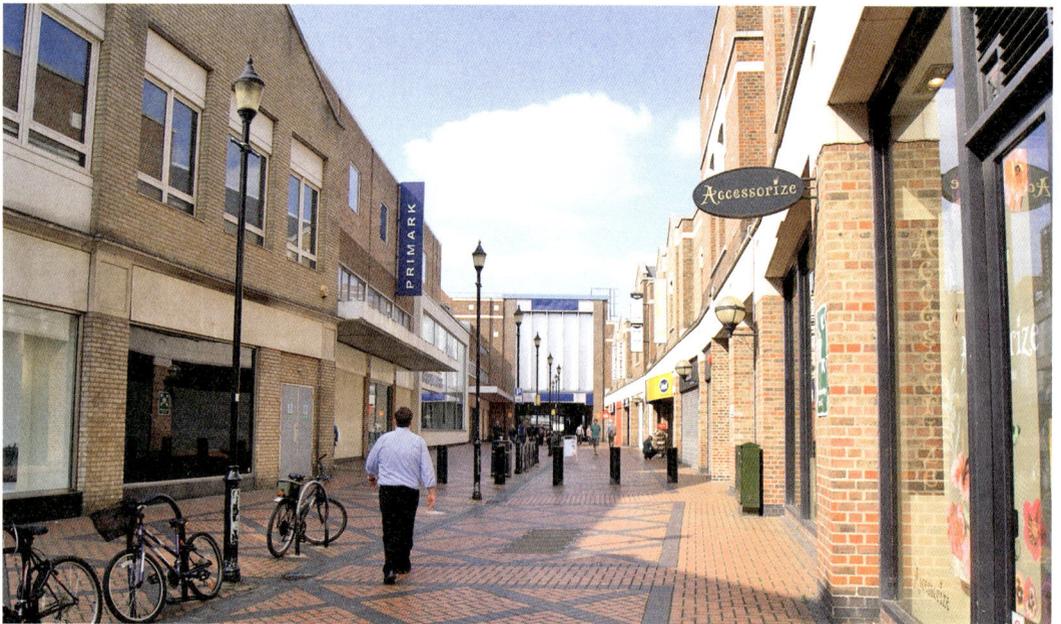

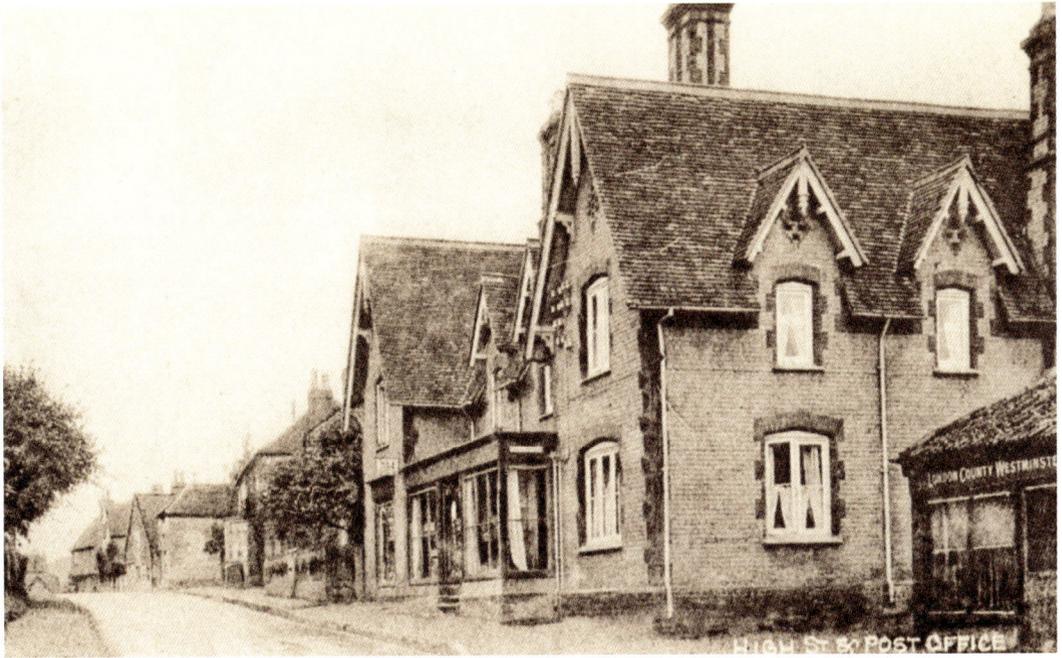

Watton At Stone

'A village in the valley of the Beane, near the centre of the county, taking its name from the number of springs in the neighbourhood, Wat, in Saxon, signifying a moist place. Watton, which was in existence as a manor in the time of the Conqueror, was the home of the ancient family of Boteler,' Lydekker's entry reads, reporting a population of just 710 in 1901. The post office on the right in the original postcard, built in the 1850s for senior estate workmen, has now been converted into a private home, but a more recent village store is now set back a little from the road just off to the right.

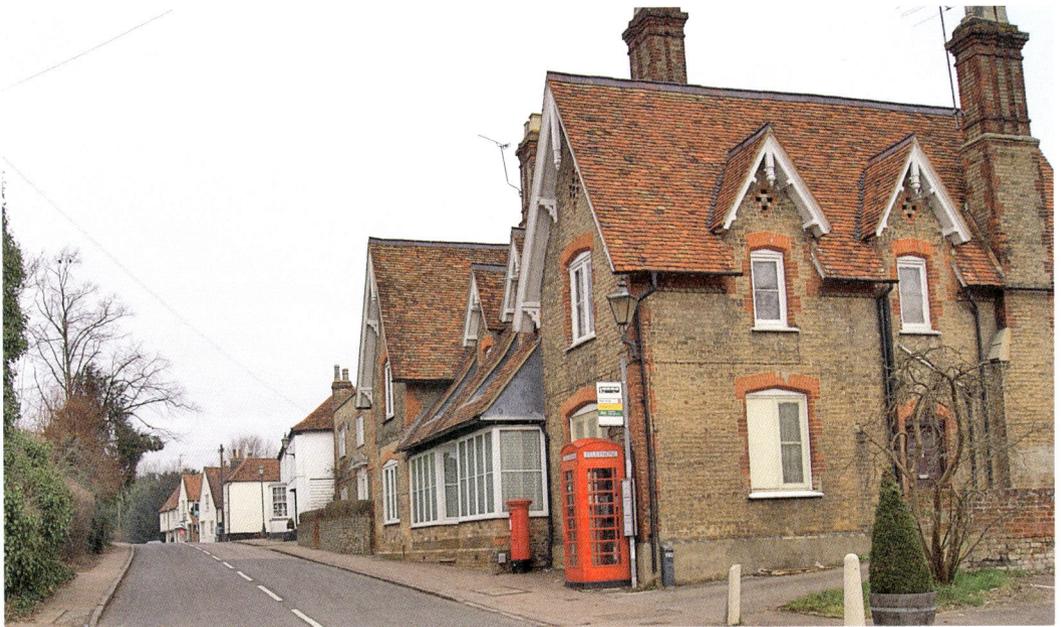

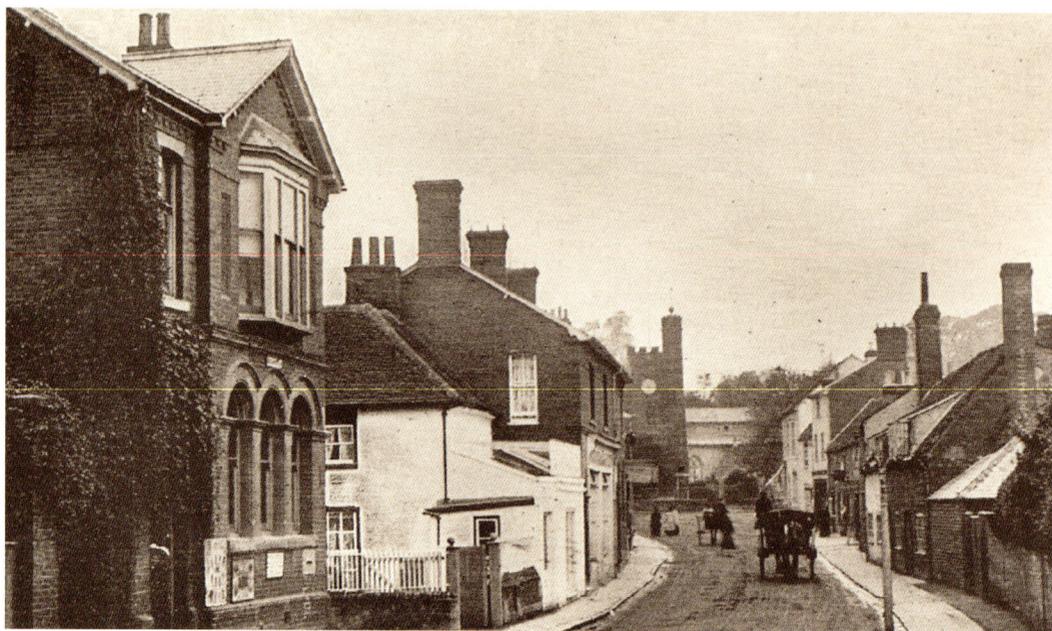

Welwyn: High Street

According to Mee, this ancient village was 'where the Roman colonists settled, probably with a temple where the church now stands ... Roman tiles have appeared in the churchyard, Roman bricks are in the church walls.' Tomkins is somewhat dismissive, calling Welwyn 'a small town in the Maran Valley, [which] can show little of interest beyond many quaint cottages, and the church, famous as that in which Dr Edward Young, author of 'Night Thoughts', officiated from 1730 to 1765.' But half a century later Pevsner describes it as, 'an old little town of much charm and far enough away from the garden city not to be swamped by suburban developments, however tasteful.'

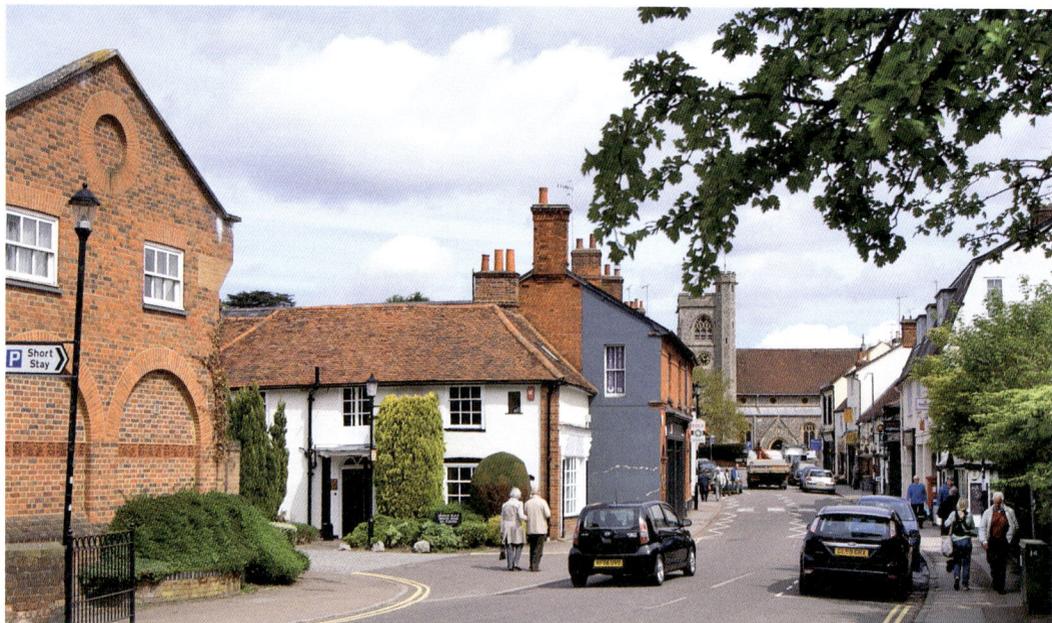

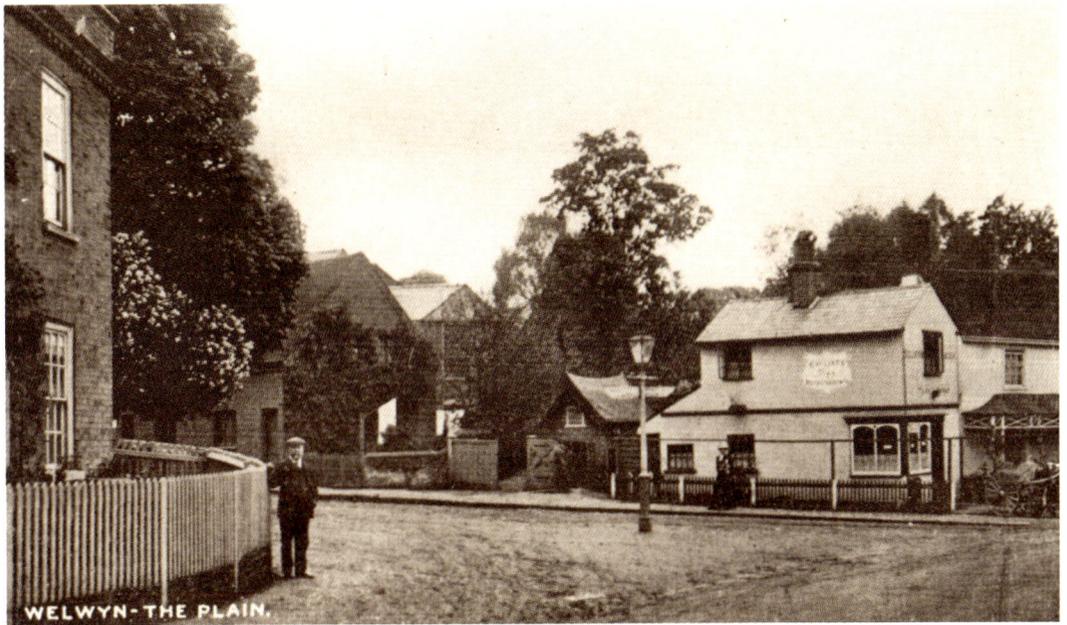

WELWYN-THE PLAIN.

Welwyn: The Plain

'The Saxons long before called this town Welnes, from the many springs which rise in this 'Vill','
Tomkins quotes, 'for in old time 'wells' in their language were termed 'Welnes'.' The *Victoria* takes
up the story of how the continued existence of these springs was used many centuries later to try
to bring prosperity to the area. 'There was a chalybeate spring in the parish ... in the corner of the
old rectory garden. An attempt was made in the 18th century under the auspices of Dr Young to
make Welwyn a watering-place. Assembly rooms were built, which enjoyed a short vogue, and
which still survive as tenements. The spring has been covered over.'

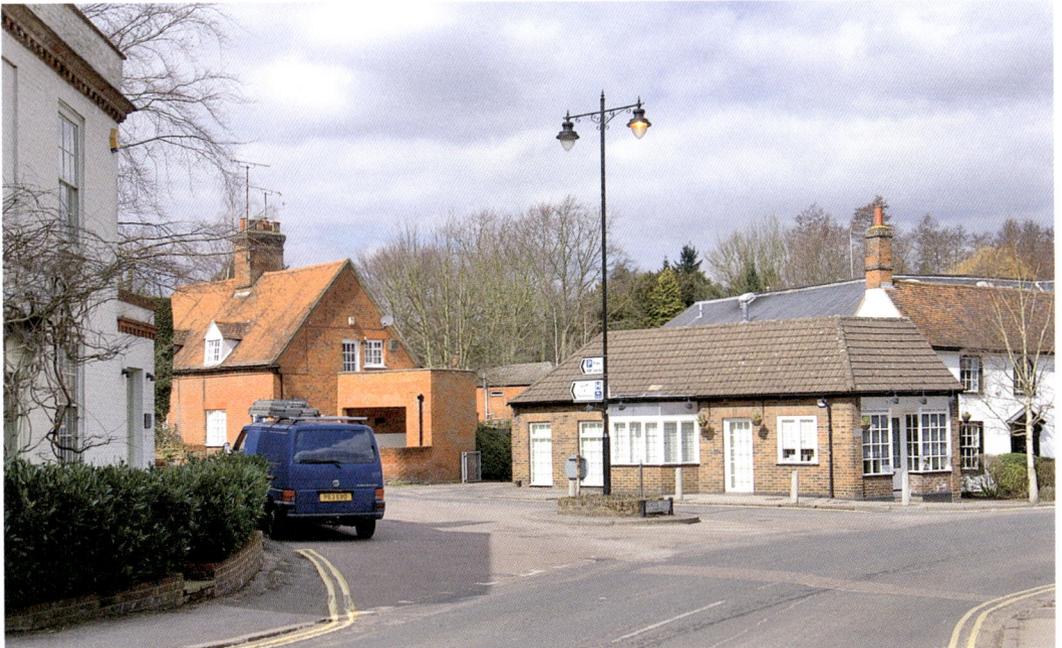

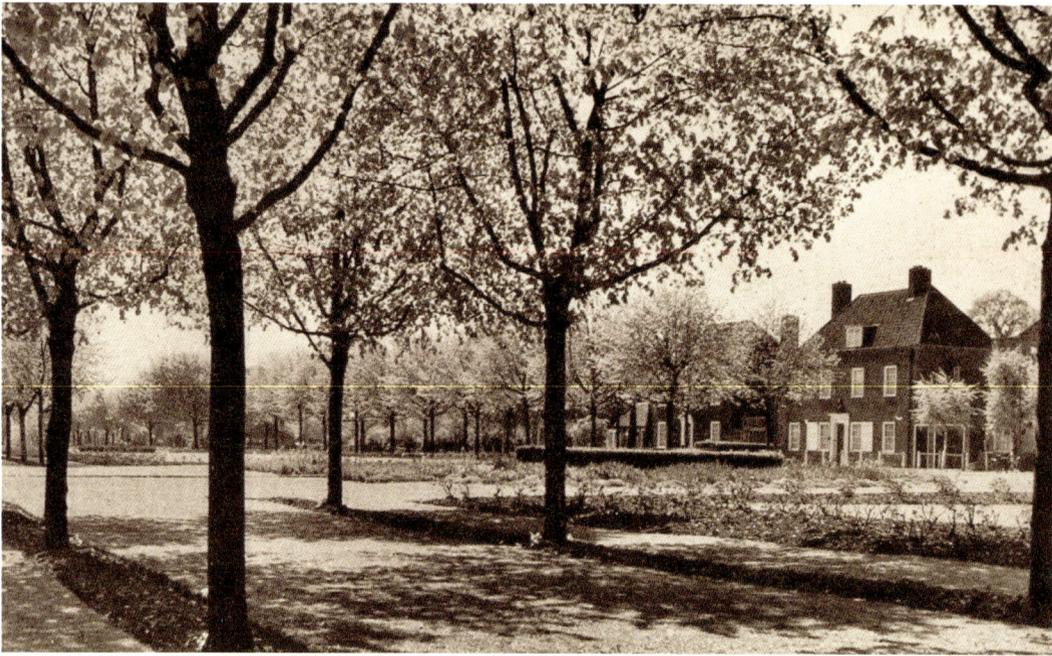

Welwyn Garden City

'It may not be a city but it is surely a garden, a lovely place of lawn and flowers, which has not yet been growing 20 years,' Mee observes. 'It is an ordered village in which the area devoted to green verged, tree-lined roads so greatly exceeds the red and white houses that the impression is of light and air everywhere.' Another two decades on, Pevsner writes, 'The predominant style of the houses ... is now a quiet, comfortable Neo-Georgian. At present the main public buildings and also the five storeyed stores, and the shopping area are all by the station and the parkway.' Remarkably, all that still remains the same in the twenty-first century.

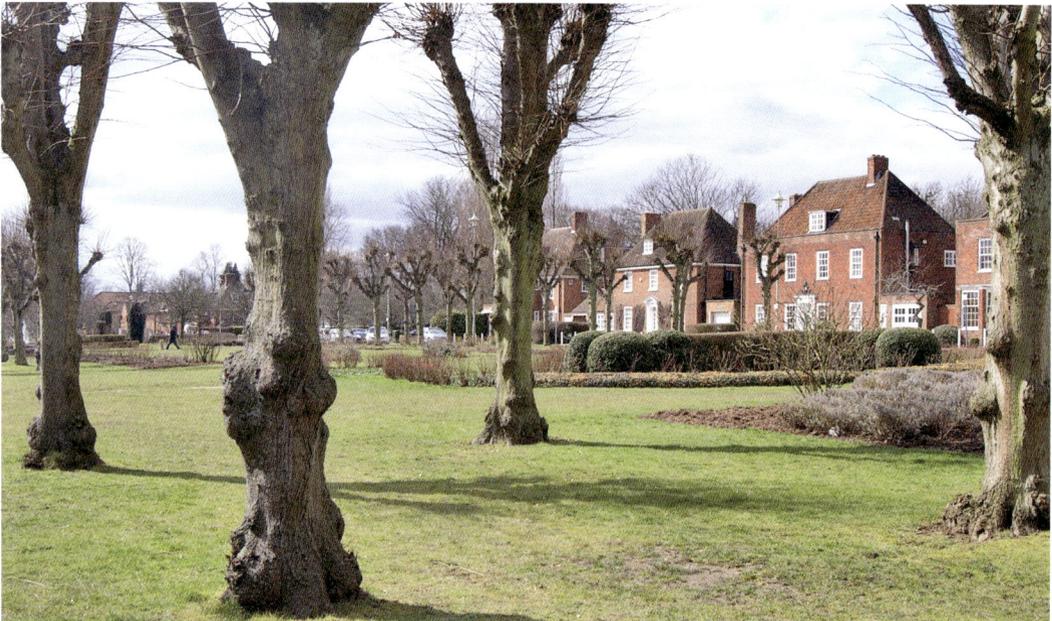

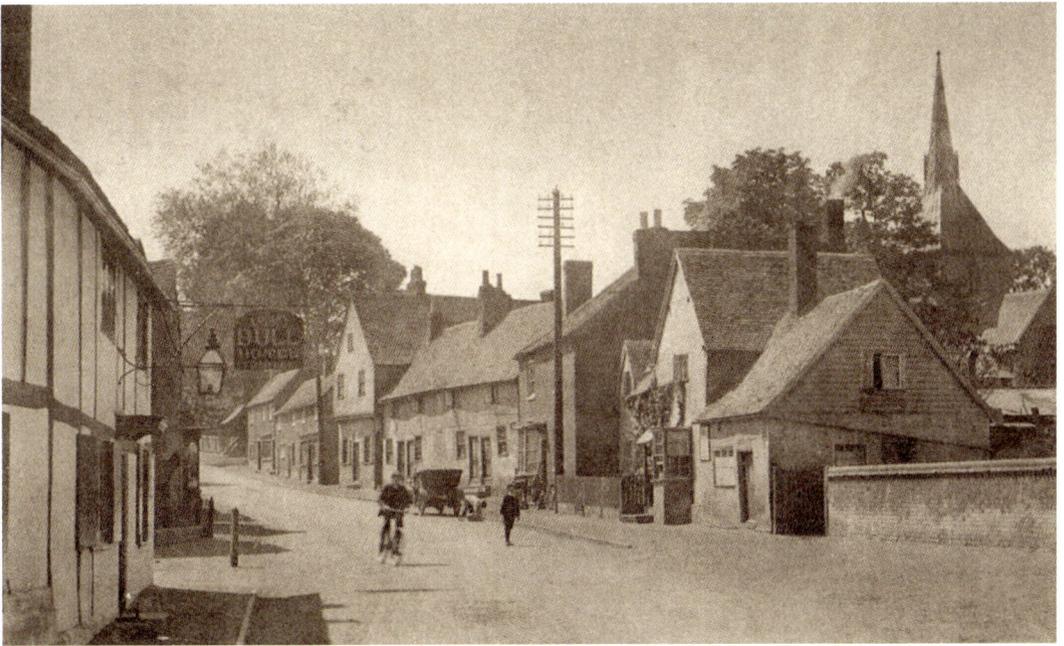

Wheathampstead

'The place undoubtedly owes its name to the fine wheat grown in the neighbourhood; it is very picturesque, particularly around the church and vicarage. Twenty years ago the village was truly rural, but the rebuilding of the old mill between the church and station and the erection of several modern shops in the main street has altered its appearance,' Tomkins writes. Mee recalls the visits of a famous poet: 'As we walk around these lanes we may imagine a queer little man clinging close to his Bridget, drinking in the beauty of the countryside, and chatting eagerly in his delight at being here. He was Charles Lamb.'

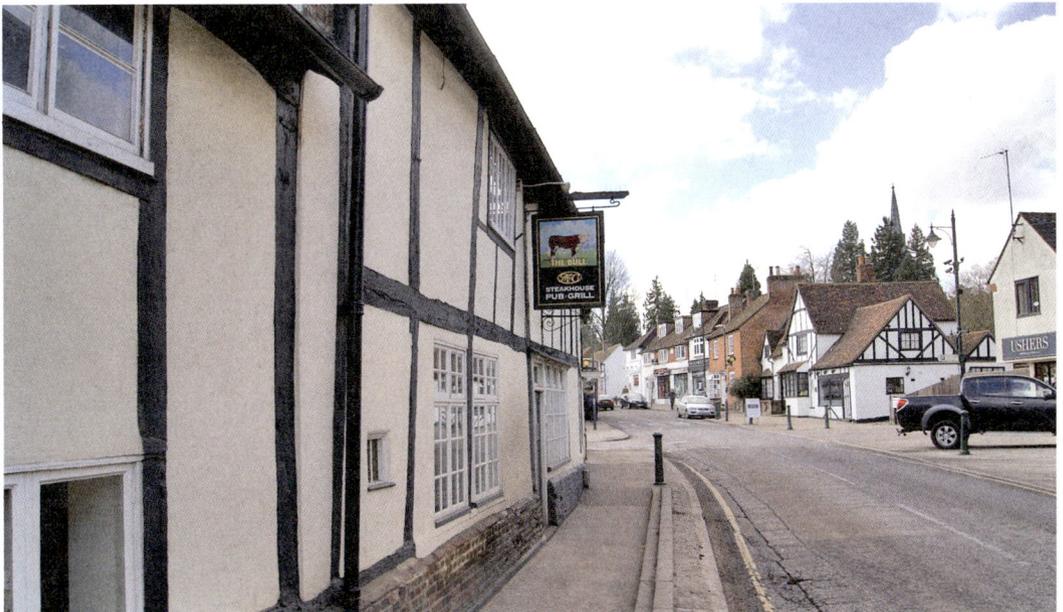

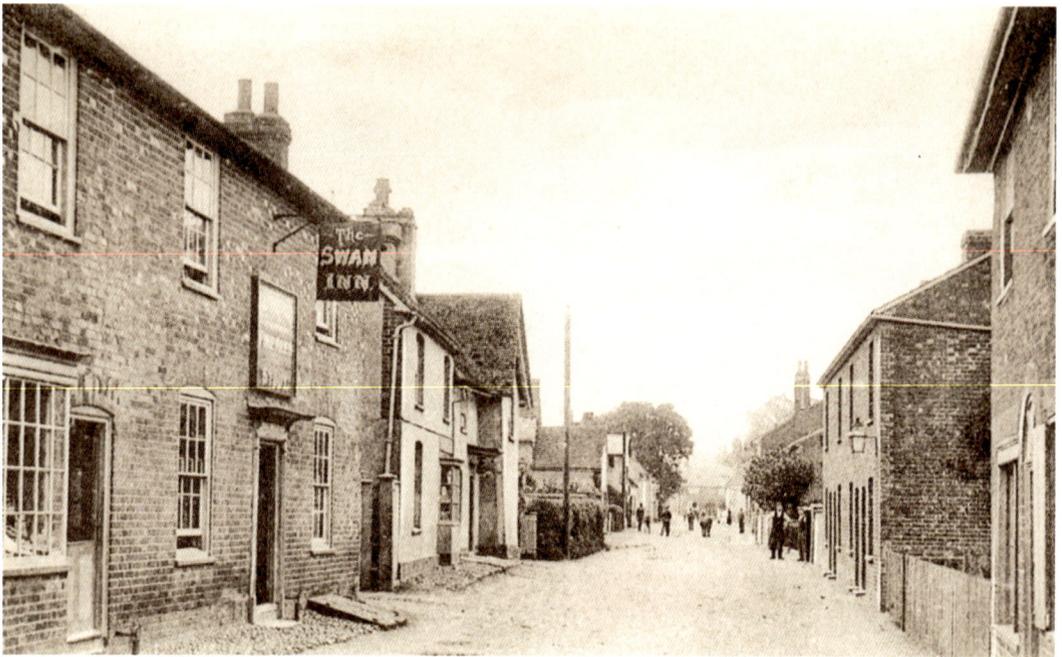

Whitwell

The *Victoria* is not impressed with the place. 'Its situation along the valley of the river is very pretty, but the village itself is unpleasing, being a long row of houses, which are, for the most part, poor ... Tanning used to be an industry here, but it was given up some thirty-five years ago. Straw-plaiting also was once an industry. Now, however, the people have to depend on agriculture and water-cress growing.' Pevsner disagrees: 'A pretty village with, along the High Street, the Youth Hostel, red brick of 3 bays *c.* 1700, and three other houses of brick and half-timber work.' The Swan may be gone, but The Bull Inn, just out of shot, is still thriving.

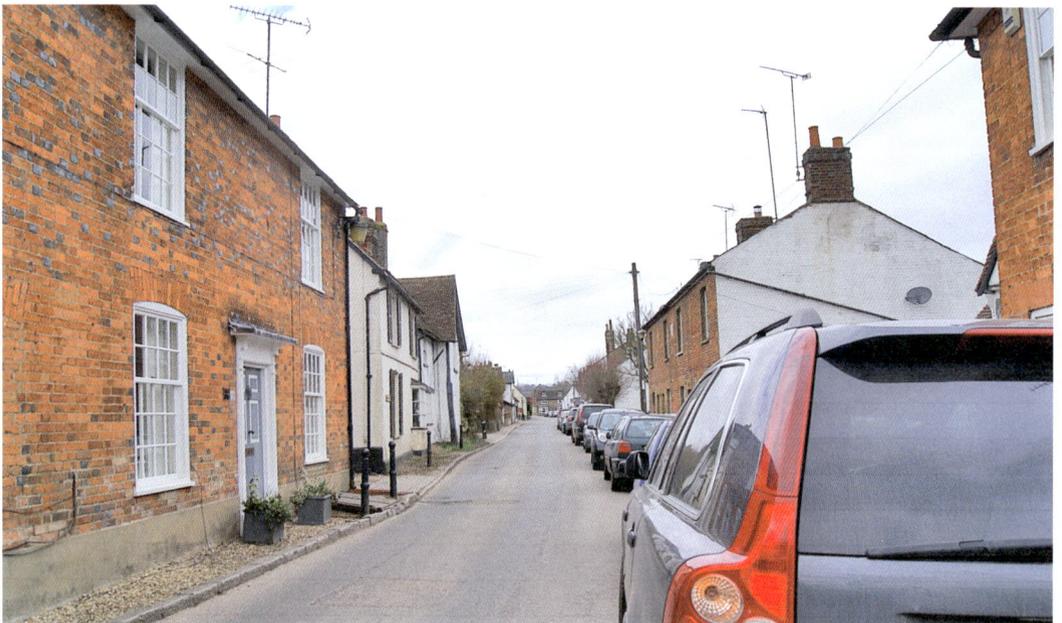